digital borderlands

Digital Formations

Steve Jones
General Editor

Vol. 6

PETER LANG
New York • Washington, D.C./Baltimore • Bern
Frankfurt am Main • Berlin • Brussels • Vienna • Oxford

digital borderlands

cultural studies of identity and interactivity on the internet

EDITED BY
johan fornäs, kajsa klein,
martina ladendorf, jenny sundén,
and malin sveningsson

PETER LANG
New York • Washington, D.C./Baltimore • Bern
Frankfurt am Main • Berlin • Brussels • Vienna • Oxford

Library of Congress Cataloging-in-Publication Data

Digital borderlands: cultural studies of identity
and interactivity on the Internet / Johan Fornäs ... [et al.]
p. cm. (Digital formations; vol. 6)
Includes bibliographical references and index.
1. Internet—Social aspects. 2. Internet users. 3. Group identity.
I. Fornäs, Johan. II. Series.
HM567 .D54 303.48'34—dc21 2001038486
ISBN 0-8204-5740-X
ISSN 1526-3169

Die Deutsche Bibliothek-CIP-Einheitsaufnahme

Digital borderlands: cultural studies of identity
and interactivity on the Internet / Johan Fornäs ... [et al.]
–New York; Washington, D.C./Baltimore; Bern;
Frankfurt am Main; Berlin; Brussels; Vienna; Oxford: Lang.
(Digital formations; Vol. 6)
ISBN 0-8204-5740-X

Cover design by Joni Holst

The paper in this book meets the guidelines for permanence and durability
of the Committee on Production Guidelines for Book Longevity
of the Council of Library Resources.

Printed in the United States of America

CONTENTS

ACKNOWLEDGMENTS

All books are collective projects. This one was the result of the actual collective research project Digital Borderlands, funded by the Swedish Council for Research in the Humanities and Social Sciences, whose support was absolutely crucial for its success. Additional support came from the Swedish Transport and Communications Research Board, as well as from the National Institute for Working Life program for Work & Culture in Norrköping, where the project had its administrative basis. The project organized an international workshop there in spring 2000, and the invited keynote speakers Brenda Danet, Steve Jones, Nina Lykke, and Terje Rasmussen were all important to us, as were all the other thirty participants, mainly from the Nordic countries. Steve Jones' generous offer to include this book in his series was particularly wonderful, and it has been a great pleasure to work with Sophy Craze and her colleagues at Peter Lang Publishers. We finally wish to thank all others who have offered us support, inspiration and information, including informants, colleagues, and friends all over the online and offline globe.

Johan Fornäs, Kajsa Klein, Martina Ladendorf,
Jenny Sundén, and Malin Sveningsson

1 *Johan Fornäs, Kajsa Klein, Martina Ladendorf, Jenny Sundén, and Malin Sveningsson*

INTO DIGITAL BORDERLANDS

Welcome to digital borderlands! Internet practices and Internet research have both crossed established boundaries and opened up new frontiers in between areas that seemed previously securely separated. In such ambiguous spaces, strange things may happen. This is an exploration of those hybridizing processes.

The emergent digital borderlands have attracted an expanding tribe of cyber-cultural studies, combining media and cultural studies with Internet research. This rapidly growing field crosses and reworks certain traditional borderlines such as those concerning identities, communities, forms of reception or media use, textual genres, media types, technologies, and research methods. Developments of communication technologies have included certain convergences between industrial branches, practices, and modes of expression, but also between previously separated academic traditions. Are new lines drawn in cyberspace, and if so, where and by whom? Is digital technology inherently transgressive? Or, should the allegedly new media instead be seen as old in that they reproduce and perhaps even amplify historical tensions?

Borders and transgressions are mutually dependent on each other. Only by crossing a border, at least in thought, can it be experienced as such. Ethic norms or group identities are regularly reinforced by discourses on that which is beyond the limit, on the "other(s)." Conversely, crossings are only possible if there are borders to cross. For transgressions and hybrids to have any meaning and value, they must contradict established limits and bridge that which is otherwise separated. Aesthetic practices combining art and popular culture offer the bonus kick precisely when their rule-breaking mixtures of high and low in new combinations are experienced as such. For those who may not have internalized that borderline, its crossing may pass unnoticed. Likewise, the transgressive function of the Internet derives its force from the technical, institutional, social, or cultural separations that older media forms have developed, so that they may now be bridged.

To some extent, these digital border-crossings are also an expansion of frontiers.[1] They may extend human capabilities and fantasies into new and hitherto unseen spaces. However, this tale of linear development and accelerating conquest of new (virtual) realities is only partly true. It must be kept in mind that history is no simple accumulation of knowledge or resources. In some instances and aspects, there are also regressions and losses. Instead of uncritically basing this introduction on linear tales of conquest and discovery, we will retain a sense of ambivalence and therefore prefer the more complex term "borderland." It is intended to modestly indicate that certain inherited borders are explored by recent media developments, in a continuous and dynamic process in which yesterday's open spaces become tomorrow's limiting structures.

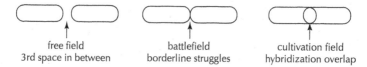

free field
3rd space in between

battlefield
borderline struggles

cultivation field
hybridization overlap

Figure 1.1. Three images of borderlands.

Borderlands may be conceived in three interconnected senses. First, as *free fields,* intellectual free zones or third spaces of refuge in between established closures. Second, as *battlefields,* fields of fighting contradiction on the very borderline where struggles take place. Third, as *cultivation fields,* fields of hybridizing bricolage construction in the overlap between what is elsewhere separated. These three sides are intrinsically and dialectically interlaced. Release from disciplining restriction and the free play of critical contradiction are both necessary conditions of creative cultivation. Like other borderlands, the digital ones oscillate between these positions. And like them, cybercultural studies can only grow through conflicts in open spaces, being constructed precisely through dialogic struggles of interpretation and liberation of imagination, in emancipatory and contradictory processes of growth.

Cybercultural Studies

A series of traditional boundaries have been problematized and made reflexively visible by recent cultural and academic trends that have deconstructed and reconstructed them without completely dissolving them, contrary to what is sometimes optimistically believed. Media types, symbolic forms of expression, and genres have been reshuffled, as have crucial distinctions between private and public spheres, fact and fiction, high and low, experience and imagination. All these will be discussed in further detail, below.

To understand the ambivalent and often hybridizing communicative borderlands of digital media, a renewed crossing of communicative and cultural perspectives is needed. Just as newer media always connect to older ones, studies of computer media must integrate media and cultural studies to catch what is really

bravely new in this digital world. Bolter and Grusin (1999) argue that both older and more recent forms of communication include processes of "remediation" whereby new media always integrate aspects of older ones, imitating their forms and genres with certain modifications or within new contexts. Digital media supplement rather than replace previous print and audiovisual technologies, and tenacious structures in media institutions as well as in everyday-life contexts of use and production work to delimit the transformations first promised by each new medium, reproducing instead certain inherited boundaries in the new media as well. Bolter and Grusin show that this results in a double logic of both immersive "immediacy" and reflexive "hypermediacy," both of which are repeatedly born again with each new media technology. On one hand, new media try to overcome the limitations of their predecessors by making communication so transparent that users may feel seamlessly connected. On the other, this never quite succeeds, and each new mediating technology gives rise to new sets of thematizations of the media world itself. This dialectic creates a need for comparative historical interpretation. At the same time, analyses of recent media phenomena can enrich cultural theories by elucidating aspects and elements of communication that are hitherto deficiently conceptualized. Through processes of digitalization and convergence, computer media have given rise to new hybrid forms, and renewed interdisciplinary crossings may likewise help us better understand both the old and the new.

The Digital Borderlands research project (1998–2001) was inspired by a deeply felt need to develop cybercultural perspectives on the Internet in relation to established media genres and cultural theories.[2] In contrast to the sweeping assumptions in much Internet literature built on self-experienced accounts of travels in cyberspace, these studies are built on extensive, well-grounded, and theoretically reflected empirical studies of digital culture. The project members share a background in media and communication studies and an interest in theories of modernity, cultural studies, and cyberfeminism. They base their cultural perspectives on critical interpretations of symbolic forms and their uses in everyday practices, combining cyberethnography with cybertextual analysis.

The main motives for doing this research may also be seen as possible reasons to take interest in its results. From the point of view of media and cultural studies, there is a need for more empirically grounded and updated understandings of how new media operate, as well as a need to enlarge the scope of media research in general to escape the self-restricting entrapment in studies of press, television, and radio only. In the field of computer studies, there is a great need to insert the new media in a more complex pattern of media and communication modes, and to learn from other analyses of mediation that may highlight what is really different with the digital media. In both these fields, there is also a need for a much more advanced understanding of cultural aspects and uses of these communicative technologies, for interpretations of their generic forms, and for including investigations of aesthetic and entertaining uses of these forms. How are meanings, communities, and identities created online? Most previous research has also put a focus on work, education, business, and other utilitarian uses of digital media, with an interest to

measure or increase their effectiveness and profitability. Cybercultural studies add to this an effort to understand how people use and produce these media in everyday life, and how aspects of play, pleasure, and fictionality are also crucial in their development. These are some possible motivations for cybercultural studies.

Cultural studies may have quantitative elements but must rely mainly on qualitative interpretations of key cases. The studies presented here focus on ethnographic work including participant observation, in-depth interviews, and close readings of Web sites and other textual or pictorial discourses. The fact that media ethnography in online communities naturally develops online results in a blurring of the lines between ethnography and textual analysis. Observation of online practices starts with reading digital texts, just as the use of interviews or field notes necessitate interpretations of them on the background of their social and generic contexts. Studies of Internet discourses are in their turn also studies of interaction between communicating media-users. This all makes it obvious that there are in fact always textual interpretations in every kind of field work, while every textual interpretation may also be experienced as an exploration of a sociocultural world.

The digital borderlands have attracted many grand ideas, not least of the postmodern inflection. There are several lofty arguments about these technological developments giving rise to a supposedly total revolution in society, community, subjectivity, communications, and aesthetics, installing a completely new era in human history. But there is also a growing body of sound empirical research that anchors such brave hypotheses in more specific analyses of how digital media are actually used. The studies presented here contribute to such an anchorage by using extensive qualitative research to discuss some key themes in today's Internet discourse. This research offers nuances and differentiations instead of the prevalent one-eyed generalizations.

Cyberspace in Cultural Studies

Digitalized media recombine old and new forms of communication. The first introduction of new media technologies always tends to open up new potential spaces for social and cultural innovation—options that may be formulated and reflected on in various fictional genres in novels or films. These mixed utopian/dystopian spaces then tend to become absorbed by everyday routines and dominant institutions, until public curiosity and creativity is reinvested in yet another upcoming media form. A series of interrelated digital media have now for some decades been the main focus of such hopes and fears.

Digital discs, telecommunications, television, and the Internet seem to have revolutionized communications by inviting the crossing of formerly rather rigid borders. They appear to offer borderlands for refugees from restricted thinking. In their use, new and richer forms of life, identity, community, experience, and reflection tempt some, while others remain skeptical or warn against the contamination of old ethic or symbolic structures that these insistent technologies entail.

The term "cyberculture" denotes those particular cultural phenomena that relate to the digital world, in particular to the many various network activities that digital media have made possible. "Cybercultures" would perhaps be a more suitable term, because there is a wide range of different cultures and media within this field. "Cyber" as in "cybernetics" derives from a Greek word for steersman, which indicates a culture focused on the management and controlling of either people or artifacts. This aspect will be further discussed here as it relates to ideas about interactivity. The term "cybercultural studies" denotes cultural studies as developed around digital communication media. How these media actually should be described will be the main theme of this text, but first some words on the choice of this cultural perspective, and its general implications.

The media of cyberculture are electronic media that are also digital media, that is, those media that process data electronically in digital form and typically include computers connected into networks. *Cyberspace* is the virtual world constructed by the use of these communication technologies. Cyberspace is a cultural concept, depicting a structured and meaningful symbolic universe—a sociocultural space for communication and symbolization, interaction and interpretation. Today, the Internet is, in practice, the main vehicle for the construction of cyberspace (see Kitchin 1998). Internet cyberspace is at base an intersubjective, cultural phenomenon, even though it is constructed through various technical manipulations. Like all cultural phenomena, it is made of relations between subjects, texts, and contexts, as human beings use digits, signs, networks, software, and hardware to construct and project imagined identities and communities. It is a collective world created in and through language: "One of the great appeals of cyberspace is that it offers a *collective immaterial arena* not after death, but here and now on earth" (Wertheim 1999: 231)—a space for collective intelligence and expressing a concrete process of globalization (Lévy 1998).

Cyberspace is a highly ideological construct, embedded in a practical multiplicity of material and institutional forces. Yet it is effectively present in the actual practices of Internet users, by representing "a utopian future conjunction of personal freedoms, market freedoms, global mobility and cultural identity . . . as normative freedom" (Miller and Slater 2000: 16). Cyberspace is today the world's fastest growing and perhaps most highly ideologically charged (virtual) territory (Klein 2000; also Wertheim 1999).

Among many different ways to study digital or computer-mediated communication, those that may be called cybercultural share a *cultural* approach and may be seen as a branch of the wider field of *cultural studies*. Cybercultural studies investigate and reflect on digital, computer-mediated communication forms in a perspective that focuses the meanings of symbolic forms.

Culture is constituted by meaning-making practices, that is, by symbolic communication. Late modernity is an age of intensified communications, shaping new communities but also spreading diversities. This process makes culture opaque—less transparently self-evident—and therefore more visible as something in and by itself. This corresponds to the double process of remediation mentioned

earlier, which Bolter and Grusin (1999) describe as the dialectic of immediacy and hypermediacy. The semantic, generic, aesthetic, formal, pragmatic, or discursive rules of symbolic systems appear more often and come into focus when people increasingly often have to cross borders between interpretive communities (Fish 1980). When it is no longer obvious why the neighbor makes a certain gesture, dances in a particular way, or uses a specific phrase, one has to step back and think about how bodies, images, music, and words make meanings. A cultural turn has made meaning and interpretation a key issue, in research as in society at large.

There is a prevailing tendency for explicitly cultural aspects and practices to become more important, widespread, and acknowledged in society at large. There is a kind of aestheticization of the economic and political spheres, as well as of education, the media, and everyday life in general. In management handbooks as well as in political debate, issues of meaning and aesthetics are increasingly often put forward. The experiential industries and cultural production have apparently become expansive and attractive. This also makes an argument for cultural studies. This ongoing *culturalization* (increasing importance of cultural practices and symbolic aspects in social life) is closely connected to *mediatization* (increasing centrality of communication media in society and daily life). Various technological and more or less institutionalized systems for mediating communications have become focal in most cultural practices.

Culture, Communication, Critique

Cultural studies correspond and respond to this process—they both answer to it and take part in it. They are not one, but legion: the term is therefore used here in its plural form, contrary to the common, reifying praxis of speaking of cultural studies as if it was one clearly demarcated school of thought. Cultural studies are a very complex set of perspectives, currents, and traditions shifting from decade to decade and from country to country. The main common traits of this intrinsically interdisciplinary field of study may be summarized along three main lines.

1. The first key term is of course *culture* itself, both as an object area and as a theoretical and methodological perspective. Cultural studies are *studies of a cultural kind;* they scrutinize how meanings and forms are constructed in all human spheres, and they analyze culture as an aspect of all social life, with interpretative methods. The growing interest in cultural aspects of modernity has put meanings and forms in focus, asking how meanings, identities, and relations are produced in various types of symbolic webs and interpretive communities. Even highly practical uses of information technologies at school or work presuppose and activate such aspects of design and interpretation and can thus be studied culturally. But cultural studies are also more particularly *studies of culture,* with a special focus on those works, activities, and institutions that are in our modern society marked as "cultural," including the arts, as well as popular culture and the aesthetic practices of everyday life. This is where cultural studies intersect with cultural politics.

This area of primarily cultural practices is particularly large and important in the digital world. The new technologies not only serve the distribution of information and news, education or (post-) industrial production; they have also quite as much to do with entertainment and aesthetics. Such cultural activities are too often regarded as just a small special sector for fun and the arts in the margin of the more crucial issues of life—an embellishing appendix to the "really essential" technical, economic, political, and pedagogic activity areas of life.

2. Culture is seen as *communication,* though not (or not only) in the sense of transmission of artifacts or messages from senders (producers) to receivers (consumers, audiences), but also (or mainly) as a hermeneutic process of creating and sharing meanings through the intersubjective use of symbolic forms. Again, this communicative trait has two facets, one pointing toward the object of study, where mediation and the media world are central, the other underlining the antireductionist emphasis on interdisciplinary dialogues between research traditions. Cultural studies see culture as communication and work themselves in a communicative way, far from building monolithic temples. Close textual interpretations are always contextualized in relation to a series of intersecting economic, political, institutional, social, psychological, and aesthetic contexts in which each text induces its meanings.

3. Cultural studies, from the Frankfurt school of Critical Theory to the later French, British, and American variants, are intrinsically *critical*. They show how power and resistance interplay in culture, striving to take part in attacking and deconstructing all illegitimate forms of domination. These may derive from state or market pressures, or from mechanisms within the life-world, where power is played out along the axes of gender, sexuality, age, generation, class, race, ethnicity, nationality, and religion. Critique in the service of emancipation has a crucial task to understand the other and to criticize the self. This double task is unfortunately too often reversed in actual research and debate, and it therefore has to be repeatedly actualized in an ongoing struggle of interpretations. Interdisciplinary cultural studies make critical interpretations of otherwise neglected phenomena of popular culture, of aesthetic distinctions and transgressions, and of processes of cultural modernization. They ultimately aim to support the further development of an open and plural public sphere, relatively independent from both the market and the state systems, but also critically reflexive toward its own hierarchies and limitations. Their critique thus runs in three directions: against commercialization, against bureaucratization, and against unjust social dominance along the shifting dimensions of social difference.

Internet Media Culture

Digital popular culture has a wide quantitative and economic spread. It plays an enormous political, ideological, social, and psychological role for society and its

individuals by offering tools for the formation and reworking of individual and collective identities, for grasping the surrounding world, for democratic opinion formation, and for handling conflicts. The whole initial development of information technologies has been motivated by technical, political, and economic imperatives, but quite as much governed by factors within the area of culture: playful stylistic youth subcultures, aesthetic desires, and intertextual influences from other genres within art, music, and literature. Digital techniques are used within an expanding series of aesthetic practices, which have central positions in everyday life and in the media world and are gradually strengthened by the ongoing "culturalization" of late modern society.

Aesthetic forms and genres frame much of the recent communications development, and entertainment in the form of popular fiction and games should be taken quite seriously in its dangers as well as in its promises. Interpretive studies of how identities, communities, values, norms, and ideas are formulated by popular cultural media genres, and formed in their use, should therefore be of great priority. Culture is no marginal addition to society, nor is it only a strategic field. Culture is central and multidimensional.

Cybercultural studies are thus a branch of cultural studies but they are also connected to *media studies*. Interactivity, cyberspace, virtual realities, and virtual communities do not emanate out of nowhere. There are several lines of predecessors both to these communication phenomena and to the theories that analyze them. Both are mixtures of new and old. Some established cultural theories are needed to better understand what happens in the computer networks. But digital media have also made some hitherto-neglected aspects of culture and mediated communication more visible, and new concepts shed new light on older cultural and communicative forms such as literature, music, and broadcasting.

A renewed cultural critique might be able to win back some of the key concepts that have been previously attacked as being closely associated with a problematic kind of technocratic view that communication is a unidirectional chain of transmission of fixed contents from encoding senders to passively decoding receivers. The Latin origin of "communication," for instance, implies an intersubjective sharing that "makes common" to the participants a set of meanings and thus joins them in an interpretive community without necessarily making them uniform. Mediated communication is not only about complex techniques for transmitting fixed and packaged meaning-contents from senders to receivers, but also about social interactions in which people gather around meaning-inviting texts to develop interpretations, experiences, and relations. This "ritual" view on communication is therefore quite as important an aspect as the "transmission" view that has dominated much conventional mass communication research, including quantitative content analysis or studies of media effects. A "medium" is something that exists "in between" and thus mediates two (or more) subjects, poles, or worlds. It is thereby a kind of messenger between them, but also a unifying link between them. "In-formation" indicates "giving form to" something in an active process that cannot be reduced to unidirectional transmission of discrete units of content. In both

common conversation and television broadcasting, much more than cognitive knowledge is sent; it actually is no fixed message, but a symbolic web whose meaning is continually developed in a potentially open process of interpretive media use, thus creating meanings, identities, and communities. The model of linear transportation of significant packages from encoder to decoder is useful to catch some aspects of institutionalized mass communication. It tends to distort the picture of communication in general, however, and therefore needs to be supplemented with a cultural view that is not in opposition to these old key concepts but rather in line with some of their significant roots.

These issues have been renewed in interesting ways by recent media developments that have made the reductive models even more obviously inadequate. To face the challenge of new computer-based communication technologies, media studies need a series of transgressions and bridges between traditions and research fields. Some taken-for-granted borders have been problematized: they have hardly been erased, as some postmodernist utopians and dystopians have jointly imagined. Rather, these boundaries have been thematized and thus made more visible by, not least, the interactive moments of recent digital media that often cross them and open up communicative borderlands.

Digital Connections

Cyberculture involves digital media of communication. Digitality—the construction of texts/images/sounds by combining discrete units of zeros and ones—makes possible certain emergent features. Like all media technologies, the digital ones have ambivalent potentials. They extend communicative options and spread them across the globe, but they also allow for an authoritarian hierarchization of communication, a subtle control of citizens and consumers. The digital codes used by these new media have certain important implications that together are the key to cybercultural studies as a subfield of cultural studies.

Compressing Time and Space

Digital media make possible an extreme degree of *compression* in time of space. Messages and works can be pressed into increasingly small units that may be transmitted in an exceptional speed or stored in a minimal space. Thus, lots of information or sense-bits may be communicated quickly over great distances or gathered in singular spots. Together with other communication, transportation and travel forms, such technologies are essential to the time-space compression and accelerating velocity of late modern everyday life.[3] This compression enables an economization of resources and an expansion of communication, as well as an accelerating invasion of everyday life by media technologies. This has its drawbacks, in the tendency to produce information stress and an opening for control over the individual's actions and thoughts. In fact, as communications are compressed, they

actually also expand on an increasing scale, verging on a virtual invasion of every-day life and a compelling pressure to be always available online.

Converging Technologies, Institutions, and Genres

Coding in digital form further enables a *convergence* between what was formerly separate technologically, institutionally, and textually. They are joined in hybrid forms where things mix in new ways with ambivalent implications.

1. *Technologies* converge with each other, forming various kinds of multimedia that allow one single system of machines and networks to serve an increasing range of purposes. The same portable electronic device may today be used for phoning, listening to radio and recorded music, watching television and films, and computing and writing. This could in principle reduce the number (and size) of machines people need to interact with, but will more probably expand the range of such machines in everyday life.

2. *Institutions* converge, as can be seen in the cooperation or fusion of telecommunication, television, film, music, and computer industries into large conglomerates. This also has ambivalent effects because it strengthens the power of multinational corporations and may thus reduce the plurality of small, specialized enterprises while dismantling certain hierarchies between branches and opening new opportunities for small, relatively unknown organizations and groups to reach out to a larger public.[4]

3. Cultural *genres* converge, in that symbolic forms of expression may now be mixed much more easily than they were with earlier mediating technologies. This textual convergence erases certain older borders between genres and inspires a lively aesthetic hybridity, but it also poses threats to the identity of inherited genres. Boundaries have been crossed between genres and contexts of communication having to do with work and leisure, usefulness and pleasure, seriousness and entertainment, instrumentality and play. Digital media forms cross the borders between serious work and playful leisure. As computer technology fuses with mass media and popular culture, hybrid genres appear. These include faction, infotainment, or edutainment, which unite entertainment with education, work, politics, and news, thus aestheticizing the serious while making pleasure more serious. Entertainment genres are used for "serious" uses such as learning or debate, while the entertainment values of "serious" issues are pushed forward. In all these ways, convergence creates options for new forms of expression that transgress old petrified boundaries while simultaneously offering more forceful tools for monopolistic power institutions.

In digital media, communication elements are mixed, and traditional borders between symbolic modes are often crossed. Digital communication forms combine speech, writing, music, and image in ways that call for interaesthetic interpretations.

Different symbolic modes of expression are not only added to each other but also fused into creative hybrids. Email letters problematize the assumedly fixed border between speech and writing by combining characteristics of telephone talk and correspondence. Mail programs introduce new modes of communication and new expressions as spin-off, for instance by the use of the forward, bcc, cut-and-paste functions, and as people are encouraged to categorize their correspondence in detailed ways and thus create new forms of archives. Online chatting becomes a strange brew of formerly more sharply separated modes of verbality. Also, while digital media are still highly verbocentric and scriptural, words are here encountering several limits, by touching the borders toward graphic design and pictoriality as well as toward nonverbal sounds and musics. Unfortunately, many information technology studies have hitherto been quite as logocentric or verbocentric as mass communication research used to be. Where media research forgot images and music in their focusing of printed or broadcasted words, studies of the Internet likewise are sadly silent about nonverbal sounds and visuals. Increasingly complex, multiple, and interactive forms of hypertextual communication make it even less clear than in broadcast media how the analyzed text is to be delimited. Distinctions between utterances, works, flows, and channels are not erased in the crossing streams of interaction in digital networks, but they have to be carefully rethought.

There is a problematic vagueness in how the predigital concepts are used in the new media environment. If the border between writing and speech seemed reasonably clear before the advent of computer texts, it is now extremely complicated. Writing is in fact a kind of hybrid concept, connoting a variable combination of verbality, visuality, and inscription. It might be useful to distinguish three separate aspects that may be combined (or mixed) in diverse ways, both in digital and in older media. One aspect is the visual/oral division (as between writing and speech, scores and music, or images and sounds in general). Another concerns the verbal/nonverbal axis (words vs. both images and sounds). A third is the inscription/process distinction (concerning degrees of durable fixation, regardless of whether it is visual or aural forms that are being stored on paper, tapes, disks, or any other material carrier).[5] Each possible combination of the three pairs may be found both in digital media and in older media forms.

Again, convergence does not in any linear fashion simply create a situation in which all old differences are erased. Traditional boundaries between high and low, between news and entertainment, and between different art or media forms are stunningly tenacious. They are underpinned by a combination of technical, physiological, psychological, institutional, social, and cultural factors that have accumulated a great offline strength that tends to be reproduced online as well. There might, for example, not anymore be any technical reason to keep music separate from imagery because they can here be reduced to just different series of digits. However, this separation has rapidly been duplicated in digital media, too, upheld by the interests of enterprises with separate histories as well as by the deeply seated habits and routines of everyday media use and underpinned by the physiological and psychological differences between the human senses. Not only

are old divisions carried over to the digital media, but there are also tendencies toward new forms of divergence; for instance, the Internet, which was at first often seen as one medium, has been gradually differentiated into a series of different uses. This means that digital media are really a plural phenomenon rather than any unified medium.[6]

Transgressing Geographic Borders

The Internet reaches out globally but unevenly. Real-world geographical borders can still be traced online in the form of identity markers, including language use, where the global dominance of Anglo-America is strong but challenged. Cyberspace geography retains close connections to earthly geography, for instance as many cyberterritories remain structured by language, even though the Net world often tries (and sometimes succeeds) to cut these links to offline territorializations.

Power online is visible in hyperlinks. Halavais (2000: 16) conducted a study of 4000 Web sites and concludes that the number of hyperlinks that cross international borders are significantly fewer than those that link to sites within the home country. Most links were directed towards the United States. The strongest tendency to link cross-border was found in multilingual sites, especially those related to the international scholarly community. Dead-end sites (with no links) were usually English-language dot.coms.

There is an ongoing struggle between the ideal of a unified, universal Net and certain tendencies to divide it into several specialized subnets—parallel to the tensions between the overarching public sphere and the complex sets of sub and counter public spheres that exist in other media as well. This may in some instances and ways offer an enhanced service in the form of narrowcasting geared toward individual needs, but it also implies a privatization that threatens the genuinely public, open and common character of the Net. And in many areas there is a tension between (dispersed) networks and (geographically bounded) nations. Digital conglomerization thus is constantly meeting a series of complex countertendencies of various kinds.

"Of all the parameters of identity it is nationalism that is most fully strengthened and extended within . . . the dynamics of positioning," is the conclusion Daniel Miller and Don Slater (2000: 114) draw from their ethnography of Internet use in Trinidad. The Trinidadians invested a lot of energy online in staging and performing Trini-ness. This was particularly true for those living abroad, something that echoes Benedict Anderson's (1998) long-distance nationalism.

Strategic hyperlinking and new tendencies toward centralization of the Web are beginning to influence economic as well as political power structures. Just think of the power of search engines such as Yahoo or AltaVista, or portals such as AOL.[7] It is important to realize that access is not only about access to hardware and training; it is also about mechanisms for finding and being found. The search engine Google claims to have indexed over one billion Web pages. Naturally, some of these sites are more powerful, more central than others. The Web is not entirely

decentralized as many still like to believe. The sad (but perhaps unavoidable) thing is that most of these Web centers give prominence to the already established and strong Web sites with many resources behind them.[8] It is the same with URLs and email addresses. There is a certain conservatism inherent in the architecture of the Internet. The early birds win. To name is to create; to set the standard equals power.

Computer-mediated communication has often been characterized by its supposedly anonymizing features, but as Donath (1999: 35ff) argues, this does not at all have to be the case. An email address, for example, often reveals a great deal about the sender, and will, according to which domain is used, give the owner a culturally determined status and credibility. In some cases, domain names might be related to the organization or what it stands for, as is the case with the domain "mit.edu," which locates the famous Massachusetts Institute of Technology in the sphere of education. Sometimes domain names point to the assumed experience of the owner, as is the case with "The WELL," because having an address there to experienced users characterizes the owner as someone who has been on the Internet for a very long time. The former ones will inevitably be out of reach for those without connections to the organization, but it might also be difficult to get an email address with the more popular Internet providers. Donath claims that "while there are not yet any recognized 'wealthy' virtual neighborhoods, it is probably only a matter of time until the exclusive online addresses become symbols of status" and as such difficult and expensive to get. People who are born 20 years from now will most likely have problems getting "good" ones.

Transgressing Media Borders

An effect of convergence is a problematization of inherited borders between media types. At the same time, a continuous internal differentiation of digital media into more specialized subforms makes it necessary to talk not of one new medium, but of a range of new digital media. This combined process of convergence and differentiation creates what has become known as multimedia or hypermedia—not discrete sets of clearly separated media but a dynamic continuum of (old and new) media forms.

The Internet is a complex mix of different media within one technological framework. It is a tool used for a range of differing functions and purposes: for mass mediation of journalist or entertainment products, for interpersonal communication, and for creating social community space. This hybrid medium complex recombines characteristics of virtually every old media form. In fact, each new medium has to relate to and build on its predecessors, as indicated by the term remediation (Bolter and Grusin 1999).[9] The Internet is particularly versatile and all-encompassing in its remediation of all that has come before. This way of using methods and forms from letters, books, telephones, records, radio, film, TV, and other media types is often motivated by a wish to overcome the inherent limitations of these other forms. There is a striving to reduce the technical disturbances

and approach a utopian ideal of unhampered communication between people and symbolic worlds. However, these efforts always also tend to highlight precisely these limitations by drawing attention to the mediation process itself. Bolter and Grusin (1999: 5) talk about "a double logic of remediation," in that our culture "wants both to multiply its media and to erase all traces of mediation: ideally, it wants to erase its media in the very act of multiplying them." This gives rise to what Bolter and Grusin describe as a tension between the contradictory imperatives for "immediacy" and "hypermediacy." On one hand, the Internet promises transparent connections between minds and texts, on the other, it leads to an explosion of technological tools that inevitably makes people aware of the processes of mediation as such, thus making the media insistently opaque rather than invisible. Sometimes, digital media appear to enable direct contact between their users. In the next moment, they engage users in a play or struggle with media forms that become fascinating objects in themselves, drawing attention to the increasing intricacies of mediation processes.

There are innumerable ways to differentiate media types. No single general principle can explain the complicated ways in which this is usually done in everyday media practices. Negotiable historical combinations of physical, technical, psychological, institutional, social, and cultural factors create the main categories ordinarily used to distinguish between radio and telephone, or between email and Web sites. Different media, for instance, use different symbolic forms such as speech, writing, pictures, or music, but they are usually mixed in various ways, so that most media—and certainly most digital media—are actually audiovisual ones. Some media mediate primarily across time through storage in writing or recording of some kind, others across space through transmission and dissemination. Technologies ending with "-graph" (from the Greek word *gráphein* for "write") indicate the former, while those starting with "tele-" (Greek word for "distant") imply the latter. However, it is not only the telegraph that combines both aspects. Book print, graphics, photography, phonography, and video all freeze time while simultaneously enabling geographic dispersion of prints, photos, or recordings. Telephone, radio, and television are primarily thought of as techniques for reaching out in the world rather than for storing contents, but they all also include moments of inscription in objectified structures that, in addition, offer options to preserve expressions over time. Yet another division between media types concerns whether media are used between single individuals or for circulation to many. Telephones are generally thought of as means for dialogue, radio as a tool for dissemination. However, these differences are more historically accidental than might first be believed. Radio can in principle be used equally well for individual communication, such as between radio amateurs who have since the early twentieth century been able to exchange long-distance messages. Telephone networks could vice versa as well be used for distributing public messages to the masses, which was actually what its pioneers hoped for.[10]

In a similar manner, the various digital media are never separated by rigid and sharply defined walls; they are the result of historical compromises that may at any

time be renegotiated and transformed. The phenomenon of remediation further blurs distinctions, since many Internet uses develop as a kind of emulation of other media forms. For instance, are digital books to be best understood as late modern forms of literature or as belonging to an emerging new cluster of computer media? How different from CD versions must records released on the Net be in content, form, or function in order to qualify as another medium? After all, vinyl records, tapes, radios, and films also came in different types, and it was never quite clear whether each such variant should be counted as a new medium or just a variant of the old one. Again, it all depends on whether one wants to emphasize differences in symbolic forms, forms of transmission, or forms of organization.

Digital Media Types

All these general problems are strongly present in the digital realm. Importing any of these categorizations to the Internet is thus no definite remedy. Still, distinctions are regularly made in its use; for lack of any fixed ground, one must content oneself with summing up some of the main differentiations presently widespread in this use.

The term "new media" is highly elastic, both between times and between contexts. When does a new medium become an old one? These days, the term is generally used to cover digital media, including primarily computer disk and network technologies. "Electronic media" cover these as well as many older media such as the traditional telephone, phonograph, and radio. They used to process data in analogic form (for instance as continuously variable curves), but the trend is for them to become increasingly digitalized so that all information in the system is predominantly coded as sets of discrete bits (each unit either a zero or a one). As already mentioned, digitalization is crucial to the compression and convergence trends that have profoundly transformed the media world. While "electronic" thus indicates the material carrier of transmissions, "digital" has to do with the code by which the transmitted content is organized. The border between "computer media" and other digital media (not based on identifiable computers but perhaps involving instead electronic instruments or telephones) is increasingly blurred. Computers nowadays exist in highly different forms, and it is hard to say if a microchip turns a refrigerator into a computer or just improves its performance.

Communications now conveniently called cybermedia or multimedia do not form any single, homogenous entity, but are actually composed of a number of very different digital techniques and uses. The same technologies have been applied differently, so that different media genres or forms have originated, much in the same way print technology has been used to produce both books and newspapers, calendars and comics.

Among "digital media," one rather fuzzy bifurcation runs between what might be called "disk media" and "net media."[11] The former are based on the use of singular computers or other interface units that need not be interconnected with each other, at least not through wires or some kind of broadcast transmission in real

time. They instead offer specific resources for local users, with playful, aesthetic or educational contents usually stored on some kind of disk, mounted into computers or other platforms, such as Nintendo or PlayStation.

In Net media, each human/machine interface is connected to others through wires or some kind of broadcast transmission, thus forming systems that connect multiple users to each other and to some shared resources. The Internet belongs to the former category, various kinds of play stations to the second. The fuzziness of this categorization partly derives from the fact that each separate digital medium may through wiring or transmission always become integrated in network systems, so that each digital (and indeed electronic) medium is at least potentially able to be swallowed up by these nets. Digital networks have a kind of hydraic quality, possessing innumerable shifting (inter-) faces and tending to expand by integrating everything else in their range. This immense potential interconnectivity makes it almost impossible to make clear differentiations between these digital media forms. They are not completely separate forms, but may rather be seen as main ways in which the various digital/computer media resources may be used. As always, technological factors combine with historical processes, social conventions, and cultural traditions to draw flexible and contested lines between categories.

The focus of our studies here is on the Internet, which certainly seems to belong mainly and simultaneously to the categories of new, electronic, digital, computer, and Net media. But the Internet consists of a range of different arenas that are structured in different ways, used for different purposes, and which use varying additional technologies (connecting systems, computer programs, interfaces, and applications). They may well be thought of as separate media, even though they partly make use of a similar technological basis of transmission. The partly (but not completely) overlapping phenomena of computer-mediated communication (CMC) and Internet media are not one homogenous kind of communication; they manifest themselves in shifting styles and genres, just as with other media. Some arenas are characterized by the techniques used, others by the goal of interaction. When talking about CMC and the Internet, one should therefore note which specific arenas are intended because they differ considerably in technology as well as in individual and social uses (Herring 1996). The disorder in the general discussion can partly be explained by the relative novelty of these forms and by their extremely fast variability in this early phase of their development. It is as yet hard to foresee how this media cluster—and indeed the whole media world—will develop in the near future, so this summarizing overview remains a provisional snapshot.

Internet Arenas

The studies of this volume all focus on the Internet, which at a first glance may seem to belong to all of the previously mentioned categories, fitting the descriptions of new, electronic, digital, computer, and Net media. However, it would be a mistake to treat the Internet as *one* homogenous medium because it hosts a range

of different arenas that are structured in different ways, used for different purposes, and supported with varying additional technologies. Some arenas and technological functions are constructed with the purpose of facilitating synchronic communication in real time; others are intended primarily for asynchronous messages, sent first and received later. Some aim to connect single persons to one another in dyadic conversation (or wider kinds of interaction); others are mostly used for group or multiparty interaction among several users. The different Internet arenas share many traits but also differ both in technical organization, social uses, and cultural conventions. They might therefore actually be thought of as separate media, even though they partly make use of a similar technological basis of transmission.[12] Some of the characteristics of the arenas depend on which technology is used, while others are related to human factors such as the purpose of the communication, groupings, and subcultures (Herring 1996). Computer-mediated communication should therefore not be seen as one homogenous kind of communication, as it manifests itself in shifting styles and genres. When talking about computer-mediated communication, one should therefore specify the kind of arena to which one is referring.

Reid (1991) categorizes computer-mediated communication into three main systems for sending messages through digital computer networks: email, newsgroups, and chat.[13] In email, messages are transmitted directly between users. In newsgroups and BBSs (Bulletin Board Systems), messages are sent to central computer databases divided into discussion groups where all members or participants can read everything entered in that specific group. These types are both asynchronous, meaning that messages can be written, sent, and read at different points of time, leaving time for reflection before they are sent or replied to. The third kinds of systems, including chats and MUDs (Multi User Domains), are synchronous, in that messages are instantaneously transmitted from the keyboard of the writer to the screens of all connected participants, enabling real-time conversations mediated by the computer. Another important aspect that influences the characteristics of computer-mediated communication is whether arenas are designed for dyadic or multiparty interaction, as shown in the model below.

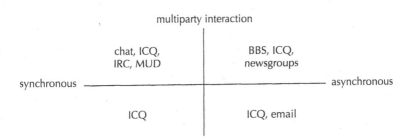

Figure 1.2. Internet arenas.

These main categories do, however, leave space for variations: regular emails may be sent to many persons simultaneously, and chat may well be used also for talk between two single individuals. The ICQ is a hybrid software with many features, as explained below.

In 1969, a United States organization for defense research, the Advanced Research Projects Agency (ARPA), connected four computers in different places to form a net. In 1983, the Internet was created out of this ARPANET, as a civil network accessible to computer users worldwide. Initially, computer-mediated communication was then mainly about sending individual messages from person to person (email).[14] When it was realized that the same technology could be used to share information within groups of people, mailing lists were soon constructed, gradually becoming specialized with respect to the subject of discussion. The terms "BBS" (Bulletin Board System) and "mailing list" were often interchangeable because the purpose and content were similar. BBSs referred to servers that users connected to by calling them up via the telephone net through a modem (Jones 1998), while mailing lists consisted precisely of email sent to a list of people. When the user is connected to a BBS, three main kinds of activity are offered. Users can (1) take part in ongoing meetings or conferences (2) send individual messages, and (3) exchange programs or files (Nissen 1993). BBSs and mailing lists both aimed at offering information and news to their subscribers, and so both were referred to as "newsgroups." The largest collection is the Usenet, which contains thousands of newsgroups on different topics (Jones 1998).

While the former arenas are asynchroneous, designed for sending messages not unlike different types of mail, there are also arenas, such as Multi User Domains (MUD), Internet Relay Chat (IRC), Web chat and "I seek you"-services (ICQ), which enable real-time interaction.

MUD was originally a multiple-user, text-based game called Multi User Dungeon, which was played through computer networks. It was related to non-computer-based role-playing games such as Dungeons and Dragons and was often set in fantasy environments (Pargman 2000). It was soon found that the technology and design could be used for purposes other than game playing, and the D in the MUD abbreviation was reinterpreted from "Dungeon" to "Dimension" or "Domain." Also other variations of the name emerged (for example MUD Object Oriented, or MOO), in order to indicate the purpose of the MUD in question. Some MUDs are still used for games, others for education purposes, still others for social interaction in general. While in IRC and chat the individual user cannot affect the setting for the interaction, MUDs allow competent users to interact with their "spatial" environment: to change and extend it with new "objects" and "rooms" in the form of written descriptions.

IRC and Web chat are both synchronous arenas designed for talking and discussing. Some chat rooms are intended for discussions around a specific subject, but their main purpose is usually social interaction in general. IRC is similar to MUDs in several aspects. They both require special software and some previous technical knowledge in their users, and they are both text-based only, while Web

chat relies mainly on the ordinary Web techniques with all the consequences this implies. The software is the regular Web browser, such as Netscape or Internet Explorer; it does not require previous knowledge exceeding some familiarity with the Web, and chat rooms often have an artistic layout with graphic design, pictures, and colors as important components. Another difference lies in the way pages are updated. In IRC and MUD, this is done automatically, and texts are shown immediately when entered. If many users are actively participating simultaneously, the result will be that texts flash by in high speed; this makes it difficult to follow and engage in conversations, especially for inexperienced users. On Web chats, on the other hand, it is the individual user who updates the page shown on his or her screen. By clicking a send/receive icon, everything that has been entered since the last update will appear. A third difference is that in IRC, users can save (log) what has been written during the time they have been connected, while Web chat messages disappear as new ones appear on the screen.

ICQ ("I Seek You") is an awareness software with several functions. To start with, it enables users to see who of their pals are currently online, provided that they also have the appropriate software installed. The software also provides fast and easy ways of contacting these persons through email, Web links, or chat connections.[15]

Historically, the early Internet included email, IRC, and MUD while the more recent development of the Internet included the World Wide Web (WWW), making it possible to show pictures and format text in more sophisticated ways through the use of HyperText Markup Language (HTML) code. Later inventions enabled Web page designers to publish also sound and video, use live Web cameras and video conferences, and engage in other activity. It is difficult to make any forecasts on how this media cluster—and indeed the whole media world—will develop in the future, but there seem to be some clues. What has emerged during the last years is abundant and playful mixes of technologies and genres, often coexisting on the same Web sites. An example can be given in that news sites, fan club sites of pop-groups, and download arenas such as Napster or Hotline often include message or chat features. Such hybrids and bricolages will probably blur the boundaries of each separate Internet media—boundaries where arenas intermingle more and more.

Web Sites and Links

What is most commonly associated with the World Wide Web, however, is the Web site. Web sites are generally composed of one or several Web pages. There are Web pages on every imaginable subject and new genres are developing quickly. A Web site can include a number of different features. Most common is authored text, with or without hyperlinks. It can also include images, sounds, and video, as well as interactive features such as guest books, discussion fora, or chat rooms. The term "Web page," with its analogies to book and magazine media, covers the former variants, whereas "Web site" extends associations from a textual to a geographical

conceptual sphere, like a stage or forum. A site is not only a collection of pages presenting pre-composed material, but may also be a place to meet others and do things using a number of different techniques. There are also a number of different sorts of Web sites: the company or organization Web site, the amateur Web site, the webzine, Web sites for different hobbies or interest groups (from neo-Nazis to cat lovers), and so on. Web sites are also found in private Intranets, and not on the global World Wide Web. A more elaborate attempt at a Web site typology might differentiate between Web centers, home pages, and specialized services:[16]

1. Web centers (meta-Web, trying to represent the entire Web)
 a. Portals
 b. Search engines
 c. Web-mapping sites
2. Home pages
 a. Personal home pages (presenting an individual)
 b. Organizational home pages (presenting an organization or community)[17]
3. Specialized services and resources
 a. Vertical portals and resource center sites
 b. Webzines
 c. Web shopping
 d. Web downloading

It should be emphasized that individual home pages (2) may contain elements of both Web centers (1) and specialized resources (3). A webzine (3b) may furthermore include a presentation of the organization/person behind the zine (2). There are no clear-cut lines.

Also, it is not self-evident how to delimit one Web site. Where do they start and where do they end? The phenomenon of linking between sites (or positions within sites) destabilizes borders between sites, while also making power and other relationships more visible. Some new organizational forms are built on linking, including Web rings in which groups of sites agree to include links to one another. It takes more effort to include a link to another Web page than it does to click on one. Including a link to someone's Web page is a public acknowledgement. In this regard, links are very different from private bookmarks. Links can be reciprocal. They can also be critical. Not least because of how search engines operate, links can be said to have economic value. Numbers of links are increasingly replacing the number of hits as the most important measure of a site's popularity.

Hypertext Fiction

It should be evident that there is no such thing as a single, homogenous "cyberspace textuality" or "electronic literature." There are many. For example, in looking at the hypertextually spatialized worlds of MUDs and MOOs—at the interplay between

a relatively stable textual architecture on one hand, and ephemeral dialogues on the other—one can see how very different types of electronic texts intermingle and new hybrids are created. Nevertheless, homogenizing concepts such as "digital textuality" are making their way through cultural and literary theory. Ironically, these all-embracing concepts have been primarily concerned with a specific type of electronic textuality, namely hypertext. Not even hypertext is a singularity, but rather the underlying principle (and ideology) of very different things such as the linkage of Web pages, multi media networks, and hypertext fiction. Actually, the whole World Wide Web may be seen as one enormous hypertext, as indicated by the abbreviation "http" (hypertext transfer protocol) in the beginning of each Web address (Svedjedal 2000).

Stories written in hypertext are maybe best thought of in George Landow's (1997) term "lexias," which he borrowed from Roland Barthes to describe reading units. Whereas pages of paper in a book are bound together in a terminate sequence, blocks of texts on a screen become lexias by the possibility to both connect them to each other and follow them in a number of ways. Stories written in hypertext have often more than one point of entry, many internal connections, and no clear ending. These stories might unfold differently each time, depending on which of any potential routes are being actualized.

Hypertext is, of course, nothing new. Obviously, literary works are hypertextual in their allusions through their intertextual references to one another and through the internal and external linkage of footnotes, references, tables of content, and indexes. On a more explicit level, there are preelectronic print examples of hypertext with a built-in structure of a multiplicity of textual routes.[18] It might be true that a bounded book seems better suited for a linear narrative to be followed from beginning to end, or that hypertext appears to be tailored for discontinuous jumps between lexias in any order desired. Still, these structures are not inherent to the medium itself. Creativity is not only a matter of exploiting easily accessible built-in features; it is also about pushing the limits of the text and to resist or transform the obviously intended interpretations of that text. Hypertext is often assumed to have the potential to liberate the reader from the author, but it is far from clear how the ability to move through the text in a nonsequential fashion in itself can liberate the reader from the creator. On the contrary, readers might actually feel less free in a textual compound whose author has not offered any clear sense of directions, but instead constructed labyrinthic spaces for readers to get lost in. The hypertext reader hardly exists in an ideological vacuum. Neither is that reader freed from the material constraint of the machine or interface. To state that hypertext *in itself* disrupts authoritarian hierarchies of language and liberates the reader is to ascribe this liberating potential to the hypertextual structure itself, and not to our ideas of what a text is and what can be done with it.

This rhetoric can be seen as a later version of what many literary theorists already have been doing for a couple of decades in relation to any text. When Roland Barthes in his "Image-Music-Text" (1977) proclaimed the death of the author, the reader was empowered over the writer. Barthes showed how the act of writing

is itself an act of reading, how positions of creation and interpretation are constantly shifting. From this point of view, there is no finished work, but rather parts that might be explored without constituting a determined wholeness. This opens up multiple readings and possibilities for textual journeys in a landscape that will never look the same twice. This perspective comes very close to the recently formed rhetoric of hypertext, but with the significant difference that hypertext theory sets traditional texts back in a position in which the divinely supreme author prevails, while multilinearity and interpretive play is reserved for hypertextual structures only.

Nevertheless, even if the particularities of hypertext are not in themselves emancipating, they do make certain textual qualities that might be found in any text particularly obvious. "What the marriage of postmodernism and electronic technology has produced is not the virtual text itself, but the elevation of its built-in virtuality to a higher power" (Ryan 1999: 96). All texts are virtual objects in their capacity to generate potential worlds, interpretations, uses, and experiences, but electronic texts, and hypertext in particular, take this virtuality-as-potential to a higher level.

Notions of the open text, the text as a web of intertextual references, reader freedom, the active interpretation, etc., are possible to ascribe to any inscriptive practice, but only in the case of *digital* hypertext do these features provide the very foundation for the text. The act of reading is indispensable for the realization of the digital text, not only for its interpretation, but to literally bring it into existence. But instead of developing an obsession with this convergence between postmodern literary theory and hypertext, a more fruitful move would be to formulate a perspective that makes visible the *material* dimensions of online textuality in all its varieties.[19] If a book easily is brought to the beach, or to a warm bath, the pleasure politics of cyberspace are very different and far from immaterial, disembodied, and nonsensuous. Blinded by the beauty of the interface, too many thinkers in cyberspace have described these textualities as disengaged from the physical reality of the medium, as well as from that of material bodies. The illusionary immateriality of online texts is, in fact, severely circumscribed through its anchorage in computer code, and in the body of the typist who brings the text into being. Avant-garde literary theory might be a point of departure for a critical theory of online text, but it is simply not enough to account for the complex interplay between bodies, computer technologies, and labyrinth-like textual nodes and networks involved in the making and reading of these texts.

Interactive Mediation

Two of the most hyped properties of digital media are interactivity (sometimes also linked to virtues such as democracy, information egalitarianism, playful involvement, and coproduction) and interaction (building communities and relationships). Digital media seem to enable a much more elaborate interaction

between users, machines, and texts than do some older mass media. This has to be qualified. There is actually interactivity and interaction in many other and older media as well, and far from all use of digital media is interactive in any stronger sense of the word than is valid for any ordinary media-user. So, in which way is this actually new to the digital era? Sonia Livingstone (1999: 65) suggests that what is new with new media is their capability to combine interactivity with dissemination on a mass scale. The intensified forms of interactivity that are evolving seem to add to the relativization or even erosion of formerly well-established borders between types of communication.

Interactivity is a notoriously polysemic concept, which may emphasize the social interaction between media-users, the technical interaction between users and machines, or the cultural interaction between users and texts. *Social interactivity* is the ability of a medium to enable social interaction between individuals or groups (i.e., subjects). *Technical interactivity* is a medium's capability of letting human users manipulate the machine via its interface, with the so-called cyborg (cybernetic organism) as a particularly fascinating case. The cyborg is a kind of hybrid combination of human and machine, popularized by science-fiction movies such as Robocop and theorized by Donna Haraway and other cyberfeminists.[20] This discourse is separate from that on interactivity, but it is possible to regard the cyborg as an extreme example of technical interactivity. *Textual interactivity* is finally the creative and interpretative interaction between users (readers, viewers, listeners) and texts. The three are often interconnected, so that an increased number of options to interact with the technology also increases one's power over textual form and content and/or the possibility to interact with other media-users.

Every medium is, to some extent, technically and culturally "interactive," by inviting its users to an activity that includes an interaction between the medium (both the machine hardware and the textual software) and its users and between the different individuals who are connected by the mediation in question. That interactivity consists of a series of choices—of commodities, channels, programs, genres, texts, times, places, and reception modes. It implies a coproduction—of knowledge, meaning, experience, identity, and even new cultural expressions in those words, gestures, or songs that might spring from this media use. It also includes the shaping of specific intersubjective social relations—of interpretive communities and other interactions between different media-users.

Some recent digital technologies have radically enhanced these kinds of interactivity by explicitly emphasizing the user's response and active assistance in the formation of the media text itself and by developing particular tools to facilitate this. The whole "cyber"-metaphorics—based on the Greek word for steersman—stresses individual steering by the media-user, and thus puts interactivity at the core of reception. The increasingly evident interactive moments in many forms of mass media should not conceal the fact that such explicit interactivity is far from new. An old-fashioned paintbook with fields to fill in, or a common songbook with melodies to perform, are both interactive in this immediate sense: the activity of the user is needed to realize their "texts" not only as meaningful works ("signifieds") but

also as material artifacts ("signifiers"). Recent digital techniques are thus not the only interactive ones, but it is true that their particularly great potential of inducing interactive uses has further problematized some habitual boundaries in media research which have long deserved to be questioned.

Interactivity resides more in the relation between media and their users than in the media themselves. Computer media explicitly offer so many different potential use modes that they cannot be abstractly classified as interactive. Some common ways to use them do not differ much from the uses of ordinary mass-media, while in other cases their interactive potentials are intensely explored. According to any of the definitions of interactivity mentioned above, every medium and every text may or may not be used interactively. A book may be simply read from beginning to end, or it may be worked through and filled with notes in the margins and across the printed text. A karaoke video may either be "passively" consumed by a watching and listening audience or "actively" used by a singer. It is hardly possible to sort out interactive media from other media in any simple way, and interactivity is hardly any distinguishing characteristic inherent in all digital media and in them alone. Different technologies have only varying potentials for interactive use, just as different individuals are variously prone to be interactive in their use of media texts, or as different contexts are more or less inviting to such interactive practices. After all, digital media seem at least to offer particularly enhanced interactive options of the technical, the textual, and the social kind, combining them in the same apparatus and genre.

Aspects of interactivity have implications for issues of democracy, power, and freedom of expression. Digital media offer new means for different individuals and social groups to take active part in key issues for societal development in the areas of politics and economy; human rights and obligations; ethics, norms and ideals; and worldviews, identities, and cultural traditions crucial to people's well-being and self-esteem. But these new media may also become organized in such a way as to confine acting subjects in preprogrammed structures that block changes and consolidate hierarchies of domination. Critical cultural media studies are crucially interested in discerning such ambivalent complexities by discerning both emancipatory and authoritarian potentials of various communicative forms.

Jens F. Jensen sums up a wide range of discussions around the concept of interactivity, pointing to its many intertwined dimensions. His concluding suggestion is to define interactivity as "a measure of a media's potential ability to let the user exert an influence on the content and/or form of the mediated communication" (Jensen, "'Interactivity': Tracking a New Concept in Media and Communication Studies," 1998: 201). This would then allow for four main dimensions: (1) transmissional interactivity, in which users may select from a continuous stream of information; (2) consultational interactivity, in which users may not only select but also request texts; (3) conversational interactivity, in which users may also produce and distribute information in the system; and (4) registrational interactivity, in which a system checks a user's activities and responds to them. Transmission is basic to the old mass media, sending out the same contents to great numbers of receivers. Consulting is

the common mode of using a library or a CD-ROM. Conversation appears in newsgroups or email, whereas registration is a kind of surveillance that may or may not be asked for by—or in the best interests of—the user. There are many other dimensions worth discussing as well, concerning, for example, whether the interaction is in real time or not.

Interactivity has become a positive buzzword. A chance to interact with others, machines, and/or texts may certainly be a useful improvement compared with more hierarchical and unidirectional forms of communication. However, there are several ambiguities in interactivity that must be acknowledged. Not all contexts create needs for opportunities to alter a text (image, music) indefinitely. Most media uses will probably remain bound to the desire to be reached by some kind of text (letter, book, film, television program or song album) published by someone else and available through dissemination in some public sphere. The dream of total, transparent self-control forgets the importance of opening oneself to other voices—to the voice of the other—and of immersing oneself in sensual experiences.[21] In other cases, interactivity—particularly of the registrational kind—involves a control of the user, which may be highly problematic. A lot of interactive elements in digital media are there to register user activities for commercial or other aims.

Productive Reception by Individualized Masses

Despite these reservations, interactive phenomena certainly do blur the distinction between *production and reception* as communication moments, as institutionalized forms of practice, and as research areas, even in view of the fact that some traditional media genres differentiate fairly strictly between them. The traditional transmission model of communication—as codified by Shannon and Weaver (1949) and as they underlie much later communication and information theory—fits communication in commodity form reasonably well. Commodification namely implies the separation of production and consumption by means of a shift in ownership status and usually also some intervening industrialized apparatus of distribution and sales. But it is too limited to serve as a general model of communication, since not every instance of media use and reception can be understood as a consumption of media commodities. Cultural media studies have strongly questioned this model, by leaning instead toward a concept of communication that stresses intersubjective constructions of meaning in uses of shared texts.[22] Qualitative and ethnographic studies of how media-users interpret the texts they encounter are necessary to explain how society is reproduced, with both its democratic resources and its oppressive mechanisms. Media reception is always productive, and media production always presupposes interpretative media reception.

Another increasingly blurred distinction is between *mass media* and *interpersonal media*. The former organize a highly centralized, formalized, and institutionalized production geared toward a dispersed receptive audience. In actual reality, this model is mostly more or less mixed with other modes, when feedback and

interpretative activity tend to blur the simple producer/audience relation. Some digital media have tended to increase this blurring by adding new intermediary forms.

Mass reproduction exists to varying degrees and in varying forms in different media types. The Internet is a hybrid form that can sometimes function much like television or records, when home-page or webzine producers distribute their texts to a wide, anonymous audience. In other ways, the Internet much more resembles postal or telephone services in that it offers tools for individual or small-group communication (including email, chat, ICQ and MUD). Its increasingly dominant existence makes it obvious that similar hybridity is true for many other media forms as well (including radio and telephone), so that this dichotomy is only a liminal case of a much more complex continuum. By a retroactive action, cybercultural studies can shed light on aspects of communication that were also valid for older media forms but which have hitherto been neglected in mainstream media research with its traditional focus on press, radio, and television. As the wide range of Internet uses is increasingly often acknowledged as relevant for media research, there may as a consequence also be a rising interest in studying films, books, records, telephones, and postcards as mediating technologies.

The Internet media fulfill shifting functions in different settings. As with all new media technologies, they tend to lean on earlier and more routinized media forms, so that Net services may seem to imitate press, radio, records, telephone, "snail" mail, photo, or film. But both the Net itself and its dense interplay with computer, telecommunications, and television technologies have problematized these older, petrified categories.

By "narrowcasting," the cultural industries project media products to smaller consumer groups, thus answering to more differentiated and pluralized societal need structures. This interacts with the creation of new contexts for social and political discussion in more or less oppositional or alternative partial public spheres. Both these *fragmentizing* trends connect to an increasing societal *individualization* in which individual identities and lifestyles are, in increasingly more cases and aspects, experienced as one's own choice and responsibility.[23] With a growing amount of media channels and outputs, individuals are forced to more and more consumption choices. However, this neither makes all individuals different nor everyone alike. Instead, the first step is generally that traditional social differences, for instance of gender and education, become visible as social patterns of media reception when monochannel uniformity is shattered.[24] This may well be the case with the spaces for interactivity and personal choice in digital networks as well, because they are predominantly used by an educated élite, thus reconstructing dichotomies of high and low in this field, too.

Mediatization not only forces consumers to choose from an expanding set of options, in a trend toward *selectivization*. They are also enabled to use media in conjunction with each other and with other activities, to which media are then an ever-present background. This *parallelization* tendency makes many media uses more out-of-focus or distanced. This has long been true for teenage music use or

for the presence of TV in American homes, and it may be the case when new media technologies are stretched into already established everyday reception habits. In some cases, they might substitute certain older forms of communication, but they will probably more often supplement these and thereby expand people's media repertoires.

Digital media make more obvious that actually all communication media may be used both for *dialogue* (in speech or gestures) and for *dissemination* (which is what mass media were primarily made for). As Peters (1999) has beautifully made clear, both these forms are equally old, equally worthy, and equally dangerous. Both existed separately before, as Peters shows by juxtaposing the dialogues of Socrates with the sermons of Jesus. In the early bourgeois public sphere, dialogic salons and letters played a key role, but so did the press and publishers, as they extended these dialogues to a larger and more open general public. Then came telecommunications and electronic audiovisual media, adding tools in both directions. On the Internet, the two realms blend even more easily. It is true that dialogue may be a free interaction between equals, but it may be, as well, a form of manipulation that forces the other to think in certain ways and permanently excludes those outside that particular interaction. On the other hand, dissemination may lend itself to asymmetric propaganda from a monolithic sender to servile receivers, but it also makes possible an unforeseeable activity of reinterpretation among those who watch, listen, or read. It is the specific dynamic and democratic combination of the two that is necessary for the vitality of modern public spheres in civil society and everyday life-worlds. Only thereby can dissemination let free the creative collective imagination of text-users while preventing dialogues from closing into aristocratic dyads of domination.

Instead of a simple dichotomy of mass versus individual media, it is thus more fruitful to operate with a continuum. On the one extreme, some "macromedia" are mainly based on the dissemination in commodity form of texts created by centralized producers among the cultural industries and then distributed to a wide (and, in principle, open) range of consumers. These consumers use the texts to shape their own interpretations and experiences, sometimes modifying them interactively. In the middle, "mesomedia" are niched products circulated locally or within alternative public spheres, with a less sharp separation of producers and consumers. At the other extreme end are "micromedia," whose communicators do not primarily read prefabricated texts but jointly create their own dialogues, for instance in email, MUDs, and Usenet discussion groups.

There are no sharp borders between these three main levels of media, from macro through meso to micro. The same communication technology can often be used in many different ways depending on its social organization. Studies combining several perspectives are needed to clarify the connections, similarities and differences between the various types of interactivity enabled by these forms. Internet studies can thus help transgressing dated dichotomies between media studies (and studies of popular culture) and dialogic studies of personal communication. Mass-mediated popular culture should be studied interpretively as a symbolic

realm closely integrated in more delimited or interpersonal media practices. Traditional mass media are only a very special case of communications media, and they are often not as simply "mass" media as many have believed.

Levels of Mediation

A strict division between *mediated and direct communication* is also relativized as media are increasingly integrated in everyday discourses. In forms such as karaoke (which is based on the digital technologies of television and the laser disc), mediated and direct moments can be interwoven in highly complex ways. Processes of mediatization also make media continually present in even the apparently most "direct" interpersonal dialogue. For instance, a modern pop concert is saturated with media presence. Standing in the back of a concert hall, one mainly hears the artists through the sound system and perhaps mostly sees them on a big monitor screen; even for the artists themselves, the use of such aural media have become an integrated part of live performances.

In a certain sense, all communication is doubly mediated: (1) It is necessarily mediated by material signifiers: physical artifacts of some kind, or at least sound and light waves that bridge the inescapable distance between subjects. There is no direct contact between minds or bodies: interfaces are obligatory. (2) It is also mediated by the intersubjective, socioculturally, and conventionally based symbolic code systems of language, music, pictorial, and other expressive forms necessary for each single communicative act to function.

This is as true for "direct" speech or dance as it is for records or books. Critical cultural media studies can counter widespread naive ideas of unlimited immediacy and community in cyberspace by pointing at those necessary symbolical mediations through which all communication has to make a detour. The hermeneutic philosopher Paul Ricoeur has consistently argued that this detour of interpretation of textualized meanings is the *sine qua non* of intersubjective communication and understanding of the world, the other, and oneself.[25] Written texts make the necessary mediation between subjects obvious; these already exist in speech, only hidden under the appearance of immediate presence. Instead of falling back to a belief in the Internet as a way beyond textual mediation, it should be used to better understand the complex distanciations involved in all communication. Interpretive conventions, generic frames, and life-worldly preunderstanding is presupposed in each seemingly straightforward talk or image-use, and only the familiarity with a medium and the belonging to a certain cultural community and tradition can make people believe that understanding evolves naturally.

However, "mediated communication" usually refers to a third kind of mediation, that of technically constructed and institutionally organized machines that intervene between the communicating actors. An increasing amount of human interactions use special mediating apparatuses or linkage systems that are technologically produced within institutionalized social organizations. Communication can be more or less mediatized in this more narrow sense of the word, but there is

in fact no sharp dichotomy between mediated and face-to-face interaction. Culture cannot be fully understood without accounting for the inherent "textual" distanciation in all dialogue, in opposition to all ideologies of pure, unmediated presence. Mediation is everywhere.[26]

Virtuality in Performance

A cultural perspective on Internet media necessitates an interpretative understanding of the symbolic forms and meanings created online. The (more or less) interactive relation between users, machines, and texts can only be fully understood by a more elaborate and careful study of how symbolic universes are created and encountered in these practices. This points toward key concepts such as virtuality, performance, identity and community. Internet practices involve interacting individuals that jointly shape individual and collective identities through the production, manipulation, and interpretation of symbolic forms used for representing subjects (persons or communities).

A dichotomy of virtual versus real is repeatedly presupposed in prevalent Net discourse. The term "virtual" ethymologically derives from the Latin "virtus," sharing its root *vir* (= man) with words such as "virtue" (moral excellence) and "virtuoso" (person with special competence, knowledge, or taste).[27] This gendered origin in manly, manful mastery has moved a long way to the sphere of virtuality, though some traces of this origin still linger on. Skilled men were seen as those who used to invent and fabricate new things, and the more they did so, they created the virtual phenomena of culture. A rarely mentioned early use of the concept of virtuality is by Susanne K. Langer (1953), who applied that term to a series of phenomena of symbolic representations: virtual space, virtual time, virtual powers, virtual life, virtual memory, virtual history, virtual past, virtual future, virtual present, and so on.[28] For Langer, virtuality was the defining characteristic of works of art as they create impressions of "otherness" from reality, a "detachment from actuality," an "unreality" as "semblance" that resembles other things in the form of "virtual objects" or "illusions." A virtual phenomenon is *almost like* something else, a simulated or emulated version that imitates something else in reality. A virtual X is *like* an X, i.e. not an X but deceptively similar to it—it is *X-like* for practical purposes though not in name or according to strict definition, so the dictionaries tell us. Virtual reality is not actual reality, though it is pretty much alike it, standing in for some absent real world. The two realities are neither completely identical nor absolute opposites. Their strange relationship easily induces some confusion.

If X' is mimetically related to a real X, this does imply that the two are in many ways similar to each other, though in some crucial way still different. This relation is one of symbolization: X' signifies X. However, even though the signified may here only exist in people's minds, the signifier itself must always possess some kind of material existence. The virtual world has a physical substratum, be it in the form

of electronic currents in silicon chips, neural reactions, or specific movements of fingers and heads. The virtual is not completely unreal or detached from materiality in that specific sense. Every computerized fantasy world is in one respect immaterial, but it still has a fully physical and tangible basis: computer chips are as material as are recorder pickups, and while the electrons they process are not palpable, they are no less "real" than book pages or sound waves. Also, mental and symbolic constructs cannot be said to be pure illusions. The real world consists of much more than what can be seen or sensed. In an important sense of the word, symbolically expressed and intersubjectively shared meanings belong to human reality even though they cannot be measured in length or weight. In this sense, the virtual is itself also real, even though it simultaneously simulates something else in that same reality.

Virtuality in this general sense has followed human culture from its very beginning. Symbols open up imaginary worlds that tend to be virtual worlds by including traits that imitate real social worlds. This was the way Langer used the term half a century ago. Its proliferation in cybercultural discourses is sadly forgetful of this prehistory and is actually full of confusion. The signifying interpretive work of each use of any mediated text (old or new, analogue or digital) comprises a kind of *virtualization* in which letters or other combinations of sound or light units trigger an intersubjective creation of imaginary worlds shared between the involved actors. All media have always offered entrances to imagined spaces or "virtual realities," opening up symbolic worlds for transgressive experiences. Any literary novel lets its readers reconstruct and temporarily "inhabit" a whole world of its own—"the world of the text" (the imaginary textual world), interrelated to "the world in front of the text" (the real social world) which it refigurates and points to.[29] Such imagined worlds are no more nor less virtual than the space a computer game lets its users experience. Hermeneutic reception theory has developed a series of relevant ideas about how readers, listeners and viewers by "disappearing acts" (Modleski 1982) enter textual webs of meaning, filling out their open "gaps" (Iser 1972) and constructing "virtual space" and "virtual time" (Langer 1953) within genre-related "interpretive communities" (Fish 1980 and Radway 1984).[30] Virtuality as such is not confined to computerized communication; it appears in all cultural genres.[31]

In Net discourse, "virtual" sometimes just denotes "computer-based" or "on-line." This is a widespread but even more problematic usage of the term because if it is combined with some kind of contrast with "real," that reality becomes computer-free. To their users, MUD spaces could well be experienced as even more real than the implied imaginary world of a fiction novel or film. The capacity of constructing virtual worlds is no dividing line between media technologies.

It is true, however, that digital media have a radically enhanced capacity to mix literary and social worlds. In this way, virtuality is a kind of potentiality for imagining and creating possible worlds.[32] As a matter of fact, Internet cyberspace is more than virtual in that it is a truly real interactional and social space for its users, though always surrounded by imaginations and by discourses on it. Cyberspace is

a specific combination of a real world of interacting people and an imagined or virtual world of their symbolic constructs of this space: It is a mix of real and utopian processes.

In cyberspace it is sometimes difficult to distinguish between artwork and fact, fantasy and reality. Fan communities, Web-spread gossip and culture jamming make those borders slippery. The juxtaposition of different narrative forms and genres is not specific for digital media, however, even though its Net forms may still surprise us. One striking example is the "rogue" sites whose creators want you to believe they are the real thing — at least for a moment. Two common techniques are (1) domain name-fudging, in which very small changes are made in Net addresses (this works because people guess URLs), and (2) search-engine manipulation using meta tags (the porn industry seem to be especially good at this advertising technique). These and other playful or deceptive practices add to a generic confusion, but they also create an acute awareness of these generic rules. The border crossings rarely erase borders; instead, they make them reflexively available. Cultural processes have a stunning capacity to reinforce generic conventions, not by cementing them as eternally fixed but by upholding an ongoing remolding of them through acts of reinterpretation and innovation. The genre experiments within digital media call for a reconsideration of inherited concepts and categories in a process in which they may certainly be revised but only rarely become completely obsolete.

Espen Aarseth (1997) points out that there is a rarely acknowledged "performative" dimension of what he calls "cybertexts," namely the ways in which the reader (or user) literally needs to complete these texts, not only through interpretation but through "work" in a quite different meaning. For example, a computer game cannot be actualized unless somebody is playing it, and no MUD can be experienced without user participation. Such textual activities are always grounded in a complex interplay between the act of typing and responses from the computer program. Thus, the use of commands in MUD, or the rapid choices made by the computer game player, have an actual impact on the game space in the sense that the world of the text (the game world) is changed. These commands, by producing the effects they name, could fruitfully be compared with what John L. Austin calls a "performative." This concept "is derived, of course, from 'perform,' the usual verb with the noun 'action': it indicates that the issuing of the utterance is the performing of an action — it is not normally thought of as just saying something" (Austin 1962: 6–7).

This argument is particularly fitting in relation to the creation of, for example, MUD characters, because these are literally "typed" into being through a combination of writing and programming, literally constituted through language acts. Textual bodies exist only as language and as such inhabit a symbolic universe; they are temporarily released from the physical reality of their typists. Still, these online bodies can never be completely released from the material and cultural conditions in which they are grounded, nor from those discourses of the gendered body that render them meaningful. This intersection of "real" and imaginary spaces of text

and matter tend to result in a blend of textual playfulness and realism important to take into consideration when online performances of subject positions are explored. Apart from being spaces for dreams and desires, virtual worlds are also networked social environments for business, research, and education, and as such they are intimately integrated into the rhythms and routines of everyday life. Evidently, there is more room for play and textual pleasure in MUDs and in chat rooms, in comparison with the United Nations Web sites, even though imaginary text worlds sometimes develop their own realist aesthetics.

The virtual worlds opened up through the Internet are in many cases spaces where each individual visitor/user may leave discernible footsteps. They are mostly textual worlds of written words, even though speech as well as nonverbal sounds and images is also present. But in a particularly urgent sense these texts are sites for performances, not only of producers/authors, actors, and artists, but also of their readers. The Internet offers a series of arenas for display and interaction. This is less obvious on Web pages where a relatively straightforward distribution of books, songs, or artworks is the main goal, but more so in those many arenas where social interaction and interactivity appear.

As in other social arenas, analytic tools from symbolic interactionism are helpful. One key example is Mead's (1934) analysis of I/me relations in the games and plays of performances in front of "generalized others." Dramaturgical metaphors such as "frontstage," "backstage," and "presentation of self" in Goffman (1959) have been influential in cybercultural studies as well, as have his discussions of disembodiment and copresence (1963/1966). Ideas from Anselm Strauss (1978) and Howard S. Becker (1982) about life-worlds, social worlds, and art worlds are likewise applicable to digital communities, as has been shown by Laurel (1991/1993) and Göttlich et al. (1998). The Internet offers specific forms and arenas for self-presentations of individual subjects, groups, and institutions in social interaction with others. This perspective is relevant both for email, Web sites, and various types of chat rooms, where new, mediated forms of presence, presentation, and action are offered to interactive users.

The Internet as a medium for social interaction and interpretation is an arena for two interlaced passages: flows of people (subjects) through virtual spaces and mediated digital texts, and flows of texts through virtual spaces and people. Together they give rise to four principal kinds of encounters, two of which are between people and texts.

1. Mediated texts flow through people through processes of *reception,* in which people make meanings by interpretations of the digital texts they use. Reception places media in people, as human subjects appropriate mediated texts through acts of interpretation. Media invade people's lives, minds, and bodies—this is the main aspect to which the mediatization debate draws attention.

2 People flow through media in the sense that the media offer *representations* of people. Media texts (Web sites as well as emails or MUDs) are symbolically populated by textual representations of human subjects.

3. People encounter other people in forms of social *interaction*. They meet each other "in front of" media (talking in an Internet café in front of a computer screen) or through them (exchanging messages via the Internet).

4. Finally, there is the *intertextuality* between different texts on the Internet, also reaching out to texts in other media. Mediated texts are criss-crossed by other texts, through open or candid references and influences.

All these kinds of encounters may lead either to transgressing contacts and hybrid fusions or to confrontations and separations. Because they entail a meaning-making interplay between subjects and texts in contexts, these encounters make clear that Internet use is always a communicative practice. It is obvious that mediated interaction always also includes reception, representation, and intertextuality: the four are not only analytically separable aspects of one complex totality.

Disembodied Identities

One of the "immediacy" trends in remediation (Bolter and Grusin 1999) that has been particularly strong in connection with the Internet is the wish to reach other beings beyond the limitations of the material body. Wertheim (1999: 260) mentions that there is an increasingly widespread view that human beings are defined by information codes, so that there might be a human essence not in bodily matter but in the data pattern of information codes. She sees this as an expression of dreams of immortality, transcendence and omniscience in a cyber-religious imagination: "By far the most bizarre aspect of mind-download fantasies is the dream of cyber-resurrection—the notion of reconstructing on cyberspace people who have died" (265). Such cyberdreams of transcendence with almost religious overtones seem to express a wish for total disembodiment. Hayles (1999: 29) likewise talks about a "contemporary pressure toward dematerialization," that affects bodies as well as texts, in a "systematic devaluation of materiality and embodiment" (48). This is ironic, because the flight from bodily matter is induced precisely by material changes in communication technology. This utopian hope for disembodied contact with others is problematic, because "human being is first of all embodied being" (283). There is no grand escape from the body: "Information, like humanity, cannot exist apart from the embodiment that brings it into being as a material entity in the world; and embodiment is always instantiated, local, and specific" (49).

Despite all ideologies of the absolute incorporeality of computer-mediated communication, the *body* remains an inescapable element. With tools and technologies, one can reach further out, but human bodies still remain the first and the last step of each communicative act, and physical carriers (in cables and chips) are as necessary to computer network as they are in everyday speech or vision.[33] Digital networks remain dependent on human bodies, both in their practical functioning and in their symbolic metaphorics. Without bodily organs and limbs, one cannot even access the PC keyboard and the computer screen cannot be read other than by human senses.

There is also a symbolic or metaphoric dependence on the human body in mediated forms of communication. The virtual world created in cyberspace remains bound to bodily metaphors if it is to be at all intelligible and useful to its human users. For instance, cyborgs or robots in science fiction films are mostly equipped with some kind of limbs and sensory organs, even when they are supposed to possess an unlimited capacity for appearing in any arbitrary shape. The recourse to an easily recognizable anthropomorph or at least an organic form makes it easier to invest them with the kind of identity that makes possible the narrative identification needed for the plot to work. The same is true in the audial world: even synthesized music continues to incorporate human sounds recognizable as individual voices, even though their electronic manipulation just as well could have made them "inhuman." Most instrumental voices in modern pop music continue to simulate familiar IRL instruments, despite the fact that such sounds could as well have been made completely alien. Communication retains a bodily dependence on all levels and contrary to a widespread belief in its disembodiment.

Digital communication thus remains based on—and repeatedly thematizes—precisely the physical and sensory body so often assumed to be eliminated in cyberspace. Virtual reality is made and interpreted by embodied subjects, and it constructs "mental bodies" and "written voices" because every interaction and narration demands some kind of recognizable embodiment of its interacting (imagining and imagined) subjects. Intersubjective dialogicity simply cannot avoid reproducing some form of dynamic and internally diversified embodied subjectivity.

Identities are the meanings of subjects, the interpretations of an acting human being.[34] They are intersubjective, sociocultural constructs. These constructs are not produced by sovereign and autonomous subjects alone, and neither are they forced on passive victims by external symbolic or social structures and institutions. Instead, they are developed in a continuing and shifting interplay between selves, others, and impersonal frames. Identities are the dynamic product of an interaction between the actions and wishes of the self, surrounding others' actions toward and understandings of that self, and its material and institutional contexts. Identity is not passively received but made, though not by oneself alone but in a complex interaction with other subjects, texts, and contexts.

These identity-producing interactions take place in the use of communicative and signifying practices, including all the available mediating technologies from pictures, letters, books, telephones, and records to digital multimedia. In all face-to-face encounters, there is already a double tendency to fix identity positions and at the same time allow moments of surprising role testing. With the insertion of a new medium, this dialectic is multiplied. Recent cybercultural studies, to be discussed and exemplified later in this book, show that while people sometimes act in fanciful disguises on the various Internet arenas, they still tend to retain some idea of identifiable personal agency with a relative stable coherence. The concept of identity generally presupposes some kind of stability and coherence: an identity is a cultural, meaningful expression of what binds a person (or a group) together in time and space. However, no identity is ever completely fixed or completely

homogenous. There is always some degree of flexibility and fragmentation of each individual subject position. This does not make identities completely illusionary, as if they were empty shells. For identities to appear there need be only some relative degree of self-continuity and coherence. Human interaction always tends to recreate such identities while continuing to keep them to some degree dynamic and heterogenous, online as well as offline.

This was all true long before the advent of computers. What digital media offer is a new set of arenas for identity constructions, always related back through remediation to earlier forms of communication. The precise relation between online and offline identities may take different forms in different arenas and genres on the Internet. There is sometimes room for experimentation and deviation in which people try out new faces of themselves, rarely shown elsewhere. But empirical research shows that there is at least as often a much tighter fit between how people behave and present themselves online and offline. In this book, both these options will be exemplified in chat and MUD arenas. Online identities may look different from those found in other contexts, but on closer inspection they seem to be developed in rather familiar ways.

Dispersed Communities

Identities may also be collective. Not only individual beings, but also groups, develop a sense of continuous unity. Through interaction, various kinds of collective formations are shaped. In modern societies, this is a key function of mediated communication. It is fascinating to see how groups are formed and restructured in some of the Internet arenas. This happens on all social levels. Tight and relatively well-defined groups as definite sets of people who gather to form microcultures can do so via email networking. More diffuse and larger collectives that identify with sets of stylistic traits to develop subcultures make use of Web sites and chats. Large social categories such as those associated with gender, sexuality, class, age, nationality, ethnicity, or religion also get new, digital means of internal and external communication. In all these instances, mediated interaction in various kinds of networks is used to form interpretative communities that produce some kind of collective identification.

The sliding between imagined and real worlds problematizes the concept of *virtual community*. Again, *all* text-users develop interpretive communities in which they, while remaining physically on distance, gather socially to share certain works, tastes, and ways of understanding. This is true for pen pals as well as for press readers, book lovers, and pop fans. In this sense, new technologies remediate older forms, offering more extensive, fast, intense, and effective means, as well as a wider combination of different communicative options within the same technological framework. That communities do not presuppose that members have to be spatially copresent or temporally simultaneous in their activities has been known for ages: already the early civic public sphere in the late eighteenth century revolved not only around bourgeois salons but also around press and book publishing.[35] In

a certain sense, "all communities are virtual communities" (Silverstone 1999: 104). There is an imaginary or symbolic side to each collective identity, because identity is a cultural rather than a physical concept.

It can be asked if such scattered communities are not quite as "real" as those that happen to be located in the same place. A married couple is no less a married couple if they happen to live in two separate towns. A subculture need not be thought of as an imaginary community only because many of its individuals never actually meet. Truly "imagined communities" do only exist as such in the symbolic realm, and subcultures or interpretive communities surely might have such imagined aspects. However, they can simultaneously be "real" configurations of actual people sharing certain characteristics, tastes and self-understandings.[36] The social world of digital media-users is inhabited by a range of differing communities that are not only virtual but also real, both imagined (symbolically constructed as collective entities) and alive (produced by human beings of flesh and blood). The paradox in this is illusionary. Mailing lists, MUDs, and Web rings of personal home pages identify a set of members with some kind of addresses; each address implies either a person or some kind of organization or group that in turn is interpreted as indicating a set of individuals. Participating in such mediated communities implies some kind of production of and identification with a collective unit. People continually move in and out of such groupings; one may well take part in several of them, and the involvement in each of them may be highly shifting and partial. A community is thus rarely any fixed constellation of people. Just like identities, communities are cultural concepts of meaning but are uniquely connected with collectives and contexts rather than with single individuals. Some such communities are reminiscent of alternative public spheres as they build their own communicative networks outside of more established mass media and institutions. Others are more like subcultures, sharing certain stylistic traits and activities that distinguish them from other citizens. Some hacker groupings can even develop into countercultural movements aiming for societal change. Most of them are probably considerably looser webs of people, more like those found among fans or ordinary consumers of genres in other media forms.

Online virtual communities are sometimes supposed to be horizontal, flat, open, and democratic. In practice, however, they are very often loose, hierarchical, or commercial. Just because they are digitally based does not guarantee any higher ethical standard than that to be found offline. Administrative and commercial forms of power are as effective on the Internet as they are in other media forms, and social forms of domination along axes such as age, gender, class, and ethnicity remain present there, too.

To get full access to a Web site with certain interactive elements, there is generally required some kind of membership with a user name and a password. This harkens back to procedures within traditional organizations or associations. Associations founded offline through nondigital procedures make themselves present on the Net as well, by creating their own Web sites. They then have a primarily offline, extracyberspatial existence, and they use the Web as an organizational tool

among others such as meetings, phone calls, newsletters, brochures, and papers. There are also intracyberspatial organizations, started via the Net and mainly operating there. It is not easy to decide either how to use these terms or which communities are to be counted as organizations and which as subcultures, groups, or public spheres. Again, this is an issue of interpretation, and that is precisely what cybercultural studies are involved in.

There is an ambiguity in the use of the term "virtual community." It is sometimes used to primarily denote communities that are dispersed, that is, those in which members might never see or talk to each other. The term is also taken to mean communities that are imagined or imaginary. This inconsistency in usage and meaning of the term leads to some confusion in the debate. A dispersed community might of course be simultaneously imagined; this is, for instance, true with many aspects of ethnic or subcultural formations. But other dispersed communities may certainly be quite real because they consist of a definite number of individuals who interact via media within some clear-cut framework. An example is pen pals or regular online organizations. On the other hand, imagined communities need not be necessarily widely dispersed across the globe. There are also imagined aspects to very local communities: a small gang might have an enormously imaginative image of itself. The duality of local/global should not at all be identified straight off with that of real/imagined: no general law makes the local more (nor less) real than the global. A small village may well primarily have a highly symbolic presence, while it might be much less obvious who, actually, its true inhabitants are. As with virtual reality and virtual identity, a virtual community is like a real community but is still not quite real: it is a symbolic representation of a community. Real interacting communities also are surrounded regularly by symbolic representations of themselves (from photos and badges to gossip and tales), and if these imaginary representations are divorced from their material basis, they may be regarded as virtual. But that concept becomes more relevant and interesting when the connection back to interacting embodied subjects is broken, so that the community is only virtual, and there is no real counterpart to the community it symbolically mimes.

These observations seem to necessitate a choice in terminology. Either the virtuality of a community is meant to denote its geographical dispersion, or the term is used to denote that a community has only a symbolic existence, being a symbolic representation of a community not corresponding at all to any specific real set of people. The latter usage seems most coherent with the understanding of virtuality as something that is like reality but still not real, whereas the former usage might derive from the alternative (and even more problematic) usage of "virtual" as a term for anything that exists online. The latter choice implies that one should not always expect that virtual communities be physically dispersed across great distances. This may or may not be the case. Also, both dispersion and imagination are in no way confined to the realm of computer media-users. Virtual communities thus may or may not be digital ones, in addition to the fact that they may or may not be dispersed. Cultural studies investigate how communities are formed in

media use through mechanisms of identification and differentiation, inclusion and exclusion. As imagined or imaginary communities, virtual communities exist both online and offline, and so do the temporally or spatially dispersed communities that in fact may be quite real.

Cyberethnographic Interpretations

Cultural studies investigate meanings by making interpretations. This requires close interaction in those interpretative communities that are studied. Cybercultural studies demand combinations of hypertextual readings and participant observation in digital arenas for mediated communication.

Cyberethnography highlights certain problems in all media ethnography. When the informants (the standard anthropological term for persons studied in their ordinary contexts) ordinarily interact only digitally, digitally mediated forms of participant observation and interviewing on the Internet might be as legitimate for ethnography as is face-to-face-interaction. Interviewing and observing chatting users on the Net would offer researchers as close contact with them as the users normally have with each other. If ethnography implies taking part in a cultural community on its own terms, just participating in online interaction should qualify as ethnography. But if ethnography demands a study along as many senses and channels of communication as possible, it has to be supplemented with contacts in other settings and face-to-face as well. It might well be important for a researcher to try to know as much as possible about the everyday activities and lifestyles of those who participate in the studied Internet arena, in order to contextualize their online texts and thereby understand them even better than other participants do. Ethnography then goes further than only reproducing the self-understanding of a given community, which is important for any cultural studies with a critical intent.

In any case, the multimedia convergence of digital technologies has given rise to an intensified combination of textual and interactional elements, which necessitates a renewed attention to the strong interplay between cyberethnography and Web site analysis. Interpretations of online transcripts can simultaneously be conceived as readings both of webs of texts and of interacting subjects. The same is actually true of ordinary talk, music, and literature as well, but Internet media make this even more obvious. There is no strict border between the two because interpretive methods are always engaged in social interaction (so that cyberethnography always includes textual readings), and texts are always situated in interacting communities (so that textual readings always invite ethnographic contextualizations).[37]

Hypertextual linking does not erase borders around texts, but it certainly does problematize them, as has already been mentioned in relation to Web sites. Multimedia content and hyperlinking force textual and discourse analysis to reflect carefully on the identification of their objects of study.

All these theoretical and methodological considerations show how the Internet

and its cyberculture cross, problematize, and redefine borders, but also how such borders are tenaciously reproduced. This is truly a borderland rather than an unbounded space—it depends on borders and continually draws new boundaries in the same practices and reflections by which old ones are questioned and blurred. This ambivalence makes cybercultural studies productive, as shown in the following chapters. Each chapter focuses on one specific Internet arena and form of communicative practice, emphasizing one particular set of general issues and perspectives.

In "Cyberlove: Creating Romantic Relationships on the Net," Malin Sveningsson analyzes how people meet and build relationships with each other first in and then outside chat rooms, thereby crossing the border between life online and life offline.[38] An important division trangressed in meetings in Internet chat rooms is the one between human and machine. Informants talk about this division as "fuzzy," involving a process of mutual self-disclosure as well as of presentation of self *out of the interface*. Other fuzzy borderlines can lie, for example, in the process of developing relationships. When does a relationship really become a relationship? How many emails do you have to exchange before a relationship is labeled as such? This question becomes even more problematic when the "relationship" is changed to "romantic relationship." How would one define love, and where are the borders between acquaintance and friendship, or between attraction, flirtation, and love? The keyword here is "process," and these latter forms of relations should be seen in borderlands terms, as hybrid and fluid phenomena that overlap and interfere with each other, with no sharp borderline between them.

In her article "Cyberbodies: Writing Gender in Digital Self-Presentations," Jenny Sundén explores notions of culture and embodiment in text-based virtual worlds (MUDs) by focusing on the creation of "characters" (online personas), and in particular on how gender is being constructed in these texts. By carefully observing and interpreting hundreds of such characters, she is able to show how stereotypical models are both reproduced and overturned. Based on two years of field work in the MUD that for the purpose of this study is called WaterMOO, her interpretations focus on several questions: What is ethnography like in immaterial textual cultures? Which images of male, female, and other-gendered bodies are salient in MUD practices? How can the "body" be conceptualized online, while being both text and matter? The article thus discusses a series of borders and borderlands such as those between bodies and texts, real and virtual, social reality and fantasy, orality and literacy, and ethnography and textual analysis.

"Cyberzines: Irony and Parody as Strategy in a Feminist Sphere" by Martina Ladendorf scrutinizes how feminist webzines, or grrlzines, as alternative public spheres and media genres remediate print magazines, with special consideration to the genre of women's popular magazines. The linking between sites gives rise to a problematization of borders between them; their interactive features blur borders between producers and consumers; and they are in different ways strongly influenced by older forms of popular media. The grrlzines subvert the conventions of the commercial women's press, but the mainstream press is also influenced by new

media content and new feminist consciousness. Remediation concerns both written texts, in which feminity and feminist identity are deconstructed, and images, in which older stereotypical images of femininity are ironically reused.

The final chapter by Kajsa Klein, "Cyberglobality: Presenting World Wide Relations," looks at the Web sites of the United Nations. Like the previous chapters, it examines self-presentations, this time organizational ones. Production, site structure, and site content are discussed in terms of inclusion/exclusion, center/periphery, and standards/diversity tensions. The relation between different UN Web sites is discussed, as well as the relation between the UN organization and the online un.org. An amalgam of globalization, public sphere and cybergeography theory serve as backdrop. It is being argued that the UN on the Web is best understood as a cosmopolitan borderland, foremost because of the effects of linking: different languages and different political actors are juxtaposed in ways that challenge traditional views of international relations.

But what do these four studies have in common and what separates them? First of all, three different types of Internet arenas are studied: Web sites, chat rooms and MUD. The first type is mainly used for information; the other two provide places where people meet and interact, perhaps forming relationships and communities. Some of the grrlzines overlap between these forms because they have places for user interaction together with traditional features and articles. Also, national contexts for the studies differ, from the international or cosmopolitan context of the UN to the national level in the study of Swedish chat rooms. Somewhere in between is WaterMOO, which is clearly North American but welcomes users from all over the world, and the studied grrlzines, which have a U.S. bias but which also include publications from Australia and Sweden.

Another important difference is the one between politics/serious matters and play. The UN Web site is best described as at the public and realist end of the continuum. It is about public information, not personal problems or pleasures. Klein raises issues of power and hierarchy more explicitly than do the authors of the other chapters.

Different studies focus on textual analysis (Sundén and Ladendorf), uses (Sveningsson), and production (Klein), even though each article combines elements of them all in shifting combinations of ethnographic and interpretive methods. Sundén and Ladendorf focus exclusively on the Internet, whereas Klein and Sveningsson both compare online meetings and media representations with their offline counterparts.

Concerning theory, both Ladendorf and Sundén are inspired by feminist theory, and their studies relate to the gendered body. All studies presented here relate to theories of media, communication, and cyberculture, but while Sveningsson also uses ideas from conversation analysis and interactional sociology, Klein adds perspectives from political science.

Together, these four chapters offer close cultural studies of a wide range of Internet arenas and phenomena: from MUDs on the border between the real and the imaginary to the realist United Nations, from intimate chat flirts to open

international publishing, from textual works to social interaction, from normal standards to underground experimentation.

In a postscript entitled "Academia and Internet Research," Professor Steve Jones of the University of Illinois at Chicago reflects on the uneasy position of Internet studies within the academic field at large. These studies thrive in the interstices between older disciplinary boundaries, building new transnational networks among highly diverse groups of researchers. Jones argues strongly for renewed and intensified attention to "the Internet's connections to other realms of human endeavour." Cyberculture needs to be understood as a practice, not merely as a neutral technology, because the Internet is embedded within culture in important ways.

It is the nexus of Internet and culture that this book examines. Welcome to a borderland exploration!

Notes

1. See Anzaldúa (1987) on ethnic and geographic borderlands; Gilroy (1993) on diaspora and hybridity; Hannerz (1996) on creolization; Clifford (1997: 246f) on borderlands/diaspora; Bauman (1999: xlixf) on borders/frontiers.
2. A point of departure was Fornäs ("Digital Borderlands: Identity and Interactivity in Culture, Media and Communications," 1998).
3. See Meyrowitz (1985) and Thompson (1995) on media, time, and space; Virilio (1990/2000) and Armitage (2000) on the impact of speed; Harvey (1990) and Giddens (1990) on general perspectives on late modern social geography; and Slevin (2000) on the general social impact of the Internet on modern culture.
4. This latter potential has often been exaggerated because corporate power is surprisingly tenacious. There are certainly decentralizing examples as well, however, both in underground and subcultural music-making, in alternative social movements, and in local activity groups (for an example, see Mele 1999).
5. "Does 'written' refer to the visual manifestations of language, or its durable inscription? The sign language of deaf communities is visual but not permanent, while audio recordings are permanent but not visual" (Ryan 1999: 10). Ryan then suggests that the relation between print, oral, and electronic textuality is best represented as triangular.
6. See Jensen ("Communication Research after the Mediasaurus? Digital Convergence, Digital Divergence," 1998).
7. For an account of the power of search engines, see Introna and Nissenbaum (2000); on AOL, see Patelis (2000).
8. The main alternative to search engines are human-made ratings based on trust in the rating individuals/institutions. Rogers (2000) distinguishes between reliability by acclaim, solidarity, or popularity.
9. See Kress and van Leeuwen (1996: 39) on the multimodality of texts and Lehtonen (*The Cultural Analysis of Texts*, 2000; " On No Man's Land: Theses on Intermediality," 2000), Fornäs (*Cultural Theory and Late Modernity*, 1995) and Becker et al. (2001) on intermediality.
10. See Bjurström et al. (2000) and Becker et al. (2001).

11. Both kinds also exist in nondigital forms, like vinyl records or surface chain-letters.

12. See, for example, the difference between books, newspapers, and junk mail, which all are printed but still could not be said to be the same media.

13. For a more thorough overview of digital media and Internet arenas, see Smith and Kollock (1999).

14. For Internet history, see Santoro (1994) or Kitchin (1998).

15. CQ ("seek you") was the call in amateur radio so-called DX-ing in the early twentieth-century (Peters 1999: 212).

16. See also Miller and Slater's (2000: 150) Web site classification based on design, technological sophistication, and ecommerce savvy: (a) the "flyer" or "advertisement," (b) the "catalogue" Web site, (c) the "interface."

17. This may range from a diary Web-ring page to the NATO home page.

18. For examples and closer analysis, see Aarseth (1997) and Svedjedal (2000).

19. See Aarseth (1997) on "ergodic literature," and Hayles (1999) on the interplay between texts, bodies, and machines.

20. Haraway (1991); see also Bryld and Lykke (2000).

21. See Bolter and Grusin (1999) on the dialectics of immediacy and hypermediacy.

22. See Fornäs (2000) and Bjurström et al. (2000).

23. See Beck (1986/1992), Ziehe (1991), or Giddens (1991).

24. As has been shown by Reimer (1994), this has happened when national broadcasting monopolies have been lifted, thus opening up the airwaves to commercial enterprises.

25. Ricoeur (1976 and 1990/1992).

26. See, for example, Fornäs (2000).

27. Ryan (1999: 88ff) provides one of many useful discussions on the concept of virtuality.

28. See also Cassirer (1957, part II).

29. See Ricoeur (1981, 1983/1984, 1984/1985, and 1985/1988).

30. See also Fornäs ("Mirroring Meetings, Mirroring Media: The Microphysics of Reflexivity," 1994; "Listen to Your Voice! Authenticity and Reflexivity in Rock, Rap and Techno Music," 1994; *Cultural Theory and Late Modernity*, 1995; "Do You See Yourself? Reflected Subjectivities in Youthful Song Texts," 1995; and "Filling Voids Along the Byway: Identification and Interpretation in the Swedish Forms of Karaoke," 1998).

31. Inspired by the French psychoanalyst Jacques Lacan, Daly (1999: 94) argues that "virtual reality" is a "blurring" between the domains of actuality and artificiality: "Actual reality is always a representation, a virtualization of the Real . . . All . . . is 'virtual' in the sense that its meanings . . . have to be represented . . . In this regard there is nothing new about virtual reality: it is as old as the symbolic order itself . . ."

32. See Lévy (1998); Wertheim (1999).

33. See, for example, McLuhan (1964/1987).

34. The concepts of subjectivity and identity are further developed in Fornäs (1995).

35. This is clear already when Habermas (1962/1989) emphasizes the crucial role of the post and the press in the genesis of the early civic ("bourgeois") public sphere. The presence of mediatizing processes is no late invention, though these have accelerated and multiplied in late modernity.

36. Anderson (1983/1991).

37. The necessary interrelation between ethnography and textual analysis was emphasized by deconstructionist anthropologists such as Clifford and Marcus (1986) and media researchers including Drotner (1994).

38. A more extensive analysis of how relations and communities are built in Web Chat is offered by Sveningsson (2001).

References

Aarseth, Espen J. *Cybertext: Perspectives on Ergodic Literature*. Baltimore and London: Johns Hopkins University Press, 1997.

Anderson, Benedict. *Imagined Communities: Reflections on the Origin and Spread of Nationalism*. 2nd ed. London: Verso, 1983/1991.

Anzaldúa, Gloria. *Borderlands/La Frontera: The New Mestiza*. San Francisco: Spinsters/Aunt Lute, 1987.

Armitage, John. *Paul Virilio: From Modernism to Hypermodernism and Beyond*. London: Sage, 2000.

Austin, John L. *How to Do Things With Words*. Cambridge, Mass.: Harvard University Press, 1962/1975.

Barthes, Roland. *Image-Music-Text*. London: Fontana Press, 1977.

Bauman, Zygmunt. *Globalization: The Human Consequences*. Cambridge, UK: Polity Press, 1998.

———. *Culture as Praxis. New edition*. London: Sage, 1999.

Bechar-Israeli, Haya. "From < Bonehead > to < cLoNehEAd >: Nicknames, Play and Identity on Internet Relay Chat." *Journal of Computer-Mediated Communication* 1, no. 2 (1999). < http://jcmc.huji.ac.il/vol1/issue2/bechar.html >

Beck, Ulrich. *Risk Society: Towards a New Modernity*. London: Sage, 1986/1992.

Becker, Karin, Erling Bjurström, Johan Fornäs, and Hillevi Ganetz (ed.). *Passager: Medier och kultur i ett köpcentrum*. Nora, Sweden: Nya Doxa, 2001.

Becker, Howard S. *Art Worlds*. Berkeley: University of California Press, 1982.

Bjurström, Erling, Johan Fornäs, and Hillevi Ganetz. *Det kommunikativa handlandet: Kulturella perspektiv på medier och konsumtion*. Nora, Sweden: Nya Doxa, 2000.

Bolter, Jay David and Richard Grusin. *Remediation: Understanding New Media*. Cambridge, Mass. and London: MIT Press, 1999.

Bryld, Mette and Nina Lykke. *Cosmodolphins: Feminist Cultural Studies of Technology, Animals and the Sacred*. London and New York: Zed Books, 2000.

Cassirer, Ernst. *The Philosophy of Symbolic Forms. Vol. 3, The Phenomenology of Knowledge*. New Haven, Conn. and London: Yale University Press, 1957.

Clifford, James and George E. Marcus (ed.). *Writing Culture. The Poetics and Politics of Ethnography*. Berkeley: University of California Press, 1986.

Clifford, James. *Routes: Travel and Translation in the Late Twentieth Century*. Cambridge, Mass. and London: Harvard University Press, 1997.

Daly, Glyn. "Politics and the Impossible: Beyond Psychoanalysis and Deconstruction." *Theory, Culture & Society* 16, no. 4 (1999): 75–98.

Danet, Brenda, Lucia Ruedenberg, and Yehudit Rosenbaum-Tamari. "Hmmm . . . Where is that Smoke Coming From? Writing Play and Performance on Internet Relay Chat." In *Network and Netplay: Virtual Groups on the Internet*, edited by Fay Sudweeks, Margaret McLaughlin, and Sheizaf Rafaeli. Menlo Park, Calif. and Cambridge, Mass.: AAAI Press/MIT Press, 1998.

Donath, Judith S. "Identity and Deception in the Virtual Community." In *Communities in*

Cyberspace, edited by Marc A. Smith and Peter Kollock. London and New York: Routledge, 1999.

Drotner, Kirsten. "Ethnographic Enigmas: 'The Everyday' in Recent Media Studies." *Cultural Studies* 8, no. 2 (1994): 341–357.

Dunlop, Charles and Rob Kling. "Personal Relationships and Electronic Communication." In *Computerization and Controversy: Value Conflicts and Social Choices,* edited by Charles Dunlop and Rob Kling. London: Academic Press, 1991.

Fish, Stanley. *Is There a Text in this Class? The Authority of Interpretive Communities.* Cambridge, Mass.: Harvard University Press, 1980.

Fornäs, Johan. "Mirroring Meetings, Mirroring Media: The Microphysics of Reflexivity." *Cultural Studies* 8, no. 2 (1994): 321–340.

———. "Listen to Your Voice! Authenticity and Reflexivity in Rock, Rap and Techno Music." *New Formations* 24 (1994): 155–173.

———. *Cultural Theory and Late Modernity.* London: Sage, 1995.

———. "Do You See Yourself? Reflected Subjectivities in Youthful Song Texts." *Young: Nordic Journal of Youth Research* 3 no. 2 (1995): 3–22.

———. "Digital Borderlands: Identity and Interactivity in Culture, Media and Communications." *Nordicom Review* 19, no. 1 (1998): 27–38.

———. "Filling Voids Along the Byway: Identification and Interpretation in the Swedish Forms of Karaoke." In *Karaoke Around the World: Global Technology, Local Singing,* edited by Tôru Mitsui and Shûhei Hosokawa. London: Routledge, 1998.

———. "The Crucial In Between: The Centrality of Mediation in Cultural Studies." *European Journal of Cultural Studies* 3, no. 1 (2000): 45–65.

Giddens, Anthony. *The Consequences of Modernity.* Cambridge, UK: Polity Press, 1990.

———. *Modernity and Self-Identity: Self and Society in the Late Modern Age.* Cambridge, UK: Polity Press, 1991.

Gilroy, Paul. *The Black Atlantic: Modernity and Double Consciousness.* London and New York: Verso, 1993.

Goffman, Erving. *The Presentation of Self in Everyday Life.* New York: Doubleday Anchor, 1959.

———. *Behavior in Public Places: Notes on the Social Organization of Gatherings.* New York: Free Press, 1963/1966.

Göttlich, Udo, Jörg-Uwe Nieland, and Heribert Schatz (ed.). *Kommunikation im Wandel. Zur Theatralität der Medien.* Köln, Germany: Herbert von Halem Verlag, 1998.

Habermas, Jürgen. *The Structural Transformation of the Public Sphere.* Cambridge, Mass.: MIT Press, 1962/1989.

Halavais, Alexander. "National Borders on the WWW." *New Media and Society* 2, no. 1 (2000): 7–28.

Hannerz, Ulf. *Transnational Connections: Culture, People, Places.* London and New York: Routledge, 1996.

Haraway, Donna J. *Simians, Cyborgs, and Women.* London: Free Association Books, 1991.

Harvey, David. *The Condition of Postmodernity.* Oxford and Cambridge, Mass.: Basil Blackwell, 1990.

Hayles, Katherine N. *How We Became Posthuman: Virtual Bodies in Cybernetics, Literature, and Informatics.* Chicago and London: University of Chicago Press, 1999.

Herring, Susan (ed.). *Computer-Mediated Communication: Linguistic, Social and Cross-Cultural Perspectives.* Amsterdam: John Benjamins, 1996.

Introna, Lucas and Helen Nissenbaum. "The Public Good Vision of the Internet and the Politics of Search Engines." In *Preferred Placement: Knowledge Politics on the Web,* edited by Richard Rogers. Maastricht, Netherlands: Jan van Eyck Akademie, 2000.

Iser, Wolfgang. *Der implizite Leser. Kommunikationsformen des Romans von Bunyan bis Beckett.* München, Germany: Wilhelm Fink Verlag, 1972.

Jensen, Jens F. "Communication Research after the Mediasaurus? Digital Convergence, Digital Divergence." *Nordicom Review* 19, no. 1 (1998).

———. "'Interactivity': Tracking a New Concept in Media and Communication Studies." *Nordicom Review* 19, no. 1 (1998).

Jones, Steven G. (ed.). *Cybersociety: Computer-Mediated Communication and Community.* Thousand Oaks: Sage, 1995.

———. *Virtual Culture: Identity and Communication in Cybersociety.* London: Sage, 1997.

———. *Cybersociety 2.0: Revisiting Computer-Mediated Communication and Community.* Thousand Oaks: Sage, 1998.

———. *Doing Internet Research: Critical Issues and Methods for Examining the Net.* Thousand Oaks: Sage, 1999.

Kiesler, Sara (ed.). *Culture of the Internet.* Mahwah, N.J.: Lawrence Erlbaum Associates, 1997.

Kitchin, Rob. *Cyberspace: The World in the Wires.* Chichester, UK: John Wiley & Sons, 1998.

Klein, Kajsa. "www.oneworld.net. Internet och den kosmopolitiska demokratin." In *IT i demokratins tjänst,* edited by Erik Amnå. Stockholm: Fakta Info Direkt, 1999.

Kollock, Peter and Marc A. Smith. "Communities in Cyberspace." In *Communities in Cyberspace,* edited by Marc A. Smith and Peter Kollock. London and New York: Routledge, 1999.

Kress, Gunther and Theo van Leeuwen. *Reading Images: The Grammar of Visual Design.* London and New York: Routledge, 1996.

Landow, George P. *Hypertext 2.0: The Convergence of Contemporary Critical Theory and Technology,* 2nd ed. Baltimore: Johns Hopkins University Press, 1997.

Langer, Susanne K. *Feeling and Form: A Theory of Art.* New York: Charles Scribner's Sons, 1953.

Laurel, Brenda. *Computers as Theatre.* Reading, Mass.: Addison-Wesley, 1991/1993.

Lehtonen, Mikko. *The Cultural Analysis of Texts.* London: Sage, 2000.

———. "On No Man's Land: Theses on Intermediality." *Nordicom-Information* 22, no. 3–4 (2000): 11–24.

Lévy, Pierre. *Becoming Virtual.* New York: Plenum Trade, 1998.

Livingstone, Sonia. "New Media, New Audiences?" *New Media & Society* 1, no. 1 (1999).

Markham, Annette N. *Life Online: Researching Real Experience in Virtual Spaces.* Walnut Creek, Calif.: AltaMira Press, 1998.

McLuhan, Marshall. *Understanding Media: The Extensions of Man.* London and New York: Ark/Routledge, 1964/1987.

Mead, George H. *Mind, Self and Society: From the Standpoint of a Social Behaviorist.* Chicago: University of Chicago, 1934.

Mele, Christopher. "Cyberspace and Disadvantaged Communities: The Internet as a Tool for Collective Action." In *Communities in Cyberspace,* edited by Marc A. Smith and Peter Kollock. London and New York: Routledge, 1999.

Meyrowitz, Joshua. *No Sense of Place. The Impact of Electronic Media on Social Behavior.* Oxford: Oxford University Press, 1985.

Miller, Daniel and Don Slater. *The Internet: An Ethnographic Approach*. Oxford & New York: Berg, 2000.

Modleski, Tania. *Loving with a Vengeance: Mass-Produced Fantasies for Women*. New York and London: Methuen, 1982.

O'Brien, Jodi. "Identity and Deception in the Virtual Community." In *Communities in Cyberspace*, edited by Marc A. Smith and Peter Kollock. London and New York: Routledge, 1999.

Paccagnella, Luciano. "Getting the Seats of Your Pants Dirty: Strategies for Ethnographic Research on Virtual Communities." *Journal of Computer-Mediated Communication* 3, no. 1 (1997). < http://www.ascusc.org/jcmc/vol3/issue1/paccagnella.html >

Pargman, Daniel. *Code Begets Community: On Social and Technical Aspects of Managing a Virtual Community*. Linköping: Tema Kommunikation, 2000.

Patelis, Korinna. "E-mediation by America Online." In *Preferred Placement: Knowledge Politics on the Web*, edited by Richard Rogers. Maastricht, Netherlands: Jan van Eyck Akademie, 2000.

Peters, John Durham. *Speaking into the Air: A History of the Idea of Communication*. Chicago and London: University of Chicago Press, 1999.

Radway, Janice. *Reading the Romance: Women, Patriarchy, and Popular Literature*. Chapel Hill and London: University of North Carolina Press, 1984.

Reid, Elizabeth M. *Electropolis: Communication and Community on Internet Relay Chat*. Unpublished Honours Thesis, Department of History, University of Melbourne, 1991. < http://www.crosswinds.net/~aluluei/electropolis.htm >

———. "Virtual Worlds: Culture and Imagination." In *Cybersociety: Computer-Mediated Communication and Community*, edited by Steven G. Jones. Thousand Oaks: Sage, 1995.

Reimer, Bo. *The Most Common of Practices: On Mass Media Use in Late Modernity*. Stockholm: Almqvist & Wiksell International, 1994.

Ricoeur, Paul. *Interpretation Theory: Discourse and the Surplus of Meaning*. Fort Worth: Texas Christian University Press, 1976.

———. *Hermeneutics and the Human Sciences: Essays on Language, Action and Interpretation*. Cambridge, UK: Cambridge University Press, 1981.

———. *Time and Narrative* (3 volumes). Chicago and London: University of Chicago Press, 1983/1984, 1984/1985 and 1985/1988.

———. *Oneself as Another*. Chicago and London: University of Chicago Press, 1990/1992.

Rogers, Richard. "Introduction: Towards the Practice of Web Epistemology." In *Preferred Placement: Knowledge Politics on the Web*, edited by Richard Rogers. Maastricht, Netherlands: Jan van Eyck Akademie, 2000.

Ryan, Marie-Laure (ed.). *Cyberspace Textuality: Computer Technology and Literary Theory*. Bloomington and Indianapolis: Indiana University Press, 1999.

Schofield Clark, Lynn. "Dating on the Net: Teens and the Rise of 'Pure' Relationships." In *Cybersociety 2.0: Revisiting Computer-Mediated Communication and Community*, edited by Steven G. Jones. Thousand Oaks: Sage, 1998.

Shannon, Claude E. and Warren Weaver. *The Mathematical Theory of Communication*. Urbana, IL: University of Illinois Press, 1949.

Silverstone, Roger. *Why Study the Media?* London: Sage, 1999.

Slevin, James. *The Internet and Society*. Cambridge, UK: Polity Press, 2000.

Smith, Marc A. and Peter Kollock (ed.). *Communities in Cyberspace*. London: Routledge, 1999.

Strauss, Anselm. "A Social World Perspective." *Studies in Symbolic Interaction* 1 (1978): 119–128.

Sudweeks, Fay, Margaret McLaughlin, and Sheizaf Rafaeli. *Network and Netplay: Virtual Groups on the Internet*. Menlo Park, Calif. and Cambridge, Mass.: AAAI Press/MIT Press, 1998.

Svedjedal, Johan. *The Literary Web: Literature and Publishing in the Age of Digital Production*. Stockholm: Kungliga Biblioteket (Acta Bibliothecæ Regiæ Stockholmiensis LXII), 2000.

Sveningsson, Malin. *Creating a Sense of Community: Experiences from a Swedish Web Chat*. Linköping: Linköping Studies in Art and Science, 2001.

Thompson, John B. *The Media and Modernity: A Social Theory of the Media*. Cambridge, UK: Polity Press, 1995.

Turkle, Sherry. *Life on the Screen*. New York, Simon & Schuster, 1995.

Virilio, Paul. *Polar Inertia*. London: Sage, 1990/2000.

Werry, Christopher C. "Linguistic and Interactional Features of Internet Relay Chat." In *Computer-Mediated Communication: Linguistic, Social and Cross-Cultural Perspectives,* edited by Susan Herring. Amsterdam: John Benjamins, 1996.

Wertheim, Margaret. *The Pearly Gates of Cyberspace: A History of Space from Dante to the Internet*. London: Virago Press, 1999.

Ziehe, Thomas. *Zeitvergleiche: Jugend in kulturellen Modernisierungen*. Weinheim and Munich: Juventa, 1991.

CYBERLOVE: CREATING ROMANTIC RELATIONSHIPS ON THE NET

During the last 10 years, it has become more and more common to create relationships on the Internet. However, even if articles in the popular press are abundant, there are few scholarly articles on the subject.[1] Previous research on social interaction online has also mostly dealt with arenas such as MUDs, MOOs and IRC, while articles about Web chat are more difficult to find. This is surprising, since Web chat is a forum aimed at social interaction, which attracts, above all, users whose main interest lies in social interaction per se. An important part of online relationships are also created in Web chat rooms, and this was therefore the forum I chose to study.

How, then are these relationships created? What happens from the first meeting in the chat room until a romantic relationship in "real life" has been established? What do people who have established romantic relationships through Web chat believe made them fall in love? Do they believe that relationships created online are different from relationships created offline, and that the conditions for such relationships to be successful are different?

In this article, I study how individuals can make contact and create relationships with other individuals through chat rooms. My focus has been on the informants' experiences of this, but also on their reflections about chat rooms as a medium for socializing. I conclude the chapter with a discussion about the informants' ideas about the Internet as a meeting place: what is really so new and different about it?

Method

This study was done through qualitative, individual interviews with 14 Swedes who had had experiences of creating relationships in chat rooms. All informants were by

the time of the interviews between 19 and 30 years old, and all of them are hetero-sexual.[2] Among the 14 informants, 7 had met a partner online. These informants consisted of 2 couples (Anna and Anders, and Mimmi and Rickard) still together, one female (Ellen) still living with her partner, one female (Åsa) having broken up with her partner after one year, and one male (Antonio) having broken up with his partner after about 2 months. Five had dated (Alex, Ingela, Olof, Tomas and Dan) and two had at least been talking on the phone with someone they first met in a chat room (Robert and Annika). The sampling procedure was as follows: Through an acquaintance I got into contact with my first respondent, who in her turn intro-duced me to the second, and so forth (so-called snowball- or chain-sampling).

Since the field is relatively unmapped, I wanted to approach it as free from any preconceived ideas as possible, and I therefore choose to conduct semi-structured interviews. The tape-recorded interviews were done with one informant at a time, either in the home of the informant (7 cases), in their places of work (2 cases), or in cafés (4 cases). The informants chose the time and place for the interviews. Each interview lasted between one and two hours, depending on how much the infor-mant could and wanted to tell me. I have made verbatim transcripts from the inter-views, but also included some nonverbal expressions such as laughter and empha-ses to try to express some of the nuances in informants' speech. All quotes are translated from Swedish.

The next step was to conduct a thematic analysis of the transcripts: to seek for recurrent patterns in the informants' stories. This qualitative approach does not allow the researcher to make any generalized claims about the field of study, and it is here important to emphasize that the aim of this study is not to find out any exact numbers of relationships created online, nor how many of them prove to be successful. This study should rather be seen as an attempt to entering into the sto-ries of a small sample of informants in order to mirror their experiences of how they created a relationship online.

A Random Way to Meet

Even if the informants' stories differ in many aspects, they also have many things in common. To begin with, one recurrent theme is how the chat medium and rela-tionships that can be created through it were experienced as without assumptions and expectations. One of the main characteristics of chat-room interaction is that, according to the informants, it lacks any specific purpose and is not aimed at find-ing a potential new partner. If one can talk about a purpose with chat, it would in-stead be a general wish to make contact with people, getting into a rewarding dis-cussion, or just small-talking and having a good time in general.

ÅSA: It was fun to just create contacts, it was fun to talk to other people who seemed to be interesting. 'Cause I've met a lot of friends, you know, online, that I still correspond with.

RICKARD: I think that we—When you enter a place like that, you just want somebody to talk to. Not pick somebody up, not like that, it wasn't that kind of things that—at least not from *my* point of view. What was at the bottom of it was that you looked for somebody to talk to, so you actively looked for people who had something to say. And all the time you made comments just to find someone who had something to tell.

In modern society, says Asplund (1992), individuals' trajectories cross each other constantly. During the course of one single day each individual may find himself or herself sharing environments with thousands, or even millions, of other individuals. Often, the crossing of trajectories occurs unexpectedly. Asplund describes what he calls *opportunities* as something that can only occur regularly in urban environments. They consist precisely of these unforeseen and random meetings that can result in changing individuals' lives. These opportunities, says Asplund, do not occur on a daily basis in rural settings; one knows in advance roughly how life is going to turn out, and there is no reason to keep open and free, like the *puer aeternus* (the eternally young or immature) of urban life, in case an *opportunity* turns up. However, the large amount of meetings of urban life results in a large social waste, that is, trajectories being crossed without any of the involved noticing it (Asplund 1992: 9). This also goes for the Internet. The fact that the online arenas for social interaction are so many, as are the participants in each of them, implies that the amount of available individuals with whom one can interact and create relationships increases drastically (Lea and Spears 1995). The Internet, with all its arenas for social interaction, may be compared to a metropolis, a big city with countless meeting places, open 24 hours a day for those who want to get into contact and socialize with other individuals. One could then compare each chat room to a street or a public square. The difference is that because of the opportunity to keep several windows open on one's screen simultaneously, one can be in several places at the same time, or at least can shift between them much faster than it would take to move one's physical body around in a city. However, just like in the big city, the large number of meeting places and potential interlocutors results in a vast amount of individuals crossing each others' ways with each individual getting to talk with only a few others. This implies that not only chat conversations are without conditions and assumptions, but who you are going to meet is also experienced as random.

ANNA: Sometimes you get almost like a *palpitation of the heart* when you think— You almost get *difficulty in breathing* when you think: "What if I hadn't logged *on* that day?" You know, it was a matter of seconds, and he, Anders, he told me that he didn't usually go to this chat room, usually he'd go to another channel. And he had logged on that day, just to *check it out,* you know. To look around and see what it was like. It feels like it was so awfully *important*. Just that second, it feels like it's all about *seconds* on the Internet, 'cause if you meet someone in a bar, you can always *return* to that bar afterwards. You can see a person,

see what he looks like, you can—You know, you've got so many more leads to follow.

It can be argued that offline-meetings too occur randomly. Perhaps the difference lies instead in the difficulty of meeting someone for the second time if you have not exchanged contact information such as email addresses or telephone numbers. But this goes also for meetings in big cities. I would rather describe the difference as the difficulty of recognizing the other at all. In a meeting face-to-face, most people have access to audio-visual information. In chat rooms, however, the only distinguishing marks are the nicknames with which users choose to present themselves.[3]

ANNA: If you *go out,* then you go out Friday or Saturday nights to a restricted number of places, but the Internet is *so* big and the chat rooms are *so* many. And the people in the chat rooms are so many and you've got so many opportunities to hide. Perhaps without wanting to. *I* might have chosen to present myself as Stina[4] the next time, for example.

Several researchers argue that both inhibition and respect decrease in computer-mediated communication, as well as individuals' fears of not being treated politely.[5] Here one should perhaps distinguish between different types of users as well as different types of arenas. The previous studies mentioned above were all conducted in professional settings, and it is by no means certain that the results can be applied to other settings in which users might have other purposes in their communications. However, if this applies also to chat users, the decreased inhibitions may be a reason for their willingness to take initiatives to communicate. The discussion above about the randomness in meetings and the importance of using all opportunities because they might not recur, might point to another reason. If one meets someone who seems interesting, one had better "lay hands" on him or her immediately. This is, by the way, how dating often works in big cities. The chance is very small of two persons meeting again, unless they have exchanged contact information or set up a date. This does not always have to be negative: because one will likely not run into the other again, the risk of losing face by being refused is experienced as less serious.

The First Meeting

None of the informants remembered how they first started to talk with the person who, in 7 cases, became their partners. The initial meetings were characterized by their openness, and there were seldom any criteria for what kind of persons the informants wanted to get in touch with. The socializing and the conversations were the essential, and they talked readily with anyone they met.

ANDERS: I think I had been there for quite a while, and talked with all kinds of

people, and I think that Anna too had been there for a while. And then some-
one who I talked to, or who she talked to logged out, I think. And then . . . well,
then you looked for someone else to talk to.

According to Lee (1996: 276), through its specific combination of orality and tex-
tuality, the Internet constitutes a social space in which messages rather than people
meet. Several of the informants also mentioned that even though they knew they
were talking to another human being sitting somewhere on the other side of the
screen, in the beginning they had difficulties in seeing them as such.

RICKARD : What's so *cool* about this is that . . . [pause] I *like* the thought of—that
the borderline between human and machine is somehow fuzzy, it's hard to see
the persons you talk to as *individuals* initially. But there *is* a border there, you
know, people have to present themselves *out of* the interface. So I don't know,
you don't think—I don't think so much about it, but just attend to what I see
and what is said, and then I say something myself.

MIMMI : It's more like reading a *book*. An interactive *book*, sort of. Even if you *know*
that you're dealing with a person on the other side, so . . . You're not *really* con-
vinced until you've heard his or her *voice,* and then *seen* the person in question.

As seen in these quotes, some of the informants were aware of the borderline—
which they experienced as fuzzy—between the human and the machine. In this
borderland, an individual does not get the shape of a human being until one has
spent some time with him or her online, and perhaps not even then. For some, it
seems to be necessary to see and hear interlocutors in order to view them as real
persons. This is perhaps not so exotic as it may sound. One informant, who in-
itially found it difficult to see the interlocutor as a person, believed that it is the
uniform interface that makes it difficult to distinguish between individuals. The
specific conditions of the medium here reduce the spectrum of means of expres-
sion. In offline contexts we often rely on visual information such as dressing codes
to give information of what group in society we belong to, who we are, or who we
would like to be. In computer-mediated contexts, however, it may be more diffi-
cult for individuals to express these aspects, at least initially. This also coincides
with previous research that suggests that despite what some may think, social in-
formation can be conveyed by computer-mediated communication; the difference
is that it demands more time than face-to-face.[6]

The absence of physical cues implies that the first impression of a person to a
great extent differs from the impression given in "real life", where physical aspects
such as gender, age, and bodily attractiveness are exposed immediately (Lea and
Spears 1995). What one sees of other participants in a chat room are only their nick-
names and their contributions to the conversations. All informants who had met
their partner online told me about feeling that there was something special about
him or her, some detail that attracted their attention among the crowd of other po-
tential conversation partners: something that made him or her different. Stories

about having perceived a partner as very special already in the first meeting may of course be constructed afterward and are also frequent in stories about offline meetings. On the other hand, the informants whose cyberdates did not lead to further relationships stressed the importance of contrasting with others for the purpose of being noticed and getting anyone to talk with them.[7] However, chat rooms seem to offer slightly different conditions, compared with the offline world. Since the medium makes all messages look roughly the same (there is no pitch of voice, no sound of accents, no appearance, etc), the way to distinguish from others will be only by *behaving* differently or *saying* something different or unexpected.

TOMAS: I suppose it's kind of a natural process of sorting out. If someone logs on and says something interesting, or has an interesting nickname which makes you curious about who that person is, then you might ask a question. But if you're already busy with some other interesting conversation, and the person who's logging on says something uninteresting and perhaps misspelled, and the nickname sounds awkward and boring, then . . . then you might just ignore it.

Depending on users' personal characteristics (for example age, occupation, interests, musical or sexual preferences), their attention may be caught by different things. Even though there are few attention-getting strategies that will always work, there are some communicative styles that typically will not work at all in a chat room. Preliminary results from a Swedish study suggests that only about half of the messages being posted in chat rooms get any response at all, and that there are ways of behaving that will, in most cases, work better than others in getting others' attention.[8]

Creating an Image of Oneself

Giddens (1990) writes about trust as an important factor in meetings. Trust tends to lean on what is perceived as "established trustworthiness" or informal rituals that are often complex. Trust toward and between individuals is no longer dependent on common ties within the local community or kinship; instead it is constructed through both parties revealing information about themselves. It "becomes a project, to be 'worked at' by the parties involved, and demands *the opening out of the individual to the other. . . .* Relationships are ties based upon trust, where trust is not pre-given, but worked upon, and where the work involved means *a mutual process of self-disclosure*" (Giddens 1990: 121).

RICKARD: Well, it's a meeting where you've been together maybe fifty hours on the computer and maybe fifty hours on the phone. So I *knew* exactly what she *studied,* what kind of *family* she had and what her *sister's* name was. *How* she lived, what her *social* situation looked like, what she was *interested* in, what kind of finances she had, I mean just about *everything,* we had been *discussing* all that.

So what was to be filled in, it was just that I would get it confirmed that she *hadn't* been lying, that she *hadn't*—*That* would be confirmed and then I'd get an appearance added.

An alternative explanation can be offered by the uncertainty reduction theory (Berger 1988). Relationships can include a large amount of uncertainty, especially in the initial stage. Uncertainty here is seen as the product of the available alternatives in a given situation, as well as the likelihood of them to occur. On the one hand, uncertainty and unpredictability can create a kind of excitement that at least some people wish that they had in their close relationships, but on the other hand, relationships must include some amount of predictability if they are to be stable. Reducing the number of alternatives, or making differences in the likeliness for them to occur, reduces uncertainty. According to Berger, the initial stages of relationships consist of rituals in which the exchange of nonevaluative demographic information plays an important role in obtaining means by which one can predict the behavior of the other. Thus the uncertainty level is decreased. These kinds of rituals can often be seen in chat rooms. One of the informants talked about the rituals that occur in most initial stages of chat conversations in which name, city of residence, age, occupation, interests, and some times even appearance are treated. This can serve as a means of assessing others' intentions, and to see whether they would be interesting enough to continue talking with, but also to get a hint about their trustworthiness in the lack of physical cues. Despite the fact that chat is an unregulated and strongly informal arena, there still seems to be a need of rituals. The openness and informality of the medium can however be the reason; perhaps people still feel a need of structure and of knowing with whom, really, they are dealing.

The informants said that they seldom bothered to describe their personality, since that would show with time anyway. When asked about appearance, some informants had standardized answers to give to everyone who asked, while some others did not at all describe what they looked like. For some, appearance was perceived as unimportant, and they claimed to not have even thought about it.

How, then, in the absence of physical criteria, was the interest attracted? All seven informants (4 women and 3 men) whose online meeting eventually led into a romantic relationship offline said that since they did not have any special feelings about the other at the outset, they did not do anything in particular to attract the other's interest or to impress him or her. However, here it may be argued that people always make choices about what impression they will make through what aspects of self are shown and not shown (Goffman 1959/1990: 28ff). Individuals often reflect on themselves and on the impression they might make on others, even though in many cases they are not conscious of doing this. What these informants probably meant was that they did not deliberately try to impress the person who was to become their partner, as a purposeful strategy to get him or her interested in entering into a romantic relationship, at least not to start with. In several cases, it was rather the absence of flirty behavior that distinguished the responding informant from other obtrusive interlocutors and therefore attracted interest.

Å s a : He found me concise. Compared to others who just babbled and really *tried*
to find someone, he felt. And then he found me interesting, since I didn't go on
like the others. I wasn't after that either, so I guess that was the reason.

It is true that chat rooms often have a flirtatious atmosphere, but this may have ,
other reasons than users looking for potential partners. Above all, the overarching
characteristic of chat room interaction seems to be the sociality; the purpose of
just talking around with other individuals, whoever. Another important character-
istic is playfulness,[9] and this may be where the flirts enter into the picture. Some of
the informants said, however, that in the initial stage they did not take the interac-
tion as seriously as if it had occurred offline.

Å s a : He had been going on for a while and talked to girls, and thought it was fun
to make them believe that they had something going on! [Laughter] Even
though it wasn't like that! He thought it was fun to try things like that. There
are a lot of people who *do* things like that, too.

Here, the informants differ from one another, and most of them stressed having
been very serious about their chatting. Several of them, however, talked about
feeling as if they had two different lives: one online and another offline. This
was not a question of one life being more real or authentic than the other, but
rather that the two spheres were perceived as significantly different, and in some
cases the informants experienced themselves as different in their two respective
roles. On the other hand, individuals always play different roles in different con-
texts, and parallels can be drawn to what Goffman (1959/1990: 57) refers to as
"audience segregation." The different roles played in different contexts by an in-
dividual can be inconsistent, and actors therefore try to keep these contexts and
audiences apart to be spared from conflicting roles. The borderline between on-
line and offline roles is often supposed to be sharp, with significantly different
identities contrasting with each other (c.f. Turkle 1995). In many ways, though,
they are not different from a person's various offline roles. Some of these are
consistent with each other and overlap, while others may be inconsistent and
kept separated.

The chatting is not seen as a game or play without links to reality, but users
often take liberties in their playful and teasing way of interacting. They also feel
that they can reveal more about their personal selves online than they can offline,
something that other researchers have also found (e.g, Van Gelder 1991).

The Power of Names

A n n a : Fact is that I used to chat a lot back then. So I don't really remember what
made me start to talk to Anders. Or what was his nickname? Mine was Mimmi
anyway. 'Cause he said, he asked me: "So, now where's Musse?"[10]

The nicknames that people use in the chat room are the first and sometimes even the only thing that others see. As such, the nickname is one of the most effective ways of attracting attention. The nickname is also extremely important for how one is perceived by others, at least in the initial stage. "Names are transformed into trademarks, distinctive individual smells by which their users are recognized as either friends or enemies within an otherwise vague and anonymous BBS environment" (Myers 1987: 240). The nickname can work as a "face," something that gives an appearance to the user and that others recognize the next time they intersect with their trajectories. Lasko-Harvill (1998) has compared online identities to masks. The mask metaphor can offer a useful perspective, but it builds on the common assumption of multiple identities as a rule rather than an exception on the Net. In some contexts, this assumption can be true, because users indeed seem to have an infinite set of "masks" to choose between, and some use this opportunity. However, many chat users, especially regulars, have more or less permanent nicknames that they always use.[11] In most chat rooms, the users can protect their nicknames with a password so that no one else will be able to use them. The name then becomes even more personal, something that belongs only to the specific user even though some nicknames can resemble each other. The nickname can thus be seen as a user's unique attribute, much the same as a face or a signature. The metaphors of face and signature (in handwriting) can both offer explanations of why it is seen as such a serious "online crime" to steal other users' nicknames (Sveningsson [b] 2001).

Even though there are users who choose to present themselves with their offline names, Myers (1987) points out an important difference in the fact that here the users themselves deliberately choose to use them in their presentations of self. The names can also be further elaborated, embellished, and provided with a personal touch to distinguish the old offline name from the new online name. Alternative ways of spellings and the use of unconventional graphic elements in the text can "decorate" the nickname. An example from a Swedish chat room is how one user put a frame around his or her nickname and thus created a symbol of mountain scenery: ~ ^ ~ ^ *HyPnOiD* ^ ~ ^ ~

The nickname can sometimes offer a subject for conversation in a way that sometimes does occur also in the offline world, where commenting on someone else's appearance or name can start an acquaintance. However, there are some differences. *What* one sees and thus comments on in a meeting face-to-face is, in most cases, visual aspects such as appearance or clothing. In online meetings, however, inner properties referring to taste, interest, or knowledge are transformed into an external "face" in a way that is not familiar to us. However, one could argue that offline attraction, based on external properties, also draws on shared cultural knowledge about style, such as that in dress. In online settings, people are able to choose their appearances, both concerning looks and personality. Opportunities for choosing between different attributes of course also exist offline, where individuals can give certain impressions through a deliberate choice of clothing and hair styles, but the spectrum is wider in online settings, where the limits seem to be

set only by what is possible to say through words. On the other hand, in reality the spectrum of opportunities may not be so wide as has been assumed, because users must have at least some knowledge about the phenomena to which their nicknames refer. Those who assume the name of a pop singer as nickname must know something about him or her, otherwise they risk losing face when someone more informed arrives.

Sometimes the choice of nickname can serve as a means of excluding uninteresting interlocutors, or as a kind of initiating rite based on shared cultural knowledge. An example can be found in users who assume nicknames after characters from literature or films, a song title, or perhaps a musician. Those who do not know what the name refers to had sometimes better not even make the effort to start a conversation. These kinds of nicknames can also be interpreted as ways of trying to transfer a touch of the image of the original to oneself, or one's online persona.

DAN: Well, I've got mine and it alludes to my personality and what I like and—
MALIN: Uhu? What do you call yourself?
DAN: Eeh, my nick is Lord of the Void.
MALIN: Yes?
DAN: And as I said, I'm an extremely big fan of Black Sabbath and it's a combination of two of their songs, called "Into the void" and "Lord of this world."
MALIN: Okay.
DAN: So that's kind of my thing.

When new to the chat medium, most of the informants tried on several different nicknames in the search for what would be the optimal one—that is, the one that would result in the best opportunities for making contact with others. Gradually, as they became regulars with friends and acquaintances in the chat room, they each retained one permanent nickname.

Creating an Image of Others

ÅSA: You had no idea whatsoever. So, it's more like you sort of create an image of this person.

Several studies show that people tend to start relationships with those with whom they interact often, such as neighbors, workmates, or classmates. It is also probable that the relationships they start are with individuals most like them with regard to race, religion, socio economic status, and educational level. (Lea and Spears, 1995: 206). The fact that those characteristics are often unknown on the Internet implies that many who would never even have begun to talk because of prejudices based upon such properties will now have a chance to get to know each other (Dunlop and Kling, 1996). There may be some truth in this assumption,

but it is also likely that shared cultural knowledge sometimes will influence chat users' choice of interlocutors, as when nicknames are used to attract attention from those with similar values or interests. However, the myth about this, as well as the claim of appearance to be unimportant, seems to be widespread among informants.

The informants had difficulties in describing how they imagined the "other," and the most frequent answer was that he or she was a nice person with whom they had many things in common, and whom they enjoyed talking with. Even though the informants seemed to be opposed to judging others from their looks, and despite the discourse about the Internet as a medium free from physical constraints, it is obvious that appearance is still important. As we will see, this is especially true when users meet offline, but sometimes also when they are still online. Some chat users may even be equally, or more, preoccupied with appearance as when offline, although perhaps in a different way. Since one cannot "check out" others as to looks, chat conversations often deal with offline aspects such as age and appearance. Talking about appearance is a way to discover one's online interlocutor's actual looks before meeting face to face. Experienced chat users, however, claim that it is mainly "newbies" who are interested in appearance, the reason being that newbies do not regard the online interaction as a goal per se, but rather as a means of getting someone into an offline date:

DAN: You know it's a newbie when they start by asking "What do you look like?" 'cause that kind of things don't matter for those who've been into it for a long time, who are *experienced*. For them it's more like—

MALIN: Why so, do you think?

DAN: I don't think you're after . . . because when you ask what people look like, then you want to meet that person right away. I suppose that's what you're after. But if you're experienced, then you're not really after jumping into . . . you're not after dating that person right away, but you'd rather chat and if you notice that you're at the same level, then you take her out for dinner or something.

In face-to-face interaction, physical aspects normally serve as criteria for the creation of relationships. In the first meetings, say Lea and Spears (1995), appearance is taken as a point of departure to draw conclusions about inner qualities such as personality, intelligence, and social desirability, before these attributes have been revealed. Physical attractiveness is also an important factor in many models of how relationships are developed. Here, the computer undermines the relevance of physical attractiveness, so that love at first sight seems impossible. Instead of being in the foreground, as in face-to-face meetings, the individual's appearance is transferred to the background, and its exposure to others is under the control of the subject, who can decide when and how to present it. This resembles what Goffman (1959/1990: 14) calls "expression given" and "expression given off." "Expression given" involves verbal symbols or their substitutes, which are used deliberately to

convey the information that is attached to these symbols. "Expression given off," on the other hand, consists of a wide range of actions that others can treat as symptomatic of the actor, where the purpose is other than conveying information. Still, "expression given off" can provide a great deal of useful information about the individual with whom one is interacting as well as about the context.

What people are used to referring to as body language, that is, what can be seen offline, is in many cases undeliberate and not controlled by the actor. It thus serves as an example of "expression given off." Even though (written) body language does occur online in the form of *emoticons,* which several researchers have described,[12] one should be careful in comparing it with offline body language, because a specific actual body movement means something different than the same body movement as described in words or emoticons. When a person blushes, or gets tics in "real life," it is an example of uncontrolled body language, that is, "expression given off." When the same person *writes* on the screen: *blushes* or *gets uncontrolled tics all over the face*, this kind of body language is probably a more or less conscious act, written with the purpose of making a specific impression to others. The body language found in online settings should therefore rather be described as "expression given." However, I do not mean to say that "expression given off" does not exist online, only that it consists of other things. "Expression given off" in online settings can be found in a user's pace of writing, mistypings, misspellings, vocabulary, language style, or choice of subjects of conversation, all of which can, in some cases, replace body language as a source of information in addition to what the actor had intended to convey.

Online communication lacks some of the elements that are usually emphasized in traditional discussions about the development of relationships, including physical proximity, information about physical appearance and group belonging, as well as information concerning a broader context (Parks and Floyd, 1996: 84). This leads Lea and Spears (1995: 206ff) to criticize existing theories of relationship development. In interaction with other human beings, people rely on nonverbal information in order to know how to contribute, and individuals' nonverbal communication often has more to say than their verbal expressions do about the social context of the interaction. Rules for behavior that are usually based on nonverbal communication are not clearly indicated when communication is restricted to text only (Reid 1991: 8). This uncertainty can be seen as something negative, but it does not necessarily have to be so. One possible consequence may be that individuals do not turn others down, judging only from information gained through their physical aspects. It is also important to ask oneself whether the elements mentioned above (physical proximity, etc) are really necessary for a relationship to develop. As a consequence, say Lea and Spears (1995: 208), models and theories, as well as representations of relationships that emphasize physical attraction, will not be relevant in online contexts. The question is, however, how true this really is. Those who believe appearance to be unimportant may, as I first did, assume that those who meet their partner online fall in love while still interacting online. This is also the image being forwarded by popular media. Now and then people do fall in love

online, but my point is that most of my informants did not fall in love until they had met face to face, or at least talked on the phone. Lea and Spears may be right concerning friendship relationships as well as romantic online relationships that are never taken offline. As long as a couple with romantic intentions cannot see each other, appearance and attractiveness may not mean a lot, but as soon as they meet offline, it becomes important.

Taking the Relationship Offline

After having talked with each other several times online, informants started to look for each other again when online. They might ask the other regulars in the chat room if they had seen the other, and ask them to say hello if s/he should "turn up" later. The typical first step, after chatting a few times, seems to be exchanging email addresses.

ANNA: You're kind of *cautious* in the beginning, you know "Hahaha. Can we *email* each other?" You kind of take it as a joke. And it doesn't feel as intimate at *all* as calling somebody up and just saying "Hi" and you know, it's just so *embarrassing* when nobody says any*thing* in the receiver.

While chat is a synchronous medium in which several users are copresent, email is an asynchronous medium that is used mostly for directing messages to one particular person. Compared with chatting, this can intensify contact, but it is still seen as a more detached medium than, for example, telephone or ordinary mail. In emailing another person, one does not need to feel intrusive, because the other can choose whether to answer or not. If not, one does not risk losing face to the same extent one might in a physical meeting or on the phone. This works also the other way around: it is usually not difficult to withdraw from online interaction. This might be the reason why email is the most usual way to continue a relationship started through chat, but sometimes also a way of contacting someone one has met in an offline location, for example, a bar. Turkle (1995) describes the Internet as a safe zone in which people can meet and interact in a relatively safe way. Those who are not willing to proceed in a relationship will not be exposed to the psychosocial pressure they would in "real life." Turkle states that relationships during adolescence are usually based on a mutual agreement and understanding that duties and commitment to the relationship are limited. Since most Internet media makes it easy to keep distance from others, cyberspace fits this kind of relationships, she says.[13] Using the word "distance" may be misleading, because many chat users invest a large amount of feeling into their online relationships. It may instead be that the pressure of expressing one's sexuality decreases because physical contact is impossible. Schofield Clark (1998) describes Net relationships as "a postmodern 'pure' [kind of] relationship: one comprised of self-reflexivity in which experimentation

and self-construction are central," where the focus is on individual gratification.[14] She continues by saying that chat rooms for teenagers thus become a space outside of everyday life, a space for the development of the contemporary "pure" relationship: "one with imagined intimacy but no need for trust or commitment; thus one that is fulfilling and liberating, ultimately and primarily, to the self."[15] What Schofield Clark describes can be regarded as a kind of moral relationship, because physical contact is impossible. This can also be seen in my informants' stories about positive feelings about the medium forcing people to get to know each other before starting a sexual relationship. The question is how to interpret this. Is it a question of neo-Puritanism, or is it rather a question of wanting to avoid embarrassing situations and time-consuming flirting rituals that do not lead to further relationships?

Even though not asked about it, several informants talked about the opportunity of keeping distance, which they saw as something positive and liberating. Quite contrary to what one would assume, the opportunity of keeping distance has a potential of bringing people in the chat rooms close to each other faster than in a meeting face-to-face. Participants can interact on their own terms and easily withdraw if a conversation partner turns out to be unpleasant or not as expected or hoped for. In most cases, informants spent a rather long time (from two weeks to several months) together online before calling each other by phone, but still they describe this transition as advancing with "rapid strides," and as a relatively dramatic change. They thereby seem to draw relatively sharp boundaries between interacting online and offline.

Meeting Face-to-Face

According to Parks and Floyd (1996), most of those who have created a personal relationship in newsgroups tend to extend the communication to several media, including email and telephone, but also to face-to-face meetings. This is not surprising, since expanding the number of contexts seems to be typical for the development of all relationships. My informants claimed that the reason for meeting in "real life" was curiosity and a desire to be able to *see* the other and get to know his or her extrinsic properties. One of the couples said that another reason was to investigate what they really felt for each other and, in the context of this, how to deal with a relationship that one of them already had. An interesting fact is that even though all of my informants stressed that they regarded their chatting experiences as real and chat rooms as fully adequate communication media, some of them still expressed it as wanting to see the other "for real," and about feeling that online interaction was not enough.

MIMMI: First of all it was about wanting to see this person for *real*. A person who you had grown very *attached* to. You don't want to *be* attached to just *words* and a voice, but you want to be attached to a person for real.

One can wonder if this is about ties to the physical world that cannot be escaped, or if it is just that people always strive to expand the number of contexts between which their relationship moves. Perhaps the offline equivalent would be that, on a long-term basis, physical intimacy would not be enough and partners would also want to get to know each other's inner qualities. Or, it may be that in both online and offline relationships, there is an urge toward physical contact and ultimately sexual union.

Two of the informants admitted that they had thought of the meeting eventually leading to a romantic relationship, but most of them claimed that they neither hoped nor tried to get involved. In general, the informants seemed to have been very realistic about the outcomes of their meetings; like the meetings in the chat rooms, the offline meetings were characterized by openness and few preconceived ideas about what would happen.

ANDERS: I had high expectations of us having a *good time* together. And I've thought about that afterwards, that it's *amazing* that I, being a guy, didn't have expectations on . . . [laughter] on other things, so to speak.

MIMMI: I had decided *in advance* that I would *not* try to flirt or try to get him fall for me in any way, by using body language or anything, so I tried to remain rather . . . I sort of adopted a wait-and-see policy. But I wasn't seductive or ingratiating or anything like that, but just friendly.

All the informants felt nervous before their actual meeting, and uncertain of how to act, because they did not know what roles they would assume in relation to each other.

ANDERS: Then, when we met, this thought turned up: "Hmm, should I shake hands or hug her?" But then it was a hug. And it felt . . . I felt *fine* with that.

Returning to the uncertainty reduction theory (Berger 1988), there were several equally possible alternatives of what the outcome of the meeting would be, as well as of what kind of relationship it would develop into. This uncertainty may explain the informants' feelings of nervousness. However, even if nervous, all but one male informant felt good about seeing the other. To start with, everyone was cautious and careful not to intrude on the other's integrity. They therefore tended to choose neutral subjects of discussion on a relatively superficial level, to be sure that the other would not feel "interrogated." Even though they had been outspoken in the chat room and on the phone, informants now felt as if they had to start all over again, to get to know each other, as if in a new dimension:

ÅSA: Well, the first *hours* were sort of . . . At *that* time I almost felt like going *home* again, 'cause it was so *hard*. I mean it *was* a nervous situation and so on, and it felt *really weird*. And I wondered what I had got *into* and so on. The first *hours* were a little tense, sort of. But then after some time it felt like we really *knew*

each other. Since we knew so much *about* each other and so on. So it didn't take very long and then we weren't nervous anymore.

MIMMI: Yeah, but somewhere you let go! And you just feel—I mean, we *know* each other! We don't need to go around being tense! For goodness' sake, we're friends, it's like *alright*. We don't *need* to get to know each other. So well, I think it's a *relief* meeting each other. When it's someone you've been communicating with for a long *time*.

Since all informants but two said they had no further aims with the meeting than just having a good time together, they did not try to impress each other to a greater extent than they would for any other person for whom they felt affection. If there were any specific properties they wanted to call attention to in themselves, it would be being an honest and nice person.

ANDERS: It doesn't matter whether you think about it or not, or try—It's always like—Well, I want to be who I am. Since I already felt that *this* was something that wouldn't be just a *superficial* contact, even if we wouldn't be lovers. Later. But I wanted to make an honest impression of myself.

MIMMI: Well, I wanted him to *like* me. But I didn't want him to fall around my *neck*! And I had *no* sexual wishes. That we would *sneak* into a hotel and . . . [laughter] No, *absolutely* not. I wanted to be *aloof,* and I didn't want to get *too* involved. I wanted to keep my *distance*.

For one of the male informants, it was a pleasant surprise finding that his dating partner had not made any endeavors to impress him:

RICKARD: What *really* impressed me was that she . . . She was so dressed *down,* sort of. That she made such a natural impression, she wore almost *no* make up, and a pair of old worn out jeans, some second hand jacket, you know. And just like that, she dared to present her *self*. I mean, women have such an *extremely* wide register, to fix them *up* you know, to use tricks and devices—and really change their looks. But she didn't *do* that, and that's what I liked.

Alberoni (1992: 78ff) writes about girls' dreams about the ideal, and Berscheid and Walster (1978) stress the importance of fantasy and daydreams for how love relationships are developed. An important question is whether the absence of physical cues online implies that users make up an ideal image of the other to a greater extent than they would offline. A fact that points to this is that even when the informants did describe their physical appearance, it did not correspond with the other's representations of them. It is possible, however, that ideal images are not created to a greater extent online, but rather that they deal with different aspects than in offline meetings. Fantasies and daydreams about other individuals often tend to be about properties that are not immediately visible, aspects that the dreamer does not know about. Since the extrinsic aspects of other individuals are

not revealed online, these would be the subjects of our fantasies when meeting someone online. On the other hand, most probably, people make up ideal images of the persons they meet offline, as well; the difference is just that in offline inter-action, it is aspects of a person's personality that are unknown and thus fantasized about by the other.[16]

Turkle (1995) describes how the creation of ideal images can give rise to dis-appointment when meeting face-to-face. She provides an example of a man who, while interacting online with a woman, perceived only characteristics that corresponded to what he wanted her to be like, but found that the meeting face-to-face gave too much information, and thus destroyed the fantasy. Five of my informants mentioned a feeling of information overload in the first offline meet-ing. They experienced a feeling of being overwhelmed by visual impressions they had difficulties in appropriating. To start with, for all 14, the meeting was perceived as tense and strange. Some of them expressed it as if they barely dared to look at each other and felt that they would rather have had a computer between them. After getting used to communicating and reading the other's reactions in the written language on the computer screen, they felt awkward try-ing to interpret the expressions of the strange face. Just as earlier in the rela-tionship when moving from email to phone communication, informants experi-enced difficulties in adjusting the physical person to the image they had created of him or her. One of the couples solved it by visiting a museum together and thus having something else to look at until they had got used to each other's physical appearances.

INGELA: And then I met him four weeks later. And it was so bothersome [laugh-ter]. 'Cause it was like we wanted a wall between us. We weren't even able to *talk* to each other so we talked through *other* persons. Because we just sat there, peeping at each other, sort of.

MIMMI: And it felt so *unreal* too, 'cause it was—I recognized his *voice,* because we had talked *several* hours on the phone, *lots* of hours on the phone. And I knew exactly how he would *express* himself. But it was this physical person that was hard to get *used* to. And I think it was hard for him to get used to *me,* too. And we sat *chain-smoking* and we didn't really dare to *look* at each other, so we sat and kept our eyes lowered and looked *furtively* at each other.

Some of the informants talked about having been disappointed in the other's ap-pearance, or at least having expected something else. They also stated that had their first meeting been in a face-to-face environment, for example a bar, they would probably not have approached the other and started to talk. In some cases the other was judged as not good-looking enough, while in others it was a matter of having totally different (clothing) styles, which signaled belonging to different groupings in society. With this as a basis, the informants said, the conclusion would have been that they had nothing in common.

ELLEN: Well, we were extremely unlike each other. Ivan is an ex . . . how shall I put it? Heavy-metal fan. He used to play in a band and all that, so I saw him in front of me and he was tall, rather thin with long hair, you know. And then I got a photo of him and well, it was nothing that I could relate to whatsoever. You know, had I met him in a bar, I wouldn't even have bothered to talk to him.

In most cases, the first surprise or disappointment went away rather quickly, informants said, but for one of them, this was not possible. He explained that he had been acting too fast, wanting to meet the young woman face-to-face too early. He therefore set up a date in which he and one of his friends would meet her and one of her friends. He had had high expectations both about the woman's appearance and of how their relationship would develop. He was very disappointed in both the appearance and how the meeting turned out, and the relationship never continued. His friend, on the other hand, who had not had any expectations before the meeting continued seeing the young women afterward.

Berscheid and Walster (1978) refer to several studies pointing to appearance as the determining factor in relation to popularity with the opposite sex. One common fear, often expressed in jokes and comic strips, is of having exchanged confidences online and maybe fallen in love with someone who turns out to be extremely unattractive, to have lied about his/her gender, or who turns out to not even being a human being.[17] I asked the informants how they would have reacted had their "cyberdate" turned up to be a major disappointment. One of the informants compared meeting their online partner to having a regular date and said that had she felt entirely bad about it, she would only have left and gone back home. The informant who was already involved in a relationship had even hoped that he would find his cyberdate unattractive:

RICKARD: I mean, in *some* way that's what I *hoped* would happen, that I would have a reason to . . . well, a reason for me to say like "No no, I'm out of here." That I would end up in a situation like: "Oh shit, I need to beat it before she sees me!" [laughter]

There have been terrifying reports about criminals using the Internet to find and contact their victims, and this has also been an important part of people's ideas of the Internet as a meeting place (Sveningsson [a] 2001). My informants, however, had no fears of this kind. On the contrary, they spoke about feeling safe because they already knew each other. Even if they were nervous before the first meeting, they were not afraid that their cyberdate might turn out to be a criminal or an unpleasant person.

ÅSA: We knew each other very *well,* which made me feel safe. I suppose that was why we wanted to *see* each other too, since we *knew* so much about each other. We had about the same *opinions* about things, and I felt *good* talking to him and so on.

ANDERS: It's quite *safe*, really. First you get to know each other anonymously and then through the telephone you get to know each other from *within*. First. Instead of as it is otherwise, in most of the cases, that you get caught by somebody's looks.

ANNA: So, *sure*, of course you can get into *trouble*, but if you put it that way you can get into trouble if you meet somebody in a bar, *too*. Because there are *loads* of people, *women*, who've been *persecuted* and *raped* and — and — and *murdered* by someone they met in a bar, too! So you know, you can find *morons anywhere!* And sometimes I get so *tired* with all that talk of the *Internet* being so *dangerous!* That you'd better *not* leave out your name on the Net, because then: "Oh dear!" and you know. Because we write out our social security number almost every day and we can give out our phone numbers in a bar, but not on the Net, you know. But after all, you don't know *that* much more about a person just because you've been sitting drinking *beer* together in a *bar!*

However, two of the female informants had made appointments with family members to call them to make sure that everything was fine, but this is what they usually do, also when the date is with someone they have met offline. The fear that informants had before meeting their online date was that he or she would be completely different from what he or she had claimed to be, or that the meeting would be embarrassing or boring. One of the young women also talked about fears of the "chemistry" being wrong in meeting face-to-face and of having to hurt the dating partner by not being able to fulfill the hopes and expectations she might have inspired him with. Here, we see a contradiction to what the informants said earlier, that sexual attraction would be of less importance than inner qualities. As was pointed out in pp. 59f, appearance still seems to be important, even though the discourse around Internet romance is that of an environment where we are free from such constraints.

The extended communication over distances that is associated with modernity implies that relationships to a large extent are characterized by a quest for trust (Giddens, 1990). Trust is associated with absence in time and space, and there would be no need for it if others' activities and thoughts were constantly visible. "It has been said that trust is 'a device for coping with the freedom of others,' but the prime condition of requirements for trust is not lack of power but lack of full information" (p. 33). This is particularly true for relationships being established and maintained through communication media, and perhaps above all for computer-mediated relationships, in which so few physical cues are "given off." By continuously interacting through computers and telephones, informants built up their trust for each other. One informant told me that he had full trust in the person he had gotten to know online and later on through phone conversation, but he was not entirely sure that the person he had met *online* would be the same person he was to meet *offline*. He had trust in her in all settings in which they had already interacted, but before each new communication medium, or each new dimension, this trust had to be re-created.

RICKARD: This has got a double meaning. Because I trusted *Cyber-Mimmi,* so to speak. But on the other hand, I *didn't* trust Cyber-Mimmi to turn out to *be* IRL-Mimmi when I met her. I mean, I *knew* one person, but I wasn't *sure* that the person I knew would be the person I met.

The medium offers few opportunities for controlling what is claimed to be true, which some researchers regard as freedom to experiment with identities.[18] This is something often discussed in relation to online romance. It is true that gender-crossing and other changes of identity do occur online, as in the stories about a middle-aged male psychiatrist presenting himself online as a handicapped woman.[19] Most of my informants emphasized that those who have even a distant thought of ever meeting an online friend face-to-face had better be honest, because any bluff inevitably will be unmasked. Perhaps one could, as Turkle does (1995: 179), assume that an online acquaintance who agrees to a face-to-face meeting has not been lying and vice versa, even if there are exceptions:

ANTONIO: It wasn't until I arrived at the city she lived in that I started to think: "what does she look like, *really?* Maybe it *wasn't* her on the image, the photo." But it was. And . . . my first thought was . . . Well, "nice" sort of. [ironic grimace] "One week . . . well I suppose one week will pass quickly" [laughter]
MALIN: What do you mean? You mean you were disappointed at the way she looked? Or did you just feel bad about it all?
ANTONIO: [laughter] Eh . . . Like I said, it was my *first* thought, I was kind of: "well, it won't be long until it's over" and it *was* because of her looks, it really was. I have to admit that it was.
MALIN: She wasn't as good-looking as you'd thought?
ANTONIO: No. No. And not as she had described herself either. Because she had exaggerated a bit. Or exaggerated—it might have been her image of herself, what do I know? But as I said, that was my first thought. But after hugging and kissing her, then I forgot about all that right away, because then it *wasn't* the outward but the *inner* qualities that mattered. So . . . Well. I feel good about proving to *myself* that it isn't the outward beauty that's supposed to be deciding.

In this case, despite his initial disappointment, the informant started to perceive his cyber-date as quite attractive after all, and the relationship developed into a physical relationship as well.

One hypothesis I had before starting this study was that a greater trust would be created when people meet and get to know each other online before actually seeing each other offline. This was not entirely confirmed. One of the informants said that the extent to which she trusts others depends on their personality, and thus has nothing to do with whether she initially has got to know them online or offline. She has been meeting several persons with whom she first got acquainted through chat rooms, and she informed me that of these she has trusted some and others not. Two male informants said that by getting to know each other online

before meeting face-to-face, a certain trust was developed that was experienced as more stable than trust developed in real-life romances in which trust is generally built up *after* having established the relationship. They felt that it is possible to build up an equally authentic trust in both ways, but that the difference online versus offline is that this is done in opposite order.

When asked if anything surprised them during the first meeting, informants of course mentioned physical qualities, and one informant argued that physical appearance is the only thing that can surprise people who have met in this way.

What Happened Afterwards?

After the first date, in most cases the contact decreased. In one case, the dating partners broke contact. For others, it was probably more of a question of needing time to think about and find out what they felt and how to handle the situation:

MIMMI: He went home and I went home. And *then* I didn't hear from him much, we sent some *emails* back and forth, but we didn't call each other, and that wasn't because of our relationship, but it was because of his relationship to . . . well, *his* life. So it took some time. And to be honest I've got no clear picture of what happened during that period, either.

However, when these couples resumed contact, the intensity of the relationship increased. After having met his future partner face-to-face, one informant said, he felt frustrated communicating through computers that did not offer enough feeling of presence. Instead, they went by almost exclusively talking on the phone. The return to computer-mediated communication as retrogression in the progressive phases of relationship development is evident here. After establishing a relationship in "real life" (in some cases a sexual one), returning to the computer medium that offered less or no physical cues would feel like a withdrawal, because of the opportunities of keeping the distance.

One interesting fact is that the informants who met their partners through chat more or less lost interest in and ceased visiting chat rooms after they took their relationship offline. For one informant, the interest in chatting had been casual, while for others it was a matter of computer access and, above all, a question of priority of time, because spending time together with the partner was experienced as more important. This exclusivity of relationships, in no way specific for relationships created online, can be found in most relationships. An important part of the need for social interaction is satisfied on home ground, and the need for seeking new contacts is therefore diminished.

MIMMI: Well, you felt like you didn't have the *time* anymore. 'Cause the *reason* why you sat in front of your computer was that you were interested, but then that interest became concentrated in one person. And when you had that person

near you, you didn't *need* to either seek new contacts or spend hours in front of a *computer*.

ANNA: I would almost feel like I *cheated* on Anders, I think, if I was to go out chatting again. Because it feels like—you *know* what's going on there. *I* don't like when *he's* out chatting. Hell, you *know* what it's all about! You seldom start talking with someone of your own sex. So to speak.

As we see in the transcript above, however, one informant explains her "abstention" from chat rooms after meeting her partner by stating that the flirty atmosphere there would make her feel she was being unfaithful to him. Both two excerpts above point to an interesting contradiction that indicates that despite of all talk about the lack of romantic intentions, the goal of chatting, after all, might have been to look for a potential partner!

The Reactions of Others

Writing love letters is usually seen as romantic, while establishing and maintaining relationships online has often been considered distasteful (Turkle 1995). Informants talked about the reactions of others as being either extremely positive or extremely negative. Positive reactions to online romances included words such as fun, interesting, modern and trendy, while negative reactions, according to the informants, were from prejudiced people who drew parallels to telephone hotlines and pickup scenes and who thought that neither online interaction nor feelings for online acquaintances were "for real." By the time one of the informants met his partner, he moved in social circles in which computers and the Internet made up a large part of life, which meant that no one he knew was surprised by the way he met his partner. His new relationship was treated like those initiated in a bar. At first, most informants were skeptical about their relationships begun online, and tried in various ways to keep distance and deny their feelings. Some also felt uneasy telling others how they had met their partner.

ÅSA: Later on, when we became a couple, we completely *forgot* about how we met, and we almost felt *ashamed* of it, because if people asked us how we'd met, then . . . We almost didn't want to tell them the truth, 'cause it was so unusual and odd and weird and so on.

On the other hand:

ANNA: Usually, I rather think its quite *fun* telling people about it. Because then people *think* that *I* think I'm cool.

When I started to do my research, the idea I had of romantic relationships started online was that of people falling in love after having only communicated through

the computer and never having seen or heard each other. The phenomenon of meeting and getting to know other individuals through a computer network is interesting per se, but what really fascinates and stimulates the imagination of people is the thought of one falling in love with a totally anonymous individual about whom one cannot be certain of anything. Perhaps too, it is not even a human being "on the other side," but only the machine? One can here distinguish between two opposing parties, one that condemns the phenomenon as absurd and/or frightening and the other that praises the emancipating qualities of this new way of meeting. Meeting like this will, according to the latter, imply that individuals discover the intrinsic beauty of others before being confronted with their extrinsic aspects. This might be a heritage from the traditional dualism between body and soul as separate entities, but it may also be about the occidental dream of escaping the body, as Todd (1996) describes.

The question is how well these ideas of online relationships correspond with reality. Most of my informants maintained that while they were still communicating online, they had no feelings exceeding mere friendship. At most, they experienced the "other" as something of a soul mate. They claimed that while online, they did not think of their relationship in romantic terms, since they assumed that they would anyway never meet face-to-face. According to Alberoni (1984: 29), friendships distinguish themselves from other forms of love in that people choose friends from moral criteria and then behave in a moral way toward them. If Alberoni is right in his assumption, the fact that the romantic relationship is started with friendship means that the criteria for choosing a partner are also different (i.e., inner qualities being more important) which could have consequences for the future relationship. Whether true or not, this seems to be a powerful myth among the informants:

ANDERS: When we *started* to get to know each other, I somehow *assumed* that I would never *meet* her. There weren't any—Those *aspects* didn't exist, but I got to know her for what she *said*.

RICKARD: You don't *start* the relationship because you want to start a *sexual* relationship. Or a love relationship, but you start the relationship without gender roles, sort of. Or of *course* there are gender roles, I mean I *don't* think I would have *talked* as much to a *guy* as I did to Mimmi, I wouldn't, but . . . I guess you can say that you don't have any ulterior motives. It *leads* nowhere, there's no *goal* with it, in fact. At least not in the same way.

Even though most of the informants claimed to have had only feelings of friendship online, it might have been something going on exceeding mere friendship. The question is here, however, where to draw the line between feeling fascination over a new acquaintance and falling in love. Only two informants claimed to have fallen in love online: one male and one female. For the others, interacting online was not enough. They needed a voice and preferably also an appearance to attach their feelings to. For some, the telephone conversations were of major importance,

and several of the female informants talked about the voice as something that made them fall in love. However, most—particularly, the male informants—needed two or more face-to-face meetings before falling in love. An interesting connection to this are studies showing that men in their preferences about qualities of partners seem to specify appearance to a much higher extent than do women, and it thus seems to be a more important factor in romance for them[20] than it is for women. Another explanation could of course be that women do not consider it proper to put forward such a need but find it important without talking about it. I was surprised to find that most informants did not fall in love online, since this is the way it is most often mirrored in media. This is not to say that the media image of online romance is wrong, but just that it is biased. People do, without doubt, fall in love online without having seen each other, but the point is that this is not how it works in all cases (for example for most of my informants). Just as in offline settings, love is something that develops with time as partners get to know more and more aspects of each other.

ANNA: Sometimes I feel that people think it's like, you know: "Well well, the *Internet*!" As if it wasn't real love, you see what I mean? Like "Falling in love on the Internet? Good heavens, how silly!"

MALIN: As if it wasn't for real?

ANNA: Yeah. Like, you know, Well. "Falling in love with someone on the Internet!" You know. "Is that *possible*?" 'Cause you can't get to know anybody on the Net, they mean. It might just as well be a *woman* who sits writing to me. But what *they* don't get is that I didn't fall in love online. I didn't fall in love with Anders when I was chatting with him. But it has grown out and it's exactly the same, you don't fall in love in the bar either. But it grows out. So I think that—I think that there's very much the same thing as meeting someone in a bar. 'Cause I think that really, the difference isn't really so big, it's just that this is something new.

So, What *Is* New?

As Anna said in the excerpt above, perhaps relationships created online are not so entirely different from those created offline. Whether or not the relationship winds up working, all my informants attribute the outcome to the offline chemistry and feelings between them and their partners, even if the ground built by communicating through email and phone did have some importance. Most informants also said that when relationships are taken offline, nothing makes them different from other relationships. The differences, they said, are rather to be found in the initial stages when individuals meet and get to know each other through written computer-mediated text. But what do these differences really consist of? Let us have a look at some presumptions and ideas surrounding online relationships.

Relationships Across Increasing Distances

One difference mentioned is that relationships created online are often between people who live far apart. It is here important to keep in mind, though, that distance relationships per se are not a new phenomenon, since many relationships before the advent of the Internet were also maintained through communication media such as telephone and letters. The main difference in this aspect between relationships created online and offline is that in most online meetings, people are separated in space when they first meet.

Acquaintance Before Sex

One appreciated difference mentioned by informants is of having to get to know each other "properly" before starting a sexual relationship. They judge the chances for relationships to last as better when the partners know each other beforehand, because they can get acquainted and "feel their way about" before starting a love relationship. One of the couples talks about this as a means of avoiding embarrassing situations. If one picks someone up in a bar, embarrassing situations may occur when it turns out that one feels the two have nothing in common and wants to break the relationship. It is easily forgotten, however, that this aspect is not specific to the chat medium, and that it is also in offline settings possible to get to know one another before starting a sexual relationship. The only specific property of online relationships in this regard seems to be that the medium makes it more or less necessary for individuals to get to know each other, at least to a certain extent, before meeting face-to-face.

Inner Qualities More Important Than "Beauty"?

A third difference is that online, interlocutors cannot see each other. This has often been assumed to lead to a decreased importance of external qualities, by informants themselves as well as by scholars.[21] In the initial phases of online relationships, individuals may make contact with people whom they would not otherwise meet, but in the final analysis, it seems that extrinsic qualities are still important for choosing the person with whom to establish a love relationship. Both "chemistry" and physical attraction have to be there, and the main difference between relationships developed online and offline is at which end one starts. There has long been an all-consuming hype around the Internet and all that surrounds it, and what one can forget is that interacting with others without seeing them face-to-face was possible also before the Internet. Relationships have previously been developed and maintained through other "faceless" communication media such as letters, telephone, and telegraph, and probably physical appearance turned out to be equally important here as well. As long as people interact through a "faceless" medium they can overlook the physical aspects of the other, but as soon as they meet in the flesh, such aspects become important.

Getting Close While Staying in Control

According to Adamse and Motta (1996), individuals communicating online drop their guard earlier than those getting to know each other in traditional ways because they feel safer and less vulnerable in cyberspace. Kaufman (1996: 527) also writes about feelings of being in control as a crucial property of online interaction. This is a recurrent theme in the narratives of my informants who say that compared with relationships developed offline, in most cases two people get close very fast and exchange confidences much earlier than they would offline. One does not need to be afraid of posing questions that might be too forward or intrusive if asked face-to-face. Keeping one's distance and integrity is easy, and interlocutors can easily withdraw from interaction at any time. However, the possibility of retaining distance does not imply that online relationships are always distanced. As a matter of fact, as one informant said, online relationships demand more involvement and engagement than do offline relationships, since it would be so easy to just "let go" and not respond. This opportunity of keeping one's distance may very well be specific for online relationships, but it is also important to remember that this is possible only in the initial phases when all interaction occurs online. On the other hand, if interlocutors open up to a greater extent in the initial phase, this may have consequences for the future relationship.

An Unbiased Way to Meet

Informants mentioned openness as one of the main advantages in meeting and creating relationships in chat rooms. Relationships, they say, are first started without ambitions of entering into a love relationship, and this is the reason why interlocutors feel they can get to know each other well. This quality of online interaction permits them to present themselves in a relaxed, open and honest way, without having to worry about what others will think of them. When they later meet face-to-face, they are already acquainted and do not have to go through the initial phase with presentations and embellishments of self once again. Another important aspect lies in what one informant points out about sexual undertones that are present in most offline meetings. When meeting someone online, interacting through written text only and assuming that one will most likely never meet face-to-face with the other, these aspects are not present to the same extent. Words online of course can also be carriers of sexuality, but the difference is that interlocutors online mainly get to know each other on the basis of what they say and what they say they are like, not through physical attraction. One recurrent theme in the informants' stories is that the initial absence of hopes and expectations, both concerning appearance and where the relationship will lead, is what makes the relationship successful. A unique property of online meetings can be the uncertainty of where the meeting will lead: the venue seems to be open, unbiased, unpredictable, and random. To start with, the users have no preconceived ambitions of it leading to something more than chatting, although somewhere

on the way, such feelings started to arise. Nevertheless, this can be true for offline relationships as well. We can never predict what is going to happen after an initial meeting takes place, and what it will develop into.

Getting Acquainted from Inside and Out

The sixth difference consists in chronology: interacting, talking, and getting to know each other through the Internet and telephone before meeting face-to-face. As Van Gelder (1991:366) puts it, individuals communicating digitally often know intimate details about each other's background, even childhood, before even having had dinner together. The typical development of this kind of relationship seems to be that after having talked to an interesting person in the chat room, one withdraws to a more private space such as email or the telephone, to be able to get to know the other without being bothered by the conversations and curious gazes of the others. In most chat rooms, it is possible to create "private rooms" in which the creator decides who will have access, and this is where interlocutors go when wanting to talk undisturbed. The next step is emailing each other. After some time, the online couple makes telephone contact, and finally they meet face-to-face. This can be seen as a progressive curve, moving from a phase offering opportunities for keeping distance and integrity to others gradually providing more and more physical cues, finally to the point at which interlocutors are urged or compelled to reveal themselves entirely in their physical person.

Although the phases involved in relationship development are in opposite order to those that occur offline, the rules of the game are not entirely different. Each involves going through a process to discover the degree of compatibility and chemistry. People exchange phone numbers, call each other, date, and do neutral things such as having lunch or a cup of coffee together, or going to the movies. Little by little, as they continue to see each other, the interaction is extended to more personal settings, and they may become close mentally as well. All these phases are enacted by "players" often uncertain about their own as well as the other's feelings and about what kind of person the other really is. In all relationships, as time goes by, more and more information is added to the image of the other. In relationships started online, this kind of "added" information consists mainly of extrinsic qualities including such as voice, appearance, and body language, while in relationships started offline the information that has to be added deals more with inner qualities. Even though the phases of online and offline relationships are in opposite order, in both cases it is a matter of exploring the other and of extending the relationship to more and more contexts.

Conclusion

Discussions about cyberspace often stress its exotic qualities, and the discourse around online relationships has been characterized by overstatements of both perils

and promises. The fact that the first meetings occur online has been assumed to imply certain consequences for the future relationship: either positive or negative ones. However, even though meetings in chat rooms do have some qualities that distinguish them from meetings in other spaces, there are also crucial similarities, and it is by no means certain that the differences will have the kinds of consequences predicted. Even when cyberspace as a meeting place does have negative or questionable consequences, it is important to remember that many of these can and do occur in offline settings as well and are thus not specific to the medium, as has been assumed.

As Parks and Floyd (1996) stated, for their informants cyberspace was just "another place to meet." Markham (1998) also shows that users just consider the meeting places of cyberspace as a choice among many others. This view was supported by my informants, even if they were aware of and sometimes conformed to others' ideas of what meeting a partner in a chat room means.[22] Chat as a meeting place is surely different from other meeting places, but the relationships created there are not different. Personal relationships will probably stay very much the same, no matter which communication media are used to establish and maintain them.

Notes

1. See for example Baker (1998); Schofield Clark (1998); Lea & Spears (1995).
2. This may explain a certain bias in both their utterances as well as in my analysis.
3. Another distinguishing mark could be the language style, but even if one has the possibility of recognizing the language style of an individual, this would no doubt require much more time than recognizing the face of a familiar person in a physical meeting.
4. 'Stina' is a Swedish female first name.
5. See for example Sproull and Kiesler (1991); Dubrovsky et al. (1991); Spears and Lea (1994).
6. Early research on computer-mediated communication such as Sproull and Kiesler (1991), and Dubrovsky et al. (1991) suggested that the Internet might be less suited for personal communication because of its reducing social contexts cues. Walther (1992), on the other hand, argued that it is possible to convey social information via computer-mediated communication but that this simply demands more time than face-to-face.
7. Here, it may be argued that attention and attraction are not the same, and it is indeed possible to catch others' attention without attracting them.
8. Karlsson (1997b) in an article about communicative competence in chat rooms.
9. See, for example, Danet et al. (1998) and Sveningsson (2001).
10. Mimmi and Musse are the Swedish names for the Disney characters Minnie and Mickey Mouse, but Mimmi is also a Swedish girl's name.
11. See, for example, Bechar-Israeli (1995), who describes how IRC users create and express their identities through their choice of name, and how deeply attached they can become to them. Bechar-Israeli also argues that most users prefer having the opportunity to get to know people under one permanent nickname over using the medium for identity games.

12. See, for example, Reid (1995).
13. In her study of teenagers' romantic meetings on the Internet, Schofield Clark (1998) follows the same track, stating that on the Net one is freed from peers' approval, which means that relationships can be more individualistic. One can choose based on one's own taste instead of listening to the opinions of friends.
14. p. 180.
15. p. 182.
16. Here, it is important to stress that inner qualities such as aspects of personality can, of course, be unknown in online contexts too.
17. For example, the cartoon Ernie had a strip where in the first 3 boxes a man, sitting in front of the screen, tells his friend about his online romance, a woman with whom he has a lot in common, and who, he says, is at the same intellectual level as him. In the last box, the setting is switched to the "woman's" side of the screen. The woman turns out to be a chimpanzee, sitting by the computer and typing. Next to her, a researcher proudly tells his colleague: "She's got a vocabulary of 122 words!"
18. See, for example, Turkle (1995) and Stone (1991; 1995).
19. Van Gelder (1991) and Turkle (1995).
20. Huston and Schwartz (1995), whose article deals mainly with the homosexual population, refers to studies of personal ads written by both homosexual and heterosexual individuals.
21. See, for example, Dunlop and Kling (1996).
22. It could be that they sometimes did not tell others about how they actually met their partners, or on the contrary, they bragged about it.

References

Adamse, Michael, and Sheree D. Motta. *Online Friendship, Chat Room Romance and Cybersex: Your Guide to Affairs of the Net*. Deerfield Beach: Health Communications, 1996.

Alberoni, Francesco. *Vänskap*. Göteborg, Sweden: Korpen, 1984. (Friendship).

Alberoni, Francesco. *Drömmar om Kärlek*. Göteborg, Sweden: Korpen, 1992. (Dreams of Love).

Asplund, Johan. *Storstäderna och det Forteanska Livet*. Göteborg, Sweden: Korpen, 1992. (Big Cities and the Fortean Life).

Baker, Andrea. "Cyberspace Couples Finding Love Online then Meeting for the First Time in Real Life." *CMC Magazine* 5 (7) July 1998. Available 7 March 2000 at < http://www.december.com/cmc/mag/1998/jul/baker.html. >

Bechar-Israeli, Haya. "From < Bonehead > to < cLoNehEAd: Nicknames, Play and Identity on Internet Relay Chat." *Journal of Computer-Mediated Communication*. 1 (2) 1995 Available 7 March 2000 at < http://jcmc.huji.ac.il/vol1/issue2/bechar.html. >

Berger, Charles R. "Uncertainty and Information Exchange in Developing Relationships." In *Handbook of Personal Relationships*, edited by S. Duck. Chichester, N.Y.: John Wiley & Sons, 1988.

Berscheid, Ellen and E. H. Walster. *Interpersonal Attraction*. Reading, Mass.: Addison-Wesley, 1978.

Danet, Brenda, Lucia Ruedenberg, and Yehudit Rosenbaum-Tamari. "Hmmm . . . Where is that Smoke Coming From? Writing Play and Performance on Internet Relay Chat."

In *Network and Netplay. Virtual Groups on the Internet,* edited by F. Sudweeks, M. McLaughlin, and S. Rafaeli. Menlo Park, Calif. and Cambridge, Mass.: AAAI Press/ MIT Press, 1998.

Dubrovsky, Vitaly J., Sara Kiesler, and Beheruz N. Sethna. "The Equalization Phenomenon: Status Effects in Computer-Mediated and Face-to-Face Decision-Making Groups." *Human-Computer Interaction* 6, 1991, 119–146.

Dunlop, Charles and Rob Kling. "Personal Relationships and Electronic Communication." In *Computerization and Controversy. Value Conflicts and Social Choices,* edited by Charles Dunlop and Rob Kling. San Diego: Academic Press, 1991.

Giddens, Anthony. *The Consequences of Modernity.* Stanford: Stanford University Press, 1990.

Goffman, Erving. *The Presentation of Self in Everyday Life.* London: Penguin Books, 1959/ 1990.

Huston, Michelle and Pepper Schwartz. "The Relationships of Lesbians and Gay Men." In *Under-studied relationships. Off the Beaten Track,* edited by J. T. Wood and S. Duck. Thousand Oaks, Calif.: Sage, 1995.

Kaufman, Margo. "They Call it Cyberlove." In *Computerization and Controversy. Value Conflicts and Social Choices,* 2nd ed, edited by Rob Kling. San Diego: Academic Press, 1996.

Karlsson, Anna-Malin. "Kallpratare på nätet. Om chattares kommunikativa kompetens och samtalsstil." *Ord och Stil, Språkvårdssamfundets Skrifter,* no 28. Issue "Språk i Dator. Svenskan i IT-samhället", edited by O. Josephson. Uppsala, Sweden: Hallgren & Fallgren, 1997. ("Smalltalkers on the Net. On Chat Users Communicative Competence and Language Style." Word and Style, Publications of the Association for Guidance on Modern Swedish Usage, 28. "Language in the Computer. The Swedish Language in the IT-Society.")

Lasko-Harvill, Ann. "Identitet och Mask i den Virtuella Verkligheten." *Montage* no 44–45, 16–21, 1998. ("Identity and Mask in the Virtual Reality.")

Lea, Martin and Russell Spears. "Love at First Byte? Building Personal Relationships over Computer Networks." In *Under-studied Relationships. Off the Beaten Track,* edited by J. T Wood and S. Duck, Thousand Oaks Calif.: Sage, 1995.

Lee, Judith Yaross. "Charting the Codes of Cyberspace: A Rhetoric of Electronic Mail." In *Communication and Cyberspace: Social Interaction in an Electronic Environment,* edited by Lance Strate, Ron Jacobson and Stephanie B. Gibson. Cresskill, N.J.: Hampton Press, 1996.

Myers, David. "A New Environment for Communication Play: Online Play." In *Meaningful Play, Playful Meaning,* edited by Gary Alan Fine. Proceedings of the 11th Annual Meeting of the Association for the Anthropological Study of Play (TAASP) held March 14–17, 1985 in Washington D. C. Champaign, Ill.: Human Kinetics Publishers, 1987.

Parks, Malcolm R. and Kory Floyd "Making friends in Cyberspace." *Journal of Communication* 46 no 1 (1996): 80–97.

Patton, Michael Q. *Qualitative Evaluation and Research Methods.* Newbury Park, Calif.: Sage, 1990.

Reid, Elizabeth M. *Electropolis: Communication and Community on Internet Relay Chat.* Unpublished Honours Thesis, Department of History, University of Melbourne, 1991. Available 15 August 2001 at < http://www.crosswinds.net/~aluluei/electropolis.htm >

Schofield Clark, Lynn. "Dating on the Net: Teens and the Rise of 'Pure' Relationships." In *Cybersociety 2.0: Revisiting Computer-Mediated Communication and Community,* edited by Steven G. Jones. Thousand Oaks, Calif.: Sage, 1998.

Sproull, Lee and Sara Kiesler. *Connections: New Ways of Working in the Networked Organization*. Cambridge, Mass.: MIT Press, 1991.

Stone, Roseanne A. "Will the Real Body Please Stand Up?" In *Cyberspace: First Steps*, Edited by Michael Benedikt. Cambridge, Mass.: MIT Press, 1991.

——. *The War of Desire and Technology at the Close of the Mechanical Age*. Cambridge, Mass.: MIT Press, 1995.

Sveningsson, Malin. "An Antisocial Way to Meet: Social representations of the Internet." In *Perspectives on Human Computer Interaction—a Multidisciplinary Reader*, edited by Mohamed Chaib. Lund, Sweden: Studentlitteratur, 2001(a).

——. *Creating a Sense of Community: Experiences from a Swedish Web Chat*. Ph D. dissertation. Linköping, Sweden: Linköping Studies in Art and Science 233, 2001(b).

Todd, Loretta. "Aboriginal Narratives in Cyberspace." In *Immersed in Technology. Art and Virtual Environments*, edited by Mary Ann Moser and Douglas MacLeod. Cambridge, Mass.: MIT Press, 1996.

Turkle, Sherry. *Life on the Screen*. New York: Simon and Schuster, 1995.

Van Gelder, Lindsey. "The Strange Case of the Electronic Lover." In *Computerization and Controversy: Value Conflicts and Social Choices*, edited by Charles Dunlop and Rob Kling. London: Academic Press, 1996.

Walther, Joseph B. "Interpersonal Effects in Computer-Mediated Communication: A Relational Perspective." *Communication Research*, 19 no. 1 (February 1992): 52–90.

Werry, Christopher C. "Linguistic and interactional features of Internet Relay Chat." In *Computer-Mediated Communication. Linguistic, Social and Cross-Cultural Perspectives*, edited by Susan Herring. Amsterdam: John Benjamins Publishing, 1996.

CYBERBODIES: WRITING GENDER IN DIGITAL SELF-PRESENTATIONS

If it is obvious that we can see, hear, feel and interact with virtual worlds only because we are embodied, why is there so much noise about the perception of cyberspace as a disembodied medium? . . . To create the illusion of disembodiment, it is necessary to draw a sharp boundary between the body and the image that appears on screen, ignoring the technical and sensory interfaces connecting one with another. Then the screen image . . . is reified, treated as constituting a world opening up behind the screen, an alternative universe that our subjectivities can inhabit. The final step is to erase awareness of the very perceptual process that brought this "world" into being.[1]

look Raechel

High-cut rust hair and ocean blue eyes, skin no darker than fresh cream. A short lass indeed, yet trim and fit, she strolls around with her hair as mussed as it can get at that length, draped in a dark red/blue/green vertical-striped terry-cloth bathrobe, belt hanging at her sides, belly exposed, breasts barely covered, white satin panties barely visible against her skin, padding along on feet with chipping red nail-polish. She looks like she needs some sleep.[2]

One day I met this "Raechel," who was virtually barefoot, padding along through electronic landscapes in the MUD I have been studying two years. She is one of several hundred inhabitants in this virtual world, and her textual appearance reveals a woman "draped in a dark red/blue/green vertical-striped terry cloth bathrobe" who just woke up from her (cybered) sleep, ready to meet the day in the wires. In an encounter with the other her textual body comes into being, and in every meeting, a different interpretation is performed and new meanings attached to her body. Communication technology mediates between the embodied self and the "she" simultaneously present in the virtual realm, transgressing the boundaries between real and virtual, flesh and representation. Identity is experienced simultaneously as "self" and "other" in embodied and imagined spaces. The interface has thus, through an act of narrativization, become a crucial site, a significantly ambiguous borderland between human and technology.

Created through strings of text that realize an openly flirtatious and seductive performance, she "strolls around" with "belly exposed" and "breasts bearly covered." At the same time, she appears to wear her hair "as mussed as it can get at that length . . . padding along on feet with chipping red nail-polish," signaling a lack of interest in her half-naked appearance. There is really no reason for hair to be entangled and nail polish to flake off in cyberspace, and an incorporation of features like these can be understood as a resistance towards the endless number of exquisitely beautiful and mysterious female creatures wandering virtual spaces. This woman even "looks like she needs some sleep." What at first sight might look like one of the millions of bare-breasted "cyberbabes" inhabiting countless bytes of disc space on the Net can be argued to be interpreted as a sign of ("third wave") feminism.

The text "Raechel," by mixing an exposure of a female body with ironic comments attached to it, can be read as an example of Rosi Braidotti's politics of the parody. In her discussion of the concept of parody, Braidotti emphasizes that "woman" is not only the objectified "other," but also the very basis for female identity and therefore containing a resistance to patriarchal identity. When "woman" is regarded as a set of options to choose from and play with, and sometimes even avoid, it becomes possible to use traditional patterns in playful and unexpected ways to create new femininities and meanings. Self-distance and humor function as the means, at least momentarily, to dissolve the contradiction between accentuation and deconstruction of femininity, in order to imagine new gender identities by moving through the heart of traditional bipolar definitions of gender.[3] Thus, "Raechel" could be understood as a realization of a distancing strategy, as a modest displacement of the dominant gender order. On the other hand, this female figure, through its openly expressed sexuality—no matter how ironic— might still be understood along the lines of highly traditional gender identities. If

the irony in her (textual) voice is drowned in a silent, voluptuous body language, the emancipatory potential of the representation is rather locked into a dependency to satisfy a male gaze.

Before further readings of textual bodies in virtual space can be possible, there are several questions that we need to have answered. What, precisely, are MUDs? How can characters who populate these online worlds be approached and understood? This essay explores notions of culture and embodiment in MUDs by focusing on the creation of characters (online personas), and in particular on how gender is being performed in these texts. All typing errors in these online texts have been left uncorrected. Writing in MUDs, typically, one keeps a high pace so there is rarely time to correct grammar and spelling mistakes. The mode of writing is further informal and spontaneous, which shows in the development of unconventional styles among the participants. What at first sight might look like slips at the keyboard can instead be an intentional move of the writer to create a particular voice. Various strategies of, for example, capitalization and punctuation (or the lack thereof) have particular meanings. In a culture in which everything must be typed into being, a specific way of putting symbols together does not only create a personal style; it sets the limits for who you can be. All URLs to home pages and names of characters in dialogue examples have been changed to protect identities of participants. Online names as part of descriptions have been left unchanged. For the purpose of doing close readings of these texts, a change of names could change the whole meaning of a text. By lending me their descriptions, the participants gave me permission to use their real online names as part of their texts.

After a brief introduction to MUDs and MUD culture, the discussion will concentrate on interpretations based on two years of fieldwork in a particular MUD, for the purpose of my study called WaterMOO. My attempt on this journey is to give a nuanced image of the creation of characters in WaterMOO, its cultural-specific categories, and its patterns and meanings. How do WaterMOOers (re)-present themselves? What can we learn from these texts about the online culture of which they are part?

Internet is often presented as a disembodied medium, a space in which bodies have ceased to matter. Even though our bodies are intimately related to who we are, how we experience ourselves, the dream of transcending this body and achieving immortality persists and is now being remapped in virtual worlds. N. Katherine Hayles, in her article "Embodied Virtuality: Or How to Put Bodies Back into the Picture," argues that the notion of disembodiment in virtual space overshadow the importance of the body in the very construction of cyberspace. The paradox that creates the illusion of inhabiting a world far beyond a material body is evident: When the body is completely separated from its representation on the screen and seen as pure "information," its physical erasure becomes possible. Hayles' attempt to reintroduce the body in this picture disrupts the simple dualisms (mind/body, computer/organism, male/female) that allow its erasure without underestimating the power of these dualisms in the creation of cultural representations. A similar disruption of "disembodied" virtual spaces is taking place

when MUD characters are created, an act that stubbornly reintroduces and reconnects bodies through online texts on the move. Seemingly disconnected from the material world beyond them, they ultimately depend on the materiality of computers, computer networks, and not least, embodied human beings—not only for their birth, but also for their ability to keep living.

@Gender (Fe)male/Other

Multi User Dungeon, or MUD, is sometimes defined as text-based virtual reality. The term "virtual reality" is often thought of as representing a highly complex computerized environment that users, dressed in body suits, helmets, and gloves, can explore and interact with. MUDs are something completely different. Instead of providing a sensory experience in solitude, they offer social experiences based on shared, imagined worlds of text. Virtual reality in these terms is not so much a technological construct (since the technology involved is very simple) as it is a cultural construct that takes shape among those who inhabit these worlds.

At first, MUD was a fusion of traditional role-playing and text-adventure computer games in which a single player, by typing short commands, could move a character through various settings and solve puzzles. This blend produced a global form of interactive computer-based role-playing games, in which Internet users could create characters, get together, and play. Some MUDs use graphics to visually create places, characters, and movements, but most of them are constructed entirely by plain (written) text. MUDs originally stood for Multi User Dungeons, in which the term "dungeon" was directly transferred from the genre of face-to-face role-playing games known as Dungeons & Dragons to its high-tech version online. As the MUD culture spread and more and more people without previous experience in role-playing began to participate, the creators started to use the terms Multi User Domain or Multi User Dimension. This attempt to change the name might well have been an effort to gain respectability and to neutralize some of the gamelike and purely playful associations.

Today, many MUDs are still closely related to the original system, and people can log on to the computer on which the MUD program is running to kill monsters, solve puzzles, find treasures, and interact with each other and with objects created within the program. The purpose is to gain as many "experience points" as possible, which are transformed into power. When a player has obtained a certain number of experience points, he or she can leave the level of the mortals and join an exclusive, immortal crowd with almost unlimited power over the virtual world. Other MUDs, sometimes called social MUDs, provide spaces for a kind of role-playing more related to improvisational theater than to a game with well-defined rules and hierarchies. These MUDs are in some cases inspired by fantasy and science fiction works such as *Star Trek*, Tolkien's *The Lord of the Rings* trilogy, and the work of Terry Pratchett, to mention a few. They can also be more loosely structured around different imaginary themes, constituting more openly structured

virtual meeting places. As opposed to its role-playing, game-oriented ancestors, WaterMOO belongs to this latter category of social MUDs as it provides its participants with a relatively open social space with the primary purpose of "hanging out" and socializing.[4]

To socialize in WaterMOO (as in most MUDs) is a purely textual affair. Every move a character makes must be typed into being in order to exist. But first of all, the character itself must be created. A character consists of a name, an @gender, and a textual description of any length (available to other participants through the <look> command). Elizabeth Reid points out that the only identity trait always "hard coded" into MUD programs is gender. Some MUDs in adventure-game style do ask players to choose a racial identity, "but the choices are more likely to be between Elvish, Dwarvish, and Klingon than between Caucasian, Black and Asian."[5] Choosing a gender is more complicated than it first might appear. In WaterMOO, for example, the following choices are available: male, female, neuter, either, spivak, splat, plural, egotistical, royal and 2nd. The choice of gender controls which pronouns the MUD program will use in referring to the player. "Neuter" uses the pronoun *it;* "either" uses *s/he* and *her/him;* "spivak" uses a set of gender neutral pronouns such as *e* and *em;* "splat," in a similar way, uses **e* and *h*6;* "plural" uses *they* and *them;* "egotistical" uses *I* and *me;* "royal" uses *we* and *us;* and "2nd" uses *you.* As will become clear later, these @gender positions are rather unequally distributed in the WaterMOO population.

The Realness of (Online) Imagination

A MUD can be described as an ongoing, collaboratively written, online performance. It consists of the writing of characters, movement, dialogues, and action. But there is also the writing of a wider social landscape and structures such as public rooms and their objects, help texts, introductory texts for newcomers with guidelines for behavior, programming, and building. The activity of building in MUDs, as Sherry Turkle puts it, is "something of a hybrid between computer programming and writing fiction."[7] A MUD is organized around the metaphor of a three-dimensional space. It consists normally of thousands of (textual) "rooms" for characters to "enter" and "exit" by using simple commands (such as <up>, <north>, etc.), which gives these systems a feeling of "being" somewhere. Moreover, every room carries its own description. This is what appears on the screen when you connect to WaterMOO:

```
*** Welcome to WaterMOO! ***

OoOo THE AQUATIC DOME oOoO

You find yourself in an immense underwater
dome composed of transparent, curved
```

geodesics. All around you the dark water is
penetrated by strong lightbeams that
illuminate a fantastic underwater scene.

The semi-opaque green beams of the WaterMOO
City Hall tower over you, the tip of its
central pediment touching the upper curve of
the Aquatic Dome.

Obvious exits: GUEST to Guest Login
Antechamber, NET to NetSpace, OTHER to Other
Worlds, WATER to The Water Area, HALL to
WaterMOO City Hall, HELPDESK to Help-Desk,
MESSAGE to Guest Message Chamber, and Park to
WaterMOO Park

To access, for example, "Guest Login Antechamber" from "The Aquatic Dome,"
the command < guest > must be typed in. But the description of a room is only one
part of its creation. For the room to be related to other rooms in the MUD, some
formal coding is required. Even though MUD spaces are collectively created and
constantly under construction, what remains for those who do not engage in the art
of programming is thus to utilize what others have already built. In other words,
even though the group of people who inhabit virtual worlds might be increasingly
diverse, the production of MUDs is still dominated by a technological elite.

The following excerpt is an example of what MUD sessions "look" like, and at
the same time an example of what actually happened when my researcher character
Jenny entered the "field":

Jenny wonders if people in here would mind
being part of her doctoral thesis . . .
Pumpkin [to Motherfucker]: "you have to
remember my short term memory loss!"
Jenny smiles at Motherfucker
Sugar appears suddenly out of nowhere.
Knight_ingale materializes out of thin air.
Motherfucker asks you, "is that
psycholoanaklyssis?"
Motherfucker asks Pumpkin, "when did that
happen girl?"
Pyrex casts his eyes down as Wolfgang passes.
He bows low, nearly sweeping the ground with
his hand.
He keeps his eyes down until Wolfgang has
passed.

```
Pumpkin [to Jenny]: "you'll get a good cross
section of the freaks."
Motherfucker laughs at Pumpkin.
Jenny chuckles
Jenny [to Motherfucker]: "not really, more
like communication studies"
Motherfucker. o O (true enough!)
Narrato has arrived Jenny laughs
MegaByte [Guest] says, "Heloo . . .
everyone."
Motherfucker asks you,
"communication . . . what in communication?"
Wolfgang (feeding the horse) waves.
Narrato (connectus interruptus) waves.
Wolfgang says, "ay up, groovers"
```

Entering in the midst of a conversation (like one always does on MUDs!), some utterances refer to things that happened earlier in the conversation ("you have to remember my short term memory loss!" . . . "when did that happen girl?"). Entrances ("Sugar appears suddenly out of nowhere") and greetings ("Narrato (connectus interruptus) waves") scatter sentences being "spoken," and speech, paradoxically, intermingles with the explicitly "unspoken" (as in "Motherfucker. o O (true enough!)," where Motherfucker's "thoughts" are marked with bubbles, as in a cartoon). When asking if people would mind being part of my doctoral thesis, Motherfucker asks: "is that psycholoanaklyssis?," harmlessly making fun of academic studies or at least in an amusing way commenting on how hard it can be to spell things like "psychoanalysis." Pumpkin fills in: "you'll get a good cross section of the freaks," which Motherfucker finds funny ("Motherfucker laughs at Pumpkin").

Mizuko Ito, influenced by Janice Radway and her *Reading the Romance*, analyzes MUD practices precisely in the tension between fantasy worlds of texts and "real" social situations and contexts in which these texts are grounded and interpreted.[8] In a reading across the gap between the text and the social, she attempts to incorporate both textual and material realities into her analysis. In contrast to Radway, she also wants to show how the textual worlds in themselves can be seen as constituting "real" social relations and that involvement in fantasy can be "a social event to be analyzed in terms not ultimately reducible to a social reality outside the text."[9] As with the reading of novels, MUDs involve physically separated bodies that interact with immersive worlds of texts, but:

MUDs differ from novels in that they foreground interactivity and travel to alternative domains through an explicitly networked sociality. So instead of focusing on how textual artifacts constructed on the Net circulate through "real" social contexts at large, I would like to examine the inter- and intra-textuality of the Net as itself a social and political context where history, politics, and discourse are being constituted.

> By insisting on the reality of the virtual I do not intend to reduce social practice to language games, but rather to foreground the inseparability of semiotic and material technologies.[10]

Ito's analysis not only puts forward the way fantasy blends into "real" life in which a reader brings text and society together through the act of reading; it also emphasizes that the distinction between "real" and "virtual" has ceased to exist. Imagination is, from her perspective, a social practice in itself rather than a commentary on, or a reflection of, "real" social relations whose ultimate ground is a biologically grounded subjectivity. Drawing from examples of marriage, romance, and sex between MUD characters, as well as cases of violence in the MUD and virtual death, she illustrates how virtual worlds can be realities that matter.

Without neglecting the material technologies of computers and computer networks, my purpose is to realize a similar analysis of the way bodies are created and rendered meaningful in WaterMOO, primarily through the creation of characters. These virtual bodies are neither disengaged from, nor reducible to, a concrete, locally situated, materially grounded body, but rather (re)embodied through prosthetic computer technologies. Along the lines of Ito's approach, I intend to explore "the inter- and intra-textuality of the Net as itself a social and political context where history, politics, and discourse are being constituted," to insist on both the "realness" of fiction and how the texts of characters cannot be understood outside the world they inhabit. Fiction is here understood as something that cannot be created without connections to the "non-fictious" or "real." Rather, the writing of fiction has to borrow certain elements from the so-called real in order to be comprehensive. What would fictious voices speak about, if they did not, in some sense, speak about reality? This is not to suggest that pieces of fiction are replicas of "real" persons and events, but that imagination can never be completely disconnected from what we experience as real.

Online Ethnography

The creation of a character is the first necessary move, even for the online ethnographer before entering "the field." Because I was coming to WaterMOO as a researcher to ask other participants for favors, I wanted to hide as little as possible. However, when I was standing on the virtual threshold, ready to enter the field, I thought that it would have been easier to create a character very different from my offline self. Because how do you textualize yourself? In contrast to many other texts in these spaces, I wanted my description not to deviate too much from the "truth." The question is how you can do this, especially if you are a person who does not believe in this so-called truth in the first place. How on earth can I even start to write those strings of text that are supposed to mediate something of "me," physically and mentally? Exactly what would be an efficient textual strategy in encounters with forthcoming informants? Who am I, anyway?

look me

You see a rather Scandinavian looking woman.
She is wearing laced boots, a pair of black
Levi's and a dark blue woolen sweater. She
has been cruising the Net for a while, and
has over time developed a strong interest for
virtual bodies rising from the point where
flesh meets text in an ongoing, electronic
dance . . . While you are looking at her, she
looks back at you, curiously, piercing, in a
way that makes her look like a very sensitive
but at the same time strong and intelligent
human being.
Jenny's time is Thu Dec 23 14:59:59 2000
Jenny appears awake and alert.
Carrying:
Cup of Cappuccino

After having created my character, my next step was to situate this Jenny within
the world I was studying. I decided to make my personal room into a virtual
office:

look

Her Office
You find yourself in the middle of a cozy
messiness. The walls are covered with book-
cases, filled with books and piles of papers,
embracing what seems to be an awful lot of
knowledge. The room is surprisingly airy, for
being a hotel room, and a window reveals one
of the most amazing views of the Bay you've
ever seen. Next to the window, there is an
old French writing desk with lots of small
drawers, and probably even some secret ones
behind the movable panel. The desk is covered
with books, journals and notebooks, and in
the middle of all this you see an open Power-
Book. In the pale blue flicker you capture a
glimpse of a direct connection to . . . Wa-
terMOO on the screen. In front of the desk,
there is what seems to be a very comfortable
chair. And if you were to lay your hand on the
seat, you would notice that it was warm . . .

```
as if someone a moment ago had been sitting
there.
```

The key sentence in this description is: "In the pale blue flicker you capture a glimpse of a direct connection to . . . WaterMOO on the screen," which I wanted to use as an illustration of the *doubleness* that characterizes life online, as well as the research on this life. The online condition is constituted through mediation between the embodied self and the textual "I." As a researcher conducting online ethnography, you constantly find yourself crossing these boundaries between the material and the virtual. One of the intentions behind the description of my virtual office was to mediate this feeling of *physically* being seated at a computer, connected to the online world. Within this world another young woman is—*textually*—seated at her virtual computer, which also appears to have a direct connection to the world that is being studied.

The office description can also be seen as a strategy to put forth the *constructedness* of knowledge-making and text production in general. Even though the border between physical and virtual locations is continually crossed in online ethnography, there is also a separating distance between the two. This distance is introduced in text-based online worlds through the act of typing and is further reinforced by the mediating computer technology itself. By actively, and more or less consciously, having to write oneself into being, a certain distance to this construction is at the same time created. The mediation between different realms—the very creation of texts by the means of computers—makes the interspace that exists between myself, and the understanding of this self, especially clear. This distance can be used for methodological purposes, to form a reflexive understanding of ethnographic procedures and of the way a researcher is herself always intertwined with these processes. The gap between online and offline realities can be used to create room for reflection on how I, the researcher, am not only a producer of ethnographic texts but also a coproducer of the reality that is being written.

Implicit in "traditional" ethnography is a physical immersion of the ethnographer's body in the culture that is being studied. This bodily "thereness" makes face-to-face encounters with the members of the culture possible; it also allows an understanding of life as it is lived and interpreted by the members themselves. Online ethnography instead treats the lack of embodied presence as the key to understanding.[11] Even if the only way to communicate online is through the use of symbols on a keyboard, this does not prevent participants from making sense of one another. On the contrary, the exclusion of physical bodies, voices, facial expressions, and gestures has resulted in highly creative and innovative uses of symbols. The question that ethnographic work online tries to answer is how people deal with this very absence; how specific online modes of communication develop, and how shared systems of meaning are created.

I have spent two years in the MOO. Through Jenny, I entered the MOO, gained permission from the wizards to conduct the study, and set up my office.[12] WaterMOO is a medium-size MOO with a population of about 1,500, of whom

only a couple of hundred are active participants.[13] I keep copies of 163 character descriptions, of which 96 are male, 55 are female, and 12 "other." This gender division roughly corresponds to the overall division in the MOO, in which male characters are in great majority, whereas characters @gendered as something other than male or female are very rare. In my attempt to disrupt the stability of the material body as a "true" starting point for its textual refiguration in virtual space, I have no knowledge of how these textual bodies correspond to the bodies of their typists. I am not saying that people, myself included, are not curious about who the person is behind a certain text; I am only suggesting that textual bodies in their own universe are as "real" as bodies in flesh are.[14] I insist on the realness of imagined worlds for those involved, to give these texts a certain independency, a type of freedom I intend to bring into my own readings. Moreover, it is to base my own readings on a fundamental online condition: One is always in a state of not knowing who the person behind the text is.

Only two participants refused me access to their texts, and neither of them gave me any elaborate answers when I asked them why. They simply did not want to be part of my work, which I, of course, respected. Usually, however, I got a very different response. I experienced a great openness in relation to me and my project, a willingness to share texts and experiences that initially surprised me. On second thought, this is not especially surprising in a culture that holds a widespread belief in the right of everybody to access information. This part of online philosophy ("information wants to be free"), in combination with the type of texts I was asking for (created to be seen), might explain why it was extremely easy to collect material. It is not the complexities and details of online relationships, feelings, fears, hopes, dreams, and desires I intend to write about and publish, but the textual appearances of online characters, written to be seen and, maybe, admired. "Will we be famous now?" one WaterMOO inhabitant whispered to me. "If I'm doing a good job, you might," I answered.

Lyrics and Poetry in the Silence of the Net

look Lithium

```
Independence limited
Freedom of choice
Choice is made for you my friend
Freedom of speech
Speech is words that they will bend
Freedom with their exception
[stanza break]

Doesn't matter what you see
```

> Or into it what you read
> You can do it your own way
> If it's done just how I say
> -Metallica, Eye Of The Beholder

> *Most contemporary popular music takes the form of song (even acid house), and most people if asked what a song "means" refer to the words. In examining what the words do mean we can follow two obvious strategies, treating songs either as poems, literary objects which can be analyzed entirely separately from music, or as speech acts, words to be analyzed in performance.*[15]

In his *Performing Rites,* Simon Frith points out that the meaning of song words is not to be found in the words themselves (in their content), but rather in their expression (in the way they are performed). When lyrics are approached as autonomous texts, he argues, the words are being isolated from the context in which they are rendered meaningful. However, "Once we grasp the issue in lyrical analysis is not words, but words in performance, then various new analytical possibilities open up. Lyrics . . . are a form of rhetoric or oratory; we have to treat them in terms of the persuasive relationship set up between singer and listener."[16] In this sense, lyrics come closer to the spoken than to the written word. Rather than analyzing textual elements, one must create an interpretation that departs from notions of dialogue and interaction. Frith further emphasizes the importance of the singing voice as a carrier of sounds and words and for how it appears to give us immediate access to the singer's "authentic" self. Similarly, a disembodied voice might seem removed from this authenticity, as if it were deprived of the "realness" the body represents. On the other hand, in our everyday lives we rarely have problems with attaching disembodied voices (whether on the phone or recorded on discs) to *imagined* bodies of a certain gender, race, class, age, etc.[17]

I argue for an understanding of MUD practices as *texts,* and by referring to Frith my intent is not to undermine my own position but rather point out the specificity of these texts. A description of a character is written, primarily, to be read by others. As opposed to written dialogues taking shape between participants in the immediacy of typing, character descriptions are not written in the midst of this flow but form relatively stable pieces of text written in advance. Nevertheless, these descriptions become intrinsic parts of MUD conversations in the way they are viewed, interpreted, and commented on, even if they are always already there when the interaction takes place. Moreover, even if a description comes close to the notion of what a written text is, many of these texts borrow qualities from the informality and the immediacy of the (typed) talk surrounding them in a way that written texts normally do not. My point is that whether character descriptions are approached as texts does not necessarily imply a perspective that treats texts as objects isolated

from the social context in which they circulate. On the contrary, they could fruit-fully be understood as *literary subjects,* to be read as part of the ongoing performance of WaterMOO.

In relation to the following readings of character descriptions, an understanding of textual performances becomes particularly interesting because some of these texts are explicitly written to be *mis en scène.* Any text can be said to contain a lack, a gap that can only be compensated for through interpretation. Scripts and lyrics make this incompleteness even more obvious by providing the reader with only a textual "raw material" for staged performances. These examples can thus be viewed as textual performances in a double sense: first, by being part of the ongoing performance of WaterMOO, and second, by being the point of departure of singing and speaking voices, written to be staged.

The character "Lithium" (who introduces this section) is constructed through a part of a song by the American heavy metal band Metallica, entitled "Eye of the Beholder." It is clear that the song is no longer part of a performance of singing voices but that in fact it has become part of a textual performance. Creating a character such as Lithium is a question of choice, and most likely of taste. One strategy of interpretation is, thus, to analyze this choice against the cultural background of WaterMOO. The title alone ("Eye of the Beholder") is very fitting for a MOO character, since the activity of viewing each other through the < look > command obviously relies on how the description appears to the other, to the beholder. Moreover, an anarchist Net philosophy can be traced in lines such as: "Freedom of choice . . . Freedom of speech." But after a quick second glance, this freedom is clearly circumscribed (the same argument could go for the development of the Net with its endless possibilities for surveillance): "Choice is made for you my friend . . . Speech is words that they will bend . . . Freedom with their exception," etc. In this respect, it is important to point out that Metallica's lyrics have played an important role as a source of inspiration in the fight for anarchist values against the growing commercialization on the Net. Several pronouns, or "shifters," are introduced in the text: a "you" addressed throughout the song, a seemingly malicious "they" in the middle, and finally a speaking "I" in the very last line and whose relation to the "they" remains unclear. The I in the end could easily be exchanged to the they in the middle because both these positions in a similar manner limits the freedom of the you: "You can do it your own way / If it's done just how I [they] say."

A reading located to the borderland between performances of "real" bodies and singing voices on one hand, and textual bodies in the silence of MOOs on the other, results in manifold layers of possible positions and meanings. One way of understanding the description of Lithium is to look at it as if the song actually were being played in the MOO—as if Lithium had a MOO version of the song (by necessity, text-based and silent) ready on a virtual CD player and were playing it every time someone looked at him. For this to work, the "listener" must be familiar with the song. For WaterMOOers not familiar with Metallica or with the song in question, the text could instead be treated as if Lithium had given them a poem. Another possibility for the listener/reader is, in this way, to more directly involve

Lithium, and themselves, in the text. They can, for example, identify with the textual "you," and ascribe the "I" to Lithium. They can also visualize Lithium performing the song (reciting the poem) for them, as if he for a moment took the place of Metallica in a karaoke-like interpretation of their performance.

Descriptions of characters in WaterMOO are shifting from those arising from wild imagination, to those of everyday ordinariness, shattered by fragmentary utterances and silence. Even among characters with quotes as descriptions, there is a blend of "high art" and "popular culture," of everything from rock lyrics to Virginia Woolf and Shakespeare:

```
look Rosencrantz
```

```
What a piece of work is man! How noble in
reason! How infinite in faculties! In form and
moving how express and admirable! In action
how like an angel! In apprehension how like a
god! The beauty of the world, the paragon of
animals! And yet to me, what is this
quintessence of dust?
```

When I asked Rosencrantz about the source of this text, he answered: "Shakespeare, I would hope. Hamlet. First act, if I recall correctly," which comes through as a very different way of speaking compared with most WaterMOO conversations. This reply was a voice from within the play *Hamlet* itself, or at least from a character very much "in character." Dressed in Shakespeare's words, Rosencrantz moves through the MOO, interpreting a personal Shakespearean drama along the way. (The quote in question is actually from Act II, which might be of minor importance. On the other hand, considering the unmistakable English flavor bordering on cultural snobbism in the response, this "mistake" might turn out to be no mistake at all. Instead, this could be an expression of pride in knowing, but not really caring, about the details). As with character descriptions filled with rock lyrics, this text is written to be staged. But instead of implying a singing voice, there is here an implication of theatrically spoken words, of voices acting out their part of the dialogue. In WaterMOO, these voices will never be heard, but they may nevertheless be imaginatively present, as part of the context from where the text is borrowed.

The name "Rosencrantz" is taken from *Hamlet* as well; he is a minor character in the play. Rosencrantz, together with his companion Guildenstern, is sent to kill the prince. The problem is that they are not clever enough to follow through before Hamlet reveals their intentions. Interestingly, the quote chosen for the MOO character does not contain Rosencrantz's lines; it reflects a famous passage in which Hamlet utters these words *to* Rosencrantz. This further strengthens the notion of the quotation being a paraphrase; a somewhat vulgarized classic take-off rather than a more sincere expression of knowledge. The name Rosencrantz could also be related to a renewed interest in this character, born in Tom Stoppard's

screenplay *Rosencrantz & Guildenstern Are Dead*. In Stoppard's surreal examination of the underlying themes of Hamlet, the whole story is being retold from these two characters' point of view. Knowing this, a use of the name Rosencrantz not only alludes to Shakespeare's play; it also takes on meanings from within a framework of contemporary film and popular culture.

Rosencrantz is @gendered male, but this gender position has also been given the more specific assignment "Serendipitous." It is possible to have a character @gendered, let us say, female, and then in a more personal manner to "name" this position something else, for example "cybergrrrl." There is no @gender called cybergrrrl, but it is still possible to assign one's character with such a supplement. This activity of naming has no effect on what pronouns the MUD program uses for a certain character "in action," but these names can be seen as part of the description, as ways of giving the online body another dimension of meaning.

Serendipity, the faculty for making desirable discoveries by accident, could as a gender assignment point toward the ability of the reader to (accidentally) discover for himself or herself the gender of Rosencrantz. "Gender: Serendipitous" could in this sense indicate a playful awareness of how gender was a shifting, many-layered construct in traditional Shakespeare productions. Performing Shakespeare was traditionally a task for male actors only, whether they were enacting male or female characters. Given that female actors at the time of Shakespeare were unthinkable in his plays, cross-dressed male performers were not only common, but indispensable. When viewed from a contemporary perspective on "cross-dressing" as a strategy to make visible the body as a cultural construct, the classical Shakespearean drama is turned into a playground of gender politics: All physical bodies on stage were male, but their staged performances can be seen as an exploration of a wide range of gender positions, which in turns opens up a variety of interpretative possibilities for the audience. This complex interplay between "real life" and "play," between bodies and masks, is through the character of Rosencrantz translated into the world of WaterMOO. His online body is hard-coded as male (e.g., the MUD program will automatically attach male pronouns to Rosencrantz's utterances and movements), but the name assigned to this body in the online drama is highly ambiguous ("Serendipitous").

Besides direct quotations from literature and lyrics in WaterMOO character descriptions, there are a number of characters in the MOO who have similar texts (i.e. "literary," "poetic") attached to them, presumably written by the typists themselves. I have chosen to include these texts in this part of my analysis because they have a similar address and can thus fruitfully be incorporated in the same discussion. Here is one example:

look lafemme

```
eyes close    pearls across a naked back
standing alone with the moon  the taste
of water on my tongue    eyes open  smile
```

```
nostalgia can be a bitter thing   or it
can be the sweet fragrance of a perfect
bouquet of flowers    held in the memory
forever    moonlight glistens on wet skin
watermarks everywhere   eyes close again
```

La femme, French for "the woman," has to be remodeled to fit the computer program. As in an email address, it is not possible to leave blank spaces in the names of MUD characters, and so la femme must be rewritten "lafemme." This could have been resolved with a hyphen: "la-femme," or with an underscore: "la_femme." By choosing the compressed version, lafemme takes on the simplistic appearance of being a single word, pronounced without hesitation or even the slightest juncture between what formerly was an article and a noun. Not surprisingly, lafemme is @gendered female, and this female figure moves through virtual rooms like a floating image with diffuse borders. If many character descriptions incorporate a gaze, a certain way of looking back at the other, lafemme opens the first line by explicitly avoiding eye contact: "eyes close." But in the next instant, those "eyes open" again, followed by a "smile," and the reader is more openly invited to take part in the text, if only somewhat delayed. The text seems to be talking about loneliness, but not without sensual enjoyment, about the pain and pleasures of memories. Fragmentary pieces of sentences and body parts, like glimpses of sensuous moments, wave by. Some of these are visual, in a tangibly physical sense of bare skin: "pearls across a naked back," "moonlight glistens on wet skin." But others, as opposed to the constant flow of visual depictions in the MOO, incorporate allusions to at least two senses other than sight: Taste ("the taste of water on my tongue,") and smell ("the sweet fragrance of a perfect bouquet of flowers").

In being lafemme, the Woman, she seems to erase the diversity of *women* and in this embodies an archetypal inscription of "womanliness." Woman as an aesthetic object incarnate, lafemme moves in a world of beauty and sensuality, of pearls, moonlight, and naked skin. As a Botticelli "Aphrodite," born out of the ocean ("watermarks everywhere") she rises in front of the reader. As when the goddess of love and beauty leaves the ocean, the symbiosis with the Mother, lafemme is born (created) as a character. The description has a cyclic shape, with a beginning ("eyes close") and an end ("eyes close again") in what seems to be the same place, ready to start all over again. The text waves between a dream state ("eyes close") and a state of nostalgic awakening ("eyes open smile nostalgia can be a bitter thing"), after losing the safety of the dream. These text cycles take her in and out of waking consciousness and bodily pleasures, as if it were possible to go back to a place untouched by language after having lost all innocence in encounters with the world. The end ("eyes close again") might even suggest a wish to stay within the dream, to not leave the presymbolic "ocean."

Her description appears to occupy a position that lies between written and oral poetry. On one hand, it seems to include the shape and structure of spoken words: "eyes close pearls across a naked back standing alone with the moon," etc.

The sentences are spread out, which leaves clear in-between spaces on the screen, as if to suggest a rhythm where these spaces indicate pauses in a (typed) voice. On the other hand, the use of white spaces is also a poetry convention. Instead of indicating a voice, they could rather be understood as purely visual, like bare patches between groups of letters. It might be one of the more rhythmic descriptions in the MOO, in which not only words but the absence of words through the use of blank spaces are significant. After carefully looking at these textual voids, they turn out to be irregular in size, as to suggest different lengths of the interruptions. They could have been machine-like, born as they are from a keyboard with the possibility of exactness. Instead, they appear with human irregularity, as signs of moments of breath, as if carrying an imagined voice along the lines. It is a text that is speaking and breathing, while in a textually silent mode.

Masculinities on the Limits of Fiction

look Speedy

```
OK! Here's briefly what I look like:
I'm 5'11". . . 175lbs, mousy hair green/grey
eyes, have all my own hair and teeth, and it
covers all my head . . . hair that is, not the
teeth . . . I'm English and try to keep a
suntan for most of the year, although our
weather tries to thwart my attempts!
I live in England, a place called Manchester,
which is an inner city. I am considered to be
intelligent, but this doesn't stop me from
making mistakes from time to time, so, I also
qualify for the classification of being human
after all. I enjoy cultured, interesting and
stimulating conversation but have no time for
infantile banter . . . so you choose to which
category you belong to before entering into
any verbal intercourse!!!
If there is anything else you wish to know
then do not be afraid to ask . . . I don't
bite . . . well not too much these days!
I finally succumbed to getting something up on
the WWW so go check out my web site at
http:\\www.tjoho.tjolahopp.uk and make me
happy that my hard work has paid off . . . :)
```

In contrast to the majority of descriptions in the MOO, the character Speedy addresses its reader with an autobiographical "I" instead of a more distanced third person. The reason behind the common third-person construction is probably that characters are written for others to "look" at. By writing "he" or "she" instead of "I," they automatically fit the perspective of the other while creating a certain distance between the text and the typist. In Speedy, the "I" instead lets the reader come closer to the text than "she," "he," or "it" ever would. The I also creates a directness and intimacy in relation to the reader, as if the I and the typist were one and the same. The I also addresses a "you" in "so you choose to which category you belong to before entering into any verbal intercourse!!!" The speaking "I" hereby opens up the text and invites the reading "you" to participate in a conversation. By making suggestions for the mode of talk and encouraging questions, the description is explicitly turned into a dialogical starting point.

The text can also be read as a way of introducing a touch of Englishness within an overall American WaterMOO culture. This American dominance can be viewed as a hidden subtext in many descriptions, and in Speedy it becomes specifically clear in the lines: "I'm English and try to keep a suntan for most of the year, although our weather tries to thwart my attempts! I live in England, a place called Manchester, which is an inner city." Americanness as the norm runs like a silent stream through a majority of the texts, where, for example, not a single description starts with "I'm American . . ." In Speedy, it becomes clear that WaterMOO, if "located" anywhere, is not to be found anywhere near Manchester. Geographical place is not only explicitly stated, but it is also implied that the reader is not already supposed to know that Manchester is an English city. A certain English flavor can even be found on the subtle level of spelling in the eyes being described as "green/grey." In American English, they would have been green/gray.

By introducing a geographic location, the text is anchored in the physical world. This not only gives it a material connection; it also creates a point of reference within a culture with diffuse origins. By further incorporating a connection to a personal home page, the text is also tied to a person in a way that makes this person morally responsible for his or her actions. Regardless of whether the home page belongs to the typist or not, the text communicates a gesture toward disrupting the facelessness of the text-based virtual world.

In the creation of characters, practically anything can be written and brought to life. Many WaterMOOers, when confronted with this "limitless" opportunity to textualize themselves, choose to present themselves in a very down-to-earth and ordinary manner. This stands in sharp contrast to assumptions among several theorists working with notions of embodied identities in online contexts. They argue that online you can be anybody or anything because nobody knows who you are:

> Of all the media and machines to have emerged in the late twentieth century, the Net has been taken to epitomize the shape of this new distributed nonlinear world. With no limit to the number of names which can be used, one individual can become a population explosion on the Net: many sexes, many species . . . there's no limit to the

games which can be played in cyberspace. Access to a terminal is also access to re-
sources which were once restricted to those with the right face, accent, race, sex,
none of which now need to be declared.[18]

Confronted with the option, here formulated by Sadie Plant, to "become a popu-
lation explosion on the Net: many sexes, many species," the impersonation by far
most common in WaterMOO is the male character. In the absence of material
bodies, these characters not only introduce and define a gendered reality; they are
doing so in a surprisingly "realistic" manner:

look Jayse

```
A 24 year old graduate student from the
south. He is 6'1 with brown eyes and short
brown hair. He is sporting a goatee. He is
dressed in a bleached pair of blue jeans, a
white tee-shirt and a blue and green plaid
flannel shirt. His feet are covered in
Timberland boots. Page him and say hi.
```

In "Jayse," the very first line hides an intriguing cultural implication: "A 24 year
old graduate student *from the south*" (my emphasis). In the WaterMOO context,
this hardly points in the direction of "Skåne" (the most southern of Swedish prov-
inces), Provence, or any other southern destination in the world. "From the
south" refers most likely to the U.S. South and is an expression that reflects the
underlying, constantly present U.S. culture in the MOO. Expressions such as "on
the East Coast" and "10.30 am, central time" are common and seem to be under-
stood in the context of an American point of view.

Instead, many characters in WaterMOO are created as if this possibility were
not there, thus pushing the online "realism" even further:

look ACW

```
A thin bald guy with a mustache, 41 years
old. His sweatshirt has an emblem of three
pine trees on it. The back of the sweatshirt
is smudged with green chalk. He knows a fair
amount of math and linguistics, and is
interested in everything. Page him and strike
up a conversation.
```

Again, my point is not to speculate about whether or not this text describes the
body of the typist. It is, rather, that "A thin bald guy with a mustache, 41 years old"
who is wearing a sweatshirt "smudged with green chalk" has been created in a place
(cyberspace) where everybody can be young, beautiful, clean, and athletic. This is

not to say that everybody necessarily would *want* to be all of this when going on-line. Rather, I suggest that it is important to pay attention to a tendency that goes against the often-assumed idealization of bodies in cyberspace. As an ironic com-ment to commercials reminding us that we do not even have to "get dressed" be-fore going online to do serious business because nobody can see us anyway, "ACW" expresses an explicit lack of interest in "keeping up" even the online appearance. The irony in this is revealed in the difference between, for example, "real" hair and online hair. Many men, unavoidably, lose hair as an effect of increasing age, whereas in the MOO this is obviously not the case. Online hair, or the lack of such hair, must be typed into being to exist. To mention that everything online must be constructed in order to exist might appear as a superfluous statement, but it can be useful to point out that no matter how "ordinary" and "everyday-like" a character might look, a character description is always the product of a certain (more or less conscious) selection and creation. What at first glance might look like an ingenuous expression of the "real" is no less a construct than something more obviously "un-real" and imaginative, which is only harder to reveal as such:

> Realism involves a fidelity both to the physical, sensually perceived details of the ex-ternal world, and to the values of the dominant ideology. . . . Realism's desire to "get the details right" is an ideological practice, for the believability of its fidelity to "the real" is transferred to the ideology it embodies. The conventions of realism have de-veloped in order to disguise the constructedness of the "reality" it offers, and there-fore of the arbitrariness of the ideology that is mapped onto it.[19]

The genre of realism is traditionally related to literature of the Western world from the Renaissance and onward, characterized by its focus on individual experi-ence and bounded by its mission to represent the "real" conditions of social exis-tence. While being driven by the same philosophy as underlying bourgeois materi-alism, the reality of the realist novel is first and foremost the reality of the bourgeoisie.[20] But instead of making visible class references, realistic texts proceed as if their ideology were not there, as if their reference were nature itself. Thus, the question that needs to be asked is not "*whether* realism of this kind is an adequate mode of expression, but *for whom* it is adequate."[21] If in literature realism is the characteristically "bourgeois" mode of representation, then realism online in gen-eral, and in WaterMOO in particular, might be of a different kind. Or rather, on-line realism can be read as middle-class representations of our time, as an imagery of the (already) privileged, "connected," and computer-literate:

```
look anarchy
```

```
Ready with a joke and a laugh, Anarchy lives
up to his name in a few ways, not the least of
which is the amount of time he spends online.
He has way too much work to do to be here, but
```

```
likes it too much to give up . . . Oh Well. If
you tell a really obscure joke or reference,
he'll likely get it, or be challened into
asking what you meant. Physically, he's about
6'5, blue eyes, borwn hair bordering on
black, in OK shape except for the hint of a
spare around his middle. Ask him about
computers and he will also likely know the
answer, especially if it's a PC/Mac kind of
thing. Almost always interested in a dep
discussion. Excuse his typing; the current
telnet doesn't have a baskpace.
```

In the text of "anarchy," the name refers to online hacker ethics, a belief in a dereg-
ulation of the Net, and everybody's unlimited access to information. The first
lines, "Ready with a joke and a laugh, Anarchy lives up to his name in a few ways,
not the least of which is the amount of time he spends online," hint at the some-
times endless sessions in front of the computer, not only common but proudly re-
ferred to within these circles. The longer the sessions, the more impressive. Eric S.
Raymond, in *The New Hackers' Dictionary*, puts forth that within hacker culture
"dry humor, irony, puns, and a mildly flippant attitude are highly valued—but an
underlying seriousness and intelligence are essential."[22] This fusion of competence
and wit is running through the text such in sentences as: "Ask him about comput-
ers and he will also likely know the answer, especially if it's a PC/Mac kind of
thing. Almost always interested in a dep discussion" in which the seriousness is ef-
ficiently weakened by the (involuntary?) misspelling of "deep." The text as a whole
gives the impression of fast and slovenly writing, with spelling mistakes in every
other sentence. In the end this is explained by "Excuse his typing; the current tel-
net doesn't have a baskpace," in which the misspelling of backspace ("baskpace")
appears suspiciously conscious, as an ironic meta-comment on the problem of not
being able to erase anything of the already written (with the particular version of
telnet in use).

In looking at descriptions of male characters in WaterMOO, a majority are
written along the lines of this specific type of "realism," and one thing these texts
have in common is that they can be very hard to grasp. The fact that these charac-
ters are cultural constructs, as much as any knight in shining armor is in the same
online spaces, might at first glance be concealed by their very ordinariness. As if
they were translations of a reality not possible to interpret differently, they tend to
be rendered invisible and only revealed through deviant others surrounding them.
This is exactly what makes them interesting: the process by which they are made
almost transparent, as if they were completely natural.

Sandy Stone, in analyzing how we easily forget that online communication re-
quires sophisticated skills for participation, captures a different type of naturaliza-
tion of (some) bodies in cyberspace:

In observing social interaction in cyberspace we find that while some aspects of meaning production escape traditional cultural codings, many things in the nets are in fact naturalized; and this more subtle naturalization can easily pass unnoticed. For example, entry to the world of virtual community requires high levels of skills in the English language and a high level of technical proficiency, but this annoying fact usually passes unremarked. . . . Of course to believe that in cyberspace everyone is equal merely because the codings that have attached themselves to voice quality and physical appearance have been uncoupled from their referents, and that this uncoupling provides a sensation that might be perceived as inherently liberatory, is to misunderstand how power works.[23]

Under the erasure of the illusory equalizing interface, in which those skills and requirements necessary for participation are wiped out, everybody seems to have the same access to online means of representation. But under this surface, a wide range of knowledges and cultural belongings are hiding; these include English language skills and technical knowledge that are indispensable to partaking. Participation in online cultures demands access to computers and computer networks, which efficiently excludes an overwhelming majority of the world population. Furthermore, concrete access is evidently not sufficient, but knowledge of how to engage with the technology, and an understanding of online cultural codes, is crucial. In accordance with Stone's obsevations, this material and cultural foundation of online life easily disappears on the screen, at least for those participants for whom access to computer technology, advanced tech skills, and familiarity with online cultures are all natural.

Stone's analysis focuses primarily on how participatory prerequisites are being hidden through the process in which the textual representation is disengaged from the "real." As far as my readings go of character descriptions in WaterMOO in general, and of "realistic" male characters in particular, necessary competencies for online participation are not disengaged from but are rather *reinscribed* in the online text. Mechanisms of erasure and obscured exclusion at work to disconnect the "virtual" from the "real," can be said to be working in reverse on the level of online textuality in WaterMOO so as to *reconnect* the "real" to the "virtual." If I understand Stone correctly, it is, first and foremost, already privileged bodies who can enjoy the liberatory sensation of the "virtual" in its uncoupling from the "real." Not surprisingly, the group of people in cyberspace who has been setting and still to a large extent continues to set the tone consists of white, middle-class, well-educated, computer-savvy, English-speaking men (although the presence of other groups are growing as I type this), who precisely because of all these components can afford to set themselves free from their own groundings and move through virtual space under the illusion of equality and emancipation.[24] The above characteristics seem to be the elements which, more or less clearly pronounced, constitute the "realistic" male character. By being more or less young, white, well-educated, and computer-knowledgeable, the "realistic" male character is the visible and, at the same time, efficiently modest incarnation of the most successful cyberspace traveler.

The Female Body as Exception

```
look Kerri

She looks at you with brown, sparkling eyes.
She is almost always grinning mysteriously,
but she'll never tell why. She wears a silver
silk blouse and black pants. Her black hair
cascades over her shoulders like dark,
special chocolate.
```

In her brief analysis of female characters on LambdaMOO, Caroline Bassett notes: "The female gender on Lambda is an exaggerated phenomenon. Hyper-femininity takes various forms. These "women" display themselves in third person, with a battery of physical features. They tend to present themselves as the object of a sexual gaze."[25] In WaterMOO, rather than constituting a norm, this type of "hyperfemininity" belongs to the exception. Many female characters might contain physical features, but few give the impression of being shaped as objects for a sexual (male) gaze. In this regard, "Kerri," dressed in "silver silk blouse and black pants," is certainly a borderline case. With "brown, sparkling eyes" she meets the eye of the reader, ready to toss her black hair while it "cascades over her shoulders like dark, special chocolate." These lines fit neatly within a heterosexual frame of beauty in which female bodies are molded to please male fantasies. Through the writing of a distanced third person, "Kerri" is reflecting herself and is herself being created within this very reflection. By creating a perspective in which she appears to be watching herself through an imagined male gaze, the body created by the text unfolds in a somewhat objectified manner, ready to be admired. The only element that might disturb this image of ingratiating femininity lies in the way "she is almost always grinning." Along the lines of female passivity and becoming moderation regularly associated with representations of women, Kerri would probably have been more "appropriate" furnished with a smile.

Electronic media artist Nancy Paterson, in her online article "Cyberfeminism," describes how a twenty-first-century Pandora, a powerful bitch/goddess and android infiltrates the imagery of the Net. The number of erotic representations of women, textually or visually floating around in cyberspace in a way in which sex and danger are linked to women and machines, are countless. This representational linkage of sexually dangerous women to disastrous cultural implications of new electronic technologies can be traced all the way back to 1927 with Fritz Lang's *Metropolis*, but its presence has seldom been more obvious than in the era of the Internet. Or as Paterson puts it: "Cyberfemmes are everywhere, but cyberfeminists are few and far between."[26] These patriarchal representations of femininity occupy the space in which women could be defining themselves and their own relationships to new technologies.

Nevertheless, these fusions of female sexuality and high technology that are very common, for example, in computer games, are hardly present at all in Water-MOO.[27] Even if gender appears to be a core issue for the participants, the exaggeration of gender in the creation of the online body, which several other researchers refer to, does not seem to be as prevalent here.[28] Rather than alluding to the type of hyperbolized images of women discussed above, "women" in the MOO are shaped through an openly sensuous, erotic vocabulary usually written in a very different mode:

look Suzanne

```
A 29 year old, who neither looks nor feels
like her age. Nor acts it (see, you can
interpret that two ways). Slender, dark-
haired and dark-eyed, her permanent half-
smile seems to suggest she knows or has
secrets she isn't likely to reveal. And if
you can't take sarcasm or cynical wit, you
better stay away from this lady.
She leans towards you and whispers, "Real
women don't have hot flashes, they have power
surges."
You see Suzanne (tough cookie) here, but is
she *really* here?
Carrying:
Official Dykes of WaterMOO badge
```

Embodying self-confidence, humor, and wit, "Suzanne" proceeds through the MOO as the "tough cookie" she is. Certain ambivalence is introduced between her age, given as 29, and the hint at "hot flashes" (here transformed into the more positively loaded "power surges"!) normally associated with older women. The sense of doubleness that follows online participation as one simultaneously inhabits both material and textual realms is implied in: "You see Suzanne (tough cookie) here, but is she *really* here?" Suzanne of WaterMOO is certainly here, in text, but the question seems to be: Where does she end? Just as communication technologies can be viewed as prosthetic extensions of physical bodies, MUD characters can be interpreted in the opposite direction. They could be seen as prosthetically extended in text, in the direction of the keyboard and the typist who provide them with necessary material groundings.

By carrying an "Official Dykes of WaterMOO badge," this text marks a different sexuality in the overall (silently) heterotextual spaces of WaterMOO. Nina Wakeford, in her investigation of bodies in cyberspace, shows how "textual body-work" is performed on "Sappho," which is the name of an online discussion list with a majority of lesbian-identified subscribers. In contrast to a view of cyber-

space as disembodied, the participants on Sappho inscribe their physical bodies and cultural identities in several ways in their postings. One way to perform a lesbian body on the list is through the use of feminist and/or lesbian signatures in the end of the message. The signature might include personal information, such as name, address, and a quotation of a central character in lesbian culture. Through interpretation of these postings, "bodies on Sappho actively subvert the norm of dominant heterosexuality in computer-mediated communication by the use of references to lesbian cultural practices."[29] Textual activities on Sappho thus not only introduce bodies in text by its (supposedly) female users; they also create a space of resistance at the margins of cyberspace. In a similar manner, Suzanne, by deviating from an unspoken heterosexual norm in the MOO, is making this norm visible.

In comparing male and female characters in the MOO, male characters are overall more similar to each other than female characters are to each other. Moreover, the fact that male characters are much more numerous makes this tendency toward uniformity strikingly clear. By being the great majority, the male character constitutes a visible norm from which other characters are deviating, more or less automatically:

look Izha

```
Izha is a slender woman of medium height,
with long black hair and eyes like cinders.
Her skin is dark, arabic, and her face is
painted in the style of Aegypt. Silver
pierces her ears, her nose, her tongue, and
dangles from her throat in a liquid seeming
chain set with black stones.
```

"Izha" not only differs from this male norm by being a woman; she is also different by being a woman of color, or at least not completely "Caucasian." The fact that "Her skin is dark, arabic" stands in sharp contrast to the overwhelmingly (textually) white population in this particular online world, marking otherness but also making visible a differently "colored" participation. Similar to the creation of *heterotextuality*, the constitution of WaterMOO as textually white is not grounded in frequent, *explicit* references to whiteness in the descriptions (even though this occasionally occurs). Instead, this assigning to characters what seems to be a fairly pale complexion is rather accomplished on a more modest symbolic level, through logical implications of hair and eye color. Put differently, the color of characters' skin might not even be mentioned, but texts that so frequently create characters as either blue-eyed and/or blond presupposes white bodies. Not a single character (implicitly or explicitly) is black. The writing of "difference" in the creation of female characters points in several directions. Categories that are more or less hidden in most character descriptions in the MOO, such as sexuality, race, and age, are explicitly exemplified in the descriptions of female characters.

In contrast to theorists proclaiming a belief that online gender can take on any form desired, Lori Kendall is one of those who expresses skepticism as to what can be changed through online performances. She believes that the specific atmosphere in MUDs crucially limits the type of identities that can be created in these spaces. Where subcultural norms, together with technical limitations, constitute the basic conditions, gender performances on MUDs are at risk of being forced into stereotypical caricatures:

> Although individuals can choose their gender representation, that does not seem to be creating a context in which gender is more fluid. Rather, gender identities themselves become even more rigidly understood. The ability to change one's gender identity online does not necessarily result in an understanding that gender identity is always a mask, always something merely performed. . . . Further, what I've found is that the standard expectations of masculinity and femininity are still being attached to these identities.[30]

Because we expect everyone to be either male or female in "real" life, Kendall claims that choosing an unusual gender will not be effective. If someone encounters a character who has set the gender to "spivak" and uses the pronouns *e, em, eir, eirs,* and *eirself,* he or she is not likely to believe that this represents the "true" gender, which turns the presentation into a useless mask. In relation to my own experiences in WaterMOO, this argument is quite fitting because it puts forth how the possibility to change gender online, or create a new one altogether, does not automatically lead to a widespread notion of gender as fluid. Quite on the contrary, in a space like WaterMOO where a majority of characters are male, and only a very small portion something other than male or female, creations of gender-transgressive bodies do not seem to be encouraged. On the other hand, the fact that most characters are either male or female does not necessarily lead to gender becoming "even more rigidly understood." And if "standard expectations of masculinity and femininity" are found attached to online bodies, an interesting issue would be to explore what these masculinities and femininities consist of.

As in the writing of male characters, notions of "realism" are occurring among female characters as well but as in the case of "Odette," in a somewhat different direction:

look Odette

You see a middle-aged woman wearing a pair of comfortable stretch pants and an even more comfortable sweater. Her hair is dark brown and her eyes are blue. She also wears a ready smile, and is waiting to say hello, should you want to speak to her. Her interests are many and varied, such as British literature,

> history, genealogy (study of family history),
> foreign language, she is attempting to learn
> French—without much success :(, she is
> somewhat shy, but really does like people :)
> She is also a born-again Christian, but does
> not feel that that makes her better than
> anyone, it's just the path she chose to
> believe in God. She is most interested in
> learning about other religions, and other
> cultures. She believes true understanding
> comes from learning about other people.

In contrast to the writing of young bodies in the MOO, "Odette" stands out as being "a middle-aged woman wearing a pair of comfortable stretch pants and an even more comfortable sweater." Instead of filling the description with physical features, as Bassett found to be the norm in LambdaMOO, this lady rather consists of formulations concerning interests in Christianity and different cultures: "she is attempting to learn French—without much success :(" (the symbol typed in for a frowning face shows the disappointment in this failure). But even if the text is fully expressive, a somewhat passive position is taking shape: "She also wears a ready smile, and is waiting to say hello, should you want to speak to her. . . . she is somewhat shy, but really does like people :)". As far as one can get from the sexually explicit, half-naked versions of women so common in online imagery, "Odette" could be the mother of grown-up children, who, instead of taking care of others and her looks, is fulfilling herself.

Interpreting cultural meanings of male and female bodies is a tricky practice, not least with an attempt to avoid pre-defined categorizations and assumptions, treating both material and textual realities in sensitive ways. To liberate oneself as a reader from dominating cultural understandings of "traditional" femininities and masculinities on one hand, and from "new" and "unexpected" ones on the other, is a nearly impossible work. Nevertheless, a world of multiplicity and chaos is never that clear-cut, and once an interpretation seems to do the text some justice, something new that demands a new reading comes up, a different perspective. As if texts, constantly, were resisting, they will always keep moving and will invite readings of both coherences and ruptures.

@Gender Other

Although gender in studies of online cultures is often found to articulate traditional gender positions, Shannon McRae gives in her article "Coming Apart at the Seams: Sex, Text and the Virtual Body" a very different picture. She argues that a choice of one of the alternative genders offered by some MUDs can be a way to avoid traditional gender assumptions. In her investigation of virtual bodies and

"netsex," she has found that, for instance, the spivak gender "has encouraged some people to invent entirely new bodies and eroticize them in ways that render categories of female or male meaningless . . . a spivak can have any morphological form and genital structure e devises for emself."[31] In a text-based virtual world, netsex can be described as collaboratively typed-in erotica where typists by moving their characters' textual bodies engage in sexual acts and enactments.[32] The creation of alternative genders illustrates how netsex, rather than being merely a sexual act, is to a great extent an act of creative reading and writing. Rather than being a crucial part of human identity, gender is altered into a mere abstraction, one of several features of the bodies that are written.

Gender on WaterMOO does not seem to be an abstraction; it is, rather, a (textual) reality, which conversations and relationships develop from. Most characters are @gendered male or female, but there are some exceptions:

```
look leighloo

delicious sadist; Unseeling faerie perched
angelicly atop the 666 building peering down
upon the frantic streams of idiocracy flowing
through the viens of the metropolis.{so much
blood} Tightly clad in a suit of metallic
blue, fluttering eir fiber-optic razored wings;
E is entranced by the faint whisper of a
pulsar star . . . somewhere . . . somewhere
. . . its calling . . .
leighloo's vampiric powers wrap em in shadow.
You can see no more from here.
```

"leighloo" is @gendered spivak (described as "an indeterminate gender" in the help texts), which becomes visible in "*E* is entranced" and "leighloo's vampiric powers wrap *em* in shadow" (my emphasis). In a colorful, fragmented imagery of a faerie's perspective of the pulsating madness of humanity, the text refuses the reader's search for innocent wholeness through its dissolving of clear boundaries. "Tightly clad in a suit of metallic blue, fluttering eir fiber-optic razored wings," "E" resists from its in-between, unfixed position any singular determination of gender and sexuality.

In a sense, MUD characters @gendered "other" wander virtual spaces as textual incarnations of Donna Haraway's mythical cyborg, offering alternative ways of seeing and being in the world. A cyborg is a fusion of human and technology, of machine and organism, combining elements that are both organic and inorganic in a sense that blurs the boundary between areas that are traditionally thought of as separate. In Haraway's understanding "s/he" is a social reality as well as a fiction, where the boundary between "real" and "virtual" is an illusion. Haraway uses the cyborg as an alternative figure of thought, a powerful political fiction that shatters

the dichotomous categorizations of Enlightenment epistemology, such as mind/body, organism/machine, public/private, culture/nature, civilized/primitive, and centrally, man/woman, male/female, masculine/feminine.[33] The strength of a cyborg understanding of textual characters in computerized environments lies in the way cyborgs, through their constantly moving borderland bodies, are both flesh and imagination, nature and culture. There are at least two ways of interpreting cyborg imagery. First, the connection between human and machine might be located within the body, surgically refigured through technological inscriptions. This fusion is vividly imagined and illustrated in films such as *Terminator* and *Robocop,* but it is also part of everyday life in the shape of transplants, implants, artificial limbs, etc. But cyborgs could also be understood in reverse, through an inscription of physicality into the immaterial reality of textual beings. In this second sense, the cyborg is integrated in an abstract flow of information, and the border between a physical body and its prosthetic extension through technologies is rather socially and culturally constructed.

On the other hand, the fact that a creation of an online body @gendered "other" is only a few keystrokes away does not necessarily lead to this being a common creation. Neither is the writing of an other-gendered body automatically subversive, leading to a notion of gender as fluid in the online world. On the contrary, the naming, @gendering, and writing of characters in WaterMOO rather seem to point toward notions of stability, through the construction of nonsurprisingly gendered male and female characters. Instead of using the Net as a place for liberating transgressions and textual deconstructions of the physical body, most WaterMOOers tend use the text to put the gendered body back into the picture, inevitably dragging a whole battery of cultural meanings with them. But at the same time, instead of reading as exaggerations of gendered bodies, WaterMOO characters seem concerned with conversational strategies. These texts clearly and often invite the other not only to interpretation but to *participation*. Instead of turning themselves into physical or literary objects to be gazed at or read in solitude, they born as they are out of the encounter with others actively disrupt such understandings by embodying speaking subjects. By explicitly addressing and challenging the reader to speak, these texts are turned into dialogical starting points—into written voices to be read, or maybe listened to, in a flow of typed utterances.

Notes

1. Hayles (1996, pp. 1–2).
2. This is a description of a character from the type of text-only virtual environments known as MUDs. A character description is part of how participants present themselves to each other and are available to others through the <look> command. When I type "look Raechel," the description that belongs to this character enters my screen and gives this character a textual appearance.

3. Braidotti, < http://www.let.ruu.nl/womens_studies/rosi/braidotı.htm > under "The politics of the parody." For a discussion of the philosophy of "as if," see also Braidotti (1994, pp. 173–190).

4. For good introductions to MUDs and MUDding, as well as helpful historical overviews, see Turkle (1995) and Cherny (1999).

5. Reid (1995, p. 179).

6. This set of pronouns clearly plays with the possibilities of the keyboard and with the fact that text-based online cultures do not need to be pronounceable. They only need to be "typable"!

7. Turkle (1995, p. 181).

8. See Ito (1997), and Radway (1984).

9. Ito (1997, p. 92).

10. Ibid., p. 93.

11. See, for example, Baym (1998), Correll (1995), Markham (1998), Paccagnella (1997), and Reid (1994).

12. In a MUD-FAQ (list of frequently asked questions) for the newsgroup rec.games.mud, the following can be found on what a wizard on a TinyMUD (for example a MOO) is: "Wizards . . . are the people who own the database. They can do whatever they want to whomever they want whenever they want. A more appropriate name for them would be 'Janitor,' since they have to put up with responsibilities and difficulties (for free) that nobody else would be expected to handle. Remember they're human beings on the other side of the wire. Respect them for their generosity."

13. With "active" participants, I here mean those who on a fairly regular basis take part in the activities of WaterMOO, and who are known to other participants (as opposed to temporary visitors and experimenters).

14. For an elaborate discussion of the complicated dance between typist and character in online conversations, see Sundén (forthcoming, 2002a).

15. Frith (1996, p. 158).

16. Ibid., p. 166.

17. Ibid., pp. 183–202.

18. Plant (1997, p. 46).

19. Fiske (1987, p. 36).

20. See, for example, Fiske (1987), Fiske and Hartley (1978), and Boumelha (1988).

21. Fiske and Hartley (1978, p. 163).

22. Raymond (1991, p. 20).

23. Stone (1995, p. 181).

24. For Internet demographics, see, for example, < http://www.geog.ucl.ac.uk/ casa/martin/geography_of_cyberspace.html > and < http://cyberatlas.internet.com/ > The problem with these, and similar sites, is that it often remains unclear how the results were achieved. Considering that the Internet covers immense territories, extremely hard to grasp, these statistical figures cannot be regarded as anything other than estimates. Nevertheless, after having checked many sites, not only those mentioned above, I have found these results to be in accordance with what I present in this text.

25. Bassett (1997, p. 547).

26. Paterson (1996).

27. For an interesting discussion on gender and computer games, see Jenkins and Cassell (1998).

28. For discussions of gender online as exaggeration, see, for example, Bassett (1997), Kendall (1996, 1998), Kramarae (1995), O'Brien (1999), Rheingold (1994), Slater (1998), and Stone (1992).
29. Wakeford (1996, p. 102).
30. Kendall (1996, pp. 221–222).
31. McRae (1996, p. 257).
32. For discussions of netsex, see, for example, Branwyn (1994), Hamman (1996), Reid (1994, pp. 75–95), and Sundén (forthcoming, 2002b).
33. Haraway (1991). For a discussion of cyborg imagery in "cyberfeminism," see Paterson (1996), (Sofia (1992), and Sundén (2001).

References

Bassett, Caroline. "Virtually gendered. Life in an online world." In *The Subcultures Reader*, edited by Ken Gelder and Sarah Thornton. London: Routledge, 1997.
Baym, Nancy. "The Emergence of Online Community." In *Cybersociety 2.0. Revisiting Computer-Mediated-Communication and Community*, edited by Steve Jones. Thousand Oaks, Calif.: Sage, 1998.
Boumelha, Penny. "Realism and the ends of feminism." In *Grafts: Feminist Cultural Criticism*, edited by Susan Sheridan. London and New York: Verso, 1988.
Braidotti, Rosie. *Nomadic Subjects. Embodiment and Sexual Difference in Contemporary Feminist Theory*. New York: Columbia University Press, 1994.
———. "Cyberfeminism with a difference." < http://www.let.ruu.nl/womens_studies/rosi/braidot1.htm > Available 28 February 2001.
Branwyn, Gareth. "Compu-Sex: Erotica for Cybernauts." In *Flame Wars: The Discourse of Cyberculture*, edited by Mark Dery. Durham: Duke University Press, 1994.
Bruckman, Amy. "Gender Swapping on the Internet." (1992). < http://www.cc.gatech.edu/fac/Amy.Bruckman/papers/index.html#INET > Available 12 December 1998.
Cherny, Lynn. "Gender Differences in Text-Based Virtual Reality." (1994). < http://www.research.att.com/~cherny/genderMOO.html > Available 12 December 1998.
———. *Conversation and Community. Chat in a Virtual World*. Stanford: CSLI Publications, 1999.
Correll, Shelley. "The Ethnography of an Electronic Bar: The Lesbian Café." In *Journal of Contemporary Ethnography* 24, no. 3 (1995).
Fiske, John. *Television Culture*. London: Methuen, 1987.
Fiske, John and John Hartley. *Reading television*. London: Methuen, 1978.
Frith, Simon. *Performing Rites: On the Value of Popular Music*. Cambridge, Mass.: Harvard University Press, 1996.
Hamman, Robin B. Cyborgasms: Cybersex Amongst Multiple-Selves and Cyborgs in the Narrow-Bandwidth Space of America Online Chat Rooms. MA thesis, Department of Sociology, University of Essex, 1996. < http://www.socio.demon.co.uk/Cyborgasms.html > Available 16 July 2001.
Haraway, Donna. "A Cyborg Manifesto: Science, Technology, and Socialist-Feminism in the Late Twentieth Century." In *Simians, Cyborgs and Women: The Reinvention of Nature*, edited by Donna Haraway. New York: Routledge, 1991. < http://www.leland.stanford.edu/dept/HPS/Haraway/CyborgManifesto.html > Available 28 February 2001.

———. *Modest_Witness@Second_Millennium: FemaleMan© _Meets_OncoMouse™*. London and New York: Routledge, 1997.

Hayles, Katherine N. "Embodied Virtuality: Or How to Put Bodies Back into the Picture." In *Immersed in Technology: Art and Virtual Environments,* edited by Mary Anne Moser and Douglas MacLeod. Cambridge, Mass.: MIT Press, 1996.

Ito, Mizuko. "Virtually Embodied: The Reality of Fantasy in a Multi-User Dungeon." In *Internet Culture,* edited by David Porter. London and New York: Routledge, 1997.

Jenkins, Henry and Justine Cassell. *From Barbie to Mortal Kombat : Gender and Computer Games.* Cambridge, Mass.: MIT Press, 1998.

Kendall, Lori. "MUDder? I Hardly Know 'Er! Adventures of a Feminist MUDder." In *Wired Women,* edited by Lynne Cherny and Elizabeth Reba Weise. Seattle: Seal Press, 1996.

———. " 'Are You Male or Female?' Gender Performances on Muds." In *Everyday Inequalities: Qritical Inquiries,* edited by Jodi O'Brien and Judith A. Howard. Malden, Mass. and Oxford, UK: Blackwell Publishers, 1998.

Kramarae, Cheris. "A Backstage Critique of Virtual Reality." In *Cybersociety,* edited by Steve Jones. Thousand Oaks, Calif.: Sage, 1995.

Markham, Annette N. *Life Online: Researching Real Experience in Virtual Space.* Walnut Creek, Calif.: AltaMira Press, 1998.

McRae, Shannon. "Coming Apart at the Seams: Sex, Text and the Virtual Body." In *Wired Women,* edited by Lynne Cherny and Elizabeth Reba Weise. Seattle: Seal Press, 1996.

O'Brien, Jodi. "Writing in the Body: Gender (Re)production in Online Interaction." In *Communities in Cyberspace,* edited by Marc A. Smith and Peter Kollock. London and New York: Routledge, 1999.

Paccagnella, Luciano. "Getting the Seats of Your Pants Dirty: Strategies for Ethnographic Research on Virtual Communities." Journal of Computer-Mediated Communication 3, no. 1 (1997). <http://www.ascusc.org/jcmc/vol3/issue1/paccagnella.html> Available 15 October 1998.

Paterson, Nancy. "Cyberfeminism." (1996). <gopher://echonyc.com/oo/Cul/Cyber/paterson>. Available 26 April 1998.

Plant, Sadie. *Zeros + Ones: Digital Women + The New Technoculture.* New York: Doubleday, 1997.

Raymond, Eric S. *The New Hackers' Dictionary.* Cambridge, Mass.: MIT Press, 1991.

Reid, Elizabeth. "Cultural Formations in Text-Based Virtual Realities." (1994). <http://people.we.mediaone.net/elizrs/cult-form.html> Available 12 December 1998.

———. "Virtual Worlds: Culture and Imagination." In *Cybersociety,* edited by Steve Jones. Thousand Oaks, Calif.: Sage, 1995.

Rheingold, Howard. *The Virtual Community: Homesteading on the Electronic Frontier.* New York: HarperPerennial, 1994.

Sofia, Zoë. "Virtual Corporeality: A Feminist View." In *Australian Feminist Studies* 15 (1992).

Stone, Allucquère Rosanne. "Virtual Systems." In *Zone 6: Incorporations,* edited by Jonathan Crary and Sanford Kwinter. New York: Zone, 1992, distributed by The MIT Press.

———. *The War of Desire and Technology at the Close of the Mechanical Age.* Cambridge, Mass.: MIT Press, 1995.

Sundén, Jenny. "What Happened to Difference in Cyberspace? The (Re)turn of the She-Cyborg" in *Feminist Media Studies* 1, no. 2 (2001).

———. " 'I'm still not sure she's a she': Textual Talk and Typed Bodies in Online Interaction."

In *Talking Gender & Sexuality: Conversation, Performativity and Discourse in Interaction,* edited by Paul McIlvenny. Amsterdam and Philadelphia: John Benjamins, forthcoming, 2002a.

———. *Material Virtualities: Approaching Online Textual Embodiment.* New York: Peter Lang, forthcoming, 2002b

Turkle, Sherry. *Life on the Screen. Identity in the Age of Internet.* New York: Simon and Schuster, 1995

Wakeford, Nina. "Sexualized Bodies in Cyberspace." In *Beyond the Book: Theory, Culture, and the Politics of Cyberspace,* edited by Warren Chernaik, Marilyn Deegan, and Andrew Gibson. Oxford, UK: Office for Humanities Communication Publications, 1996.

CYBERZINES: IRONY AND PARODY AS STRATEGIES IN A FEMINIST SPHERE

In the early days of the Internet, most users were North American white males. In the mid-1990s, researchers in gender studies reported the online harassment of women and women's feelings of exclusion (Cherny and Reba Weise 1996). Even though sexism on the Net is far from ended, the situation is quite different. On the Net, one can find everything conceivable, including women-centered material and feminist communities (Hawthorne and Klein 1999). One of these is the genre of the grrlzine, the playful Web magazines directed toward a young female audience. Here, I will analyze eleven grrlzines from North America, Sweden, and Australia, all of which have connections to what is often called the third wave of feminism.[1]

These publications transgress several borders. I will discuss the transgression of borders between Web sites in the section about hypertextuality. Links between different Web sites create connections between them, putting in question where a site actually starts and ends. Also, the borders between producer and writer and between user and reader are challenged in interactive Net media such as the grrlzine. Here, users get a chance to coproduce the media texts and also to interact with other users. One of the most important borders crossed is the one between commercial popular culture and the political movement of feminism. The grrlzines, in the same manner as women's magazines, use the generic conventions of female popular culture, but are less restrictive when it comes to gender norms and roles. An important tactic used to do this is the use of irony and parody.[2]

In many cases there is an obvious use of irony. To be ironic is to apparently say one thing but to mean something else; words, therefore, have at least two different meanings. The names of grrlzines are often ambiguous, carrying several different meanings.[3] One, *Riotgrrl,* is named after the Riot grrrl movement.[4] This connotes

subversive punk rock and young feminism. To riot is to quarrel, publicly dispute (i.e., a riot of color), to disturb the peace, but it also has other possible meanings such as debauchery, excess, and extravagance. To "riot in" can mean to take great pleasure in something, or it can also mean unrestrained revelry or merrymaking. Riot consequently connotes both disturbance and uproar, but also excess and extravagance. Most of these meanings signify traits or activities usually seen as inappropriate for girls. The use of the word "riot" can thus be seen as a rejection of the female gender role in patriarchal society.[5] Another webzine is called *Bust,* a word that means both torso and the breasts of a woman. But it can also mean (as a verb) to hit, pinch, slug, punch, or sock (in the nose). One can also "get busted" (be caught) or "go bust" by becoming bankrupt or broke. Here the use of the word "bust" can be seen as a particularly successful form of feminist irony. The word denotes both a body part and its measurement; in Western society the attractiveness of a woman can include the size and/or form of her bust. But the word also has a more aggressive meaning: to hit somebody. To "get busted" also has connections to the world of crime, which is seen as *un*feminine.

Finally, I will analyze the grrlzine *Geekgirl.* Originally, the "geek" was a fool employed by carnivals in the United States to bite the heads off live chickens or snakes, a figure that can be seen as the lowest of the low. Later on, boys who were academically successful but also had peculiar hobbies such as stamp collections or computer programming were referred to as geeks. With the advent of information-network society, geeks interested in computers became rich and achieved a high status. The traditional (computer-) geek is male, and therefore a female geek is often seen as an anomaly. The name *Geekgirl* is hence an attempt to reverse sex roles and cover new grounds for girls.[6]

Accordingly, I will explore the reuse of old conventions and images in an ironic or parodic way. Here, borders between old and new are transgressed and the resulting mix forms a kind of collage, montage, or bricolage. Therefore, I will discuss the older genres or media forms related to the grrlzines.

Forerunners of Today's Grrlzines

Three main traditions are the forerunners of the grrlzine: the alternative press with its self-published material, fanzines, and the women's magazine. Stephen Duncombe (1997) has conducted the first comprehensive study of fanzines. Duncombe sees the roots of the zine in political pamphlets and recognizes its congeniality with the underground press of the 1960s and its future on the Web pages, BBS's and newsgroups of the Internet. Fanzines are noncommercial; they are made by amateurs and are often produced and distributed by a single person, usually in a very limited edition. The fanzine saw the light of day in the United States in the 1930s. Science fiction fans started publishing their own magazines that soon came to be called fanzines—a fusion of "fan" and "magazine." In the mid-1970s, the punk fanzine followed. The fanzine form fits the do-it-yourself ideology of the

punk rockers, hand in glove. Today there are fanzines within a wide range of subjects. The shorter term "zine" has emerged to cover a broader range of self-published journals. According to Baym (1998: 4), many of the acronyms that are common on the Internet originate from early science fiction fanzines. This pinpoints how important fan cultures and their fanzines have been for the development of Internet culture.

The fanzine, however, has even more ancient historical roots—in self-publishing and political pamphlets. Self-publishing is a practice that has been common since Gutenberg invented the printing press with moving type in the late fifteenth century. In the early days, when there was not yet a institutionalized publishing system, every author was a self-publisher. The ideas of Jürgen Habermas (1962/1989) concerning the bourgeois public sphere and its transformations are relevant in the discussion about the history of print media. The printed pamphlets, literary works, and periodicals were, together with certain locales such as coffeehouses or clubs, one of the necessary conditions for a reasoning public. The idea of the public sphere, which has had great influence among media scholars, is also highly relevant to cybercultural studies in which news groups and other forums have been seen as "virtual coffeehouses" or places for democratic discussions (Connery 1996).

The other important tradition that has played a role for the grrlzine is the women's magazine. The first magazine for a female audience was *The Ladies' Mercury*, first published in 1690. The women's magazines did not become popular until the end of the nineteenth and the beginning of the twentieth century when they became an industry, thanks to advertising. Women were considered an important consumer group because they were responsible for the acquisition of everyday commodities (White 1970). According to Habermas, the commercialization of media led to a decline of this public sphere and the public became passive consumers of culture and media instead of active debaters.

During the last years of the eighteenth century, periodicals for a female audience were published in Sweden, too. But it was family-oriented journals such as *Illustrerad Familje-Journal* (Illustrated Family Journal), established 1879, that made the women's magazine a popular genre in Sweden (Larsson 1989). A related and particularly relevant genre is the girl's magazine, i.e., a women's magazine intended for a young female audience. A Swedish example of the genre is *VeckoRevyn* (see Hirdman 1996).

Feminists have realized the importance of creating their own, alternative media since the beginning of feminism. Linda Steiner (1992) describes the development of feminist media during the last 250 years. The American suffragettes had been dependent on periodicals to communicate and bind together the feminist movement over the spacious American continent since the nineteenth century. Today there are feminist magazines all over the globe. The magazine with the biggest circulation, *Emma*, is German, and the oldest now existing feminist magazine, *Hertha*, is published in Sweden. There are many feminist publishing companies and distribution channels all over the world.

The Riot grrrl movement was started by girls in punk rock, as a mixture of punk rock and feminism. Some of their ideas were that women should make fanzines, organize punk shows, and play in bands. Examples of the latter are Bikini Kill and Bratmobile (See *Riot grrrl*, at the Web site dictionary of popular culture: *Altculture*). Riot grrrl is not an organized movement, and Riot grrrls do not consider themselves a homogenous group with one single goal. Every woman may call herself a Riot grrrl, and also define what Riot grrrl means, and the movement itself should be seen as a common platform for communication (Duncombe 1997: 65–70). Together with a wide range of grrlzines, *Riotgrrrl* has a place on the Net. A practical reason for using the word "grrl" in the URLs of the Internet is to show that these sites are not about pornography or sex, something which is widespread on the Net (Wakeford 1997: 60).[7] But the origin of this alternative spelling can of course be found in the Riot grrrl movement, which originated outside the Internet. A reason for this was to give the word girl, which denotes a young woman and in our society connotes powerlessness and weakness, new connotations, such as anger and strength. Onomatopoetically, the word "grrrl" sounds like a growl from a wild and dangerous animal. Even though this could sound somewhat sexual in nature, it is important to point out that the alternative spelling does not imply that young women are sexual objects, even though they of course can be sexual *subjects*.

Ezines, Webzines, and Grrlzines

Magazines distributed electronically on the Internet have come to be called ezines. In the early stages of the Internet, ezines were distributed as text documents via email or Usenet and gopher servers. But with the World Wide Web came the possibilities to publish HTML-documents with pictures and more advanced text formatting.[8] The magazines published with this new technology were called webzines. The difference between the terms "ezine" and "webzine" is that the former covers all magazines distributed on the Internet, and the latter just the ones on World Wide Web (McHugh 1996). One of the genres within ezines or webzines is the feminist grrlzine. They have been described by Nina Wakeford (1997) and by Krista Scott (1998).

I conducted an Internet search for "grrl" in March 1999. Yahoo gave some 70 matches, Altavista and Webcrawler yielded almost 200 each, and Excite and Lycos each identified more than 1,000 occurrences. On Excite, some 40% of this references were commercial sites or newsgroup messages; personal home pages and music related sites accounted for 15% each, and the remaining 275 matches were related to grrlzines or other feminist grrl movement activities. The many matches indicate that "grrl" is a common term on the Net. Besides musical performance references, the word is often used in aliases in chat rooms or on personal home pages, where names such as Fan Grrl, Party Grrl or Space Grrl are used. There were no hits on pornographic sites.

As a guide to the grrlzines on the Internet, the Web ring/portal *Chickclick* was

used in the study.[9] Six of the analyzed webzines are members of this Web ring (*Bust, Disgruntled Housewife, Razzberry, Riotgrrl, Smile and act nice,* and, of course *Chickclick* itself). The reason for their inclusion was that they covered general subjects and were women-centered, but also that they seemed to be mature publications. Two sites identified as central in the grrlzine community were added: the Australian grrlzine *Geekgirl* and the New York–based *gURL*. The inclusion of three Swedish publications, *Darling, Lumumma,* and *Corky,* all from a small country which is often (by North American ebusinesses but even more by the Swedes themselves) considered to be in the frontline of new digital technology, counteracts the Anglo-American centeredness of computer mediated communication (CMC) and cybercultural research. As a result, a total number of eleven webzines were investigated (seven United States, one Australian, and three Swedish).

In the genre of grrlzines, there is an oscillation between features very similar to those in more traditional women's media and features that offer more innovative elements. The latter are both generic and technological and relate to content as well as form. The new technological advantages of the Internet are used to different extents and in different ways. The next section of this article will describe how the grrlzines use such new possibilities, especially hypertext and interactivity. Like all technologies, they also have crucial implications for the meanings and the forms of the media texts they enable; I will discuss these in the last two sections.

Uses of Technology for Networking and Interaction

The Internet is a relatively recent medium, or perhaps rather *set* of media, and like all new media, it offers certain technological possibilities and advantages compared with older media. First, linking offers new possibilities both for reading and choosing between texts, as well as ways for Web producers to build networks and show kinship with other Web sites. Second, the grrlzines in varying ways and to various extents use the different interactive possibilities offered by digital technology.

Hypertextuality

Hypertext or links characterize the Internet, and this has been theorized thoroughly.[10] A hyperlink is a text which, when selected, leads to another page, or place on a page, on the Web. This can either be on the same site or even document, or on a different web site. Links that lead to other Web sites will here be referred to as *links out*. They invoke the concept of intertextuality (Fornäs 1995: 205). Links out are frequent in almost all grrlzines. Often they are gathered on certain link pages. A webzine that defines itself through the use of links is *Geekgirl* (no. 1, April–June 1999). This Australian grrlzine has been online since 1995, and it is hence is one of the pioneers among feminist Web sites. It calls itself "the world's first cyberfeminist hyperzine." The word *hyperzine* follows the concept of hypertext. The April–June 1999 issue is composed mainly of listed world events, related

to art, feminism, science, technology, and activism. There are also many links to other Web pages, together with articles about events from different places. This issue of *Geekgirl* can be seen as a global publication, that relates itself to both the Internet world and offline issues and events, thus forming a kind of "supersite" (Klein 1999).

Relations of Hyperlinks

To understand links and networks, theories about the public sphere and ideas about online cooperation and networking are helpful. The idea that there is, and should be, one single public sphere has been questioned by feminists and others. According to Nancy Fraser (1997), subordinate groups, for example young women, are disadvantaged in the bourgeois public sphere, both because they tend to be portrayed stereotypically and because they cannot participate in it as equals. Therefore, these groups have created alternative publics, spaces that Fraser calls *subaltern counterpublics*. Here, participants can oppose stereotypical descriptions and form alternative identities. This can be done inside the counterpublic itself, but the process may also be directed outwards to the larger public. The Internet is a space in which women and girls can create such publics. In this study, one can see how different features work together to attain this. Linking creates a greater potential for collaboration and networking, and the Web rings or link pages themselves can be seen as public spheres.

Speaking of linking, the notion of Internet communities as "gift economies" (Kollock 1997) is useful. A well-known example of a gift economy is the "open source" ethic of programmers who cooperated in writing programming code via the Internet to create the operative system Linux.[11] Here, the programming code source is open for everybody to see and improve, and the resulting program is distributed free of charge. Different linking strategies could be read along these kinds of early Internet ethics.

But links to other Web pages also offer a way for sites to position themselves. This goes both for "your" links to others and for others' links to "you." Web sites that link to each other are neighbors, and to be linked is to be placed, put in a certain context. This is exemplified by hackers sabotaging the Web site of a company or organization and inscribing links to, for instance, porn sites. Even if the content is not altered, these links themselves call into question the company's or organization's credibility. Marres and Rogers (2000) talk about hyperlink diplomacy in the linking of sites that share the same issues. Links have a capability of generating certain identities and kinships among Web publications; they can generate authority to specific sites. Linking can be a way to get valuable contacts with other organizations or groups. By linking to other sites, the borders of the sites are also transgressed and problematized, so that it might even become difficult to distinguish where a Web site starts and ends.[12]

Marres and Rogers (2000) also distinguish between *popularity* (links from all types of Web sites) and *relevance* (links within networks of interest). The first gives

preference to established sites, but the latter is an acknowledgement of the site's relevance. Another important factor is whether links are *reciprocal* or not. Reciprocal links show cooperation between sites, that they acknowledge each other as relevant actors in an area of interest. This can be a sign of authority and importance within a certain specialty network. These networks can be seen as alternative publics.

Another important function of links is to help users distinguish between relevant and not-so-relevant actors. This is particularly important if the user is new to a certain field. Editors of *Corky*, a Swedish webzine with a printed version for lesbians and bisexual women, said in an interview that their link page could function as a "course for lesbians 1a" for those who were new to the gay community and perhaps lived in small towns. This can explain why so many sites link to others that don't link back to them. Linking can be seen as an expression of gift economy because information that benefits both users and producers is put out, free of charge. A commercial magazine would not advertise its competitors, but cooperation among different publications is common in the alternative press, for example the feminist press. Links out have been seen as "intentional ceding[s] of power" and as "contribution[s] to the network community spirit" (Aarseth 1997: 172).

Marres & Rogers also mention different types of strategic links to other sites:

1. Benevolent (to sites one likes)
2. Aspirational (links to actors one would like to relate or associate with)
3. Critical (for example, boycotts or critical reviews)

Critical links, though common on the Web, did not occur in my material. Benevolent links can above all be seen as a service to users, whereas aspirational links is a way to position oneself and achieve a certain identity.

Through a simple search on Altavista.com, it is possible to see how many links exist within different grrlzines. These are related to the concept of popularity, mentioned above. Those who had few links in (from other Web sites) were less inclined to link out, and this can be part of the explanation, of why they themselves receive less links in. *Corky*, as a site for lesbian and bisexual women, is more marginalized in the grrlzine network and is instead part of a strong gay network. The sites that linked to them were mostly part of the gay community. The site that received most of the links in was *gURL*, which stands outside of the Web ring *Chickclick*. The Web ring *Chickclick* also had many links in, partly explained by its status as a Web ring. *Geekgirl* and *Riotgrrl* are the oldest of the grrlzines and are therefore worth linking to by newcomers who want to be associated with these well-known pioneers. That the Swedish sites had received less links in than the

TABLE 1: Number of links in a search on Altavista March 13th 1999 (*gURL* = 5,301)

Chickclick	1,952	Geekgirl	1,298	Riotgrrl	1,063
Bust	788	Disgruntled housewife	309	Razzberry	184
Smile and act nice	76	Corky	23	Darling	6
		Lumumma	0		

others can be explained by the Swedish language being a minority language among Internet users

The link page of *Disgruntled housewife* is organized in four link categories: "Girls & Women," "Boys & Men," "Gender neutral sites," and "Chickclick, Past and Present." Consequently, the most important principle of categorization is gender. The links can be seen as benevolent, and as a service for users.

The *Bust Girl Wide Web* (access date 8 December 1999) links pages are a great Web resource, with 1,639 unedited links that indicate the presence of women and girls on the Web. The links are divided into different categories: "Girly" (feminist sites and webzines), "Miscellaneous," "Personal" (personal homepages), "Pop Culture" (TV, film, magazines and music), "Sex" (sex information and explicit sexual material), and "Shopping." The teen girl community *Razzberry* (access date 8 December 1999) also lets the users come up with the links, but then edits them. Users have sent in their suggestions, of which the editors have selected nineteen. The original provider gets the honor of appearing with her (nick-) name by the link.

In the selection of grrlzines, there are other examples of how users are invited to participate. *gURL,* a site for teenaged girls, has a section called "gurlpages," in which users can upload their own Web pages. They are then divided into different subsections. *gURL* does not have links to other webzines; but to its sponsor, the mail-order clothes retailer, Delia. The Web ring *Chickclick* also has a similar section, called "Chickpages." Both *gURL* and *Chickclick* use a service offered by Lycos. The offer to users to create their own Web sites indicates that the editors imagine their readers/users not only as a target group at the receiving end but also as active creators of messages and new media content. The result is the creation of networks among users. Here the border between producer and user is weakened as users are encouraged to provide content to a link page and publish their own Web pages. The borders between individual users are also transgressed in this medium, which does allow within itself direct discussion among users.

Riotgrrl does mainly link inside a tight network of sister sites such as *Grrlgamer* and *Teengrrl* and of sites belonging to contributors to the issue. But it also links to the Web ring *Chickclick. Smile and act nice* had one single link, to *Chickclick*. As it is quite a new site, this indicates that the importance of links is now less than it was in the early days of the Web.

Current issues of *Darling* only link to their mother company: the Internet bureau Spray, its portal, and other sister publications. In the early days of the webzine, they had a traditional link page. In an interview, editor Brita Zilg explained the current absence of a link page simply by saying that nobody on staff wanted to update it. This shows that, unlike in the early years of the grrlzine, link pages are not prioritized anymore. Earlier, the articles had many links to sites in the same area of subject as the articles. One such example is the article "Cyberfeminist? Javisst," which can be translated: "Cyberfeminist? Yes, of course," where there are links to a number of grrlzines.[13] These can be seen as aspirational links. A reason for this change in priorities could be that links are important in order to place and

give identity to a Web site early on in its career. Later, when it has formed an identity, links are less important.

It is interesting that both *Corky* and *Bust* have shopping-related links (to different Internet stores), and that *gURL* links to Delia, its sponsor. Almost all the grrlzines have advertisement banners and consequently live under the laws of commercialism. The commercial laws could also tighten the relationship between the members of *Chickclick*. The advertising banners go through *Chickclick* to all of its members. This is further substantiated by the same banners recurring over and over again on the different *Chickclick* members' sites. Consumption is, however, an important theme in women's magazines, and the elements of commercialism can be seen as a connection to these.[14]

As has been shown, there is a wide spectrum between sites that do link extensively and sites who don't link at all. In some cases, producers explain that they do not have time to do link pages. There also seems to be a difference between older webzines and more recent ones. In the beginning of the World Wide Web, users were less experienced and needed guidance. The Net was also less commercialized, and idealistic ideas of networking and cooperation were more dominant. But today, many pages link, and linking remains an important identity marker that indicates desired association. Links may indicate inclusiveness or exclusiveness as well as which publications one wants to be associated with. In this, an important difference between sites is the willingness to let users supply links. This is done by three of the grrlzines: *Razzberry, Bust,* and *Corky.* Here, the link page becomes an interactive feature: This is another important criterion of public spheres.

Interactivity

A concept often used in talking about the Net and multimedia is "interactivity." But opinions differ on what interactivity really is. The main criterion of interactivity most relevant here is the ability of users to influence their webzine—to what degree they can contribute to its content. Another important factor is whether the webzine enables interaction among users. The producers of Web media can only create the space and opportunity for users to participate and interact; it is the user who decides whether these opportunities are realized in actual interaction or not. Interactivity is, however, a highly contested term. Instead of talking about levels or types of interactivity, Espen Aarseth (1997: 173–177) refers to levels of usership or creative intervention, meaning the power of the user in digital systems.

A form of interactivity seen in all the grrlzines is *consultational* interactivity (Jensen 1998), or the user's ability to choose between information (examples are CD-ROMs or hypertext home pages). Compared with older media such as books, magazines, or TV, however, this type has no additional features. In these media, it is also possible to choose what to read and in what order, or to select different TV programs with the remote control. Consultation interactivity is realized through hypertext in the grrlzines, with links within the individual grrlzine that lead to different sections or articles, as well as links to other sites.

Another type that is used in all of the grrlzines is *feedback,* the opportunity to send response via email. In comparison with traditional media such as radio, TV and the press, consultation and feedback types of interactivity are not new. It is possible to phone or write to traditional media producers as well, but online links increase the scope of consultation and email enables feedback by letting users contact editors directly via the same technology with which they accessed the publication.

Forms and questionnaires from the producers/editors directed to users is another type of interactivity. The Danish media researcher Jens F. Jensen (1998) calls this *registrational* interactivity, in which the medium collects feedback from and information about users. Examples of registrational activities are forms, mail order, "cookies" (sends information about users to Web site owners), and the opportunity to contact producers. This evokes the idea of the panopticon, which is of immediate interest in today's discussions of the Internet. It is now possible to trace Net users' every move and use it for various purposes.

A fourth type, *commentary,* provides the possibility for readers to publish their views and to debate about a certain online article. These inputs are published on the Web page immediately. Here, users can debate or simply agree or disagree with the writer of the original article and/or with each other. Of course it is possible to write whatever one wants, but the reference point is the original article and/or the questions asked by the editors. Grrlzines that have these features include *Darling, Lumumma,* and the American *Bust.* The feature is also common in print journals in "letters to the editor," but online it is faster, more direct, and often unedited.

Moreover, *Bust* also features interactive possibilities of the fifth type, *interaction,* in its "Lounge," a discussion forum in which users can discuss a broad selection of topics. This type can be described as interaction between users under loosely defined topics, or topics defined by users themselves. Other grrlzines that have discussion forums are *Riotgrrl* and *Smile and act nice.* In the year 2000, *Darling* started its own discussion forums and chat room.

Commentary and interaction correspond to Jensen's (1998) "conversational" interactivity, in which the possibility exists for the user to publish information, both stored (email, forums or guestbooks) and real-time (for instance, chat rooms or MUDs).

The teenage-oriented *Razzberry* has no articles per se but instead functions as an interactive virtual community. What would happen to a medium, if a group of users that traditionally has had very little power and influence in society should gain any measure of control over it?[15] In traditional magazines for girls, articles are written *for* the readers, on *Razzberry* they can create their own material. *Razzberry* consists to a large extent of chat rooms and forums. Users are encouraged to work for the Web page and become chat or forum host. The goal of *Razzberry* is to create a community in which users contribute and discuss issues that are important to them. Often, members initiate chat topics. This type of active community-building can be seen as a sixth type of interactivity, *participation,* which allows users to participate in decision-making on how to structure the content of the Web site.

TABLE 2 : Types of interactivity

Type	Definition	Examples	Grrlzines
I Consultation	The opportunity to choose what to read/ see and in which order.	Hypertext, TV with various channels, print magazines.	All grrlzines; for example, *Darling*
II Feedback	Possibilities to send feedback to editors. Letters to the editor.	Most dailies or weeklies, department for complaints at TV or radio.	All grrlzines; for example, *Geekgirl*
III Registration	Editors ask for feedback in special forms. The information is sent in from users and is not published in the webzine.	Questionnaires, contests in different media (magazines, radio, TV, etc.).	
IV Commentary	Possibilities for feedback on certain articles, which are published in links to articles. Discussion is framed by the content of the original article.	Certain webzines or home pages.	*Darling* (some issues), *Bust, Lamumma*.
V Interaction	Discussion forums or chat rooms in which users can discuss specific issues.	Web forums, chat rooms, news groups.	*Bust, Smile and act nice, Riotgrrl, Chick-click, Darling*.
VI Participation	Somewhat like level IV but where users can participate in decision-making and are encouraged to take active responsibility for forum or chat topics etc.	Certain Web communities and MUDs in which users are encouraged to coedit.	*Razzberry*.

Types II and III can be found in both old and new media, but registration is easier and more far-reaching in digital media. They do, however, not give the reader outlet for her views and creativity. She does not influence content, other than indirectly. Types IV and V add something new concerning user participation. In most traditional media, user/reader participation is limited to the interpretation or decoding of texts. In interactive media, the user is allowed to inscribe her own texts in the media space. Thus, she can interact with and influence other users. This increases the importance of the discussion spaces as public spheres.

The technological possibilities of the World Wide Web allow features that are much more advanced than hyperlinks and interactivity. For example, there are new technologies for handling and showing pictures; these include moving images and sound.

Body Politics and Girlie-Feminism

The subjects of this study are *feminist* webzines that relate themselves to feminism in name, image, or content.[16] Most of the grrlzines in the study actively respond and try to create alternatives to the feminist critique of the stereotypical gender representation in the media.[17]

During the late 1990s, feminism seemed once again to have become fashionable. The Spice Girls sold records, facial makeup, and lollipops under the motto "Girl Power," which was taken directly from the angry, alternative and noncommercial Riot grrrls. In Sweden, the tabloids offered semi-feminist women's supplements, and popular TV shows such as *Silikon* were also marketed as "feminist."[18] Some feminist critics, such as the Swedish journalist Nina Björk (1999) have argued that this amounts to a commercial watering down of feminism. Against this ambiguous background, it is interesting to study the feminism advocated by the grrlzines. All webzines in my study do not label themselves feminist, but they are all publications created by young women, for young women, and with woman-centered material. They all relate to feminism in certain ways. There is of course many versions of feminism, and what a feminist should do, look like, or behave is often discussed.

Bust and *gURL* have outspoken feminist intentions; *gURL* deals with problems and issues specific for teenage girls:

> *gURL* is a different approach to the experience of being a teenage girl. We are committed to discussing issues that affect the lives of girls age 13 and up in a nonjudgmental, personal way. Through honest writing, visuals and liberal use of humor, we try to give girls a new way of looking at subjects that are crucial to their lives. . . . We hope to provide connection and identification in a way that is not possible in other media. (*gURL*, info)

Sexuality and the body are key themes in *gURL*, as are issues such as being different,

and growing up and freeing oneself of parents and family. Photographs are absent in *gURL*, which is illustrated by funny drawings, for example of different types of breasts: big, small, bouncing, lop-sided, etc.[19] Thus, it avoids traditional ideal beauty images. Many other girls' magazines use images of perfect women that may foster feelings of inadequacy in girls and young women, making them more vulnerable to marketing ploys. The dominant ideology of femininity in many girls' and women's magazines says that a woman must constantly perfect herself, both inwardly and outwardly, to obtain the female ideal. Here one can instead read the message that women are good enough as they are, along with various critiques of ideals of beauty and other demands on young girls. Hence, *gURL* has an explicit feminist intent. Without big and complicated words about feminism and liberation, the editors challenge gender stereotypes and try to increase self-confidence in their female readers.

Historically, feminism has had different strategies to attain its goal: a society in which gender is considered unimportant and both genders have equal rights. Today, different feminisms advocate different strategies; Nancy Fraser (1997; 2000) has described some of these. Subordinate groups suffer from both economic injustice and cultural injustice. The former can be remedied by redistribution of wealth and the latter by recognition and reevaluation of the group in question. But poor economic distribution and misrecognition occurs to various degrees in different subordinate groups. Women as a group are, however, disadvantaged both economically and culturally. They are, in Fraser's terms, a *bivalent* collective; they are equally disadvantaged in both aspects. Fraser states:

> Certainly, a major feature of gender injustice is androcentrism: the authorative construction of norms that privilege traits associated with masculinity. Along with this goes cultural sexism: the pervasive devaluation and disparagement of things coded "feminine," paradigmatically—but not only—women. (Fraser 1997: 20)

But the methods to attain redistribution and recognition go in opposite directions. To dissolve gender division in work, gender division has to disappear. To do away with misrecognition, gender specificity must instead be recognized and embraced through group identity politics. Here, Fraser distinguishes between affirmative and transformative remedies for both poor distribution and misrecognition. The former "proposes to redress disrespect by revaluing unjustly devalued group identities, while leaving intact both the contents of those identities and the group differentiations that underlie them" (Fraser 1997: 24). Fraser instead advocates transformative remedies, which have much in common with deconstruction and which destabilize both group identities and differentiations. Instead of just increasing the self-reliance of subordinate groups, these transformative remedies would "change *everyone's* sense of self" (Fraser 1997: 24) and thus could be a way for real change. An example of such a transformative strategy is queer politics, which seeks to destabilize both heterosexuality and the identity of the homosexual. The same can be seen in feminism, in which affirmative recognition seeks to

revalue femininity but fails to do away with the gender dichotomy that underlies the notion of femininity and has created and given meaning to it. In deconstructive feminism, gender identities are forever shifting, and identity orders other than gender are acknowledged. A disadvantage of deconstructive feminism is, according to Fraser, that its theories and ideas are far removed from most women's lives.

A feminist group identity politic is to celebrate the feminine, which traditionally has been devalued, to give it equal or even higher value than the masculine. Such a strategy can be seen in Debbie Stoller's column "Feminist Fatale" in *Bust*, in which she challenges stereotypes of how a feminist should be, behave, and look. Stoller describes the conflict between second- and third-wave feminists when it comes to appearance. Dressed in a tight T-shirt and platform shoes and wearing lots of makeup, she compares herself to a drag queen. But being a feminist intellectual, she is criticized by other feminists who say that her "look" proves she is suppressed by men and that her feminist message is ruined by her appearance. Stoller denies this and says her style of dress is a feminist statement:

> I am proud of this girly shit; I embrace it, love it, take pride in it, and want to validate it. Because the way I see it, as long as we continue to denounce the culture of glamour as being oppressive, misogynist, and just a big waste of time, we do ourselves, as well as RuPaul, a great amount of harm. We are essentially siding with the guys who have always said that everything girly was stupid. We are agreeing with Rex Harrison who asked "Why can't a woman be more like a man?" So I choose to be a feminist fatale. It's womanly, yes, but I like it too.

Stoller thus seeks to counteract cultural sexism by trying to revalue the femininity despised by society. Her article is in line with the rest of the content in *Bust*, in which editors celebrate and form their own cultural expressions out of symbols from female popular culture (for example, pinups from the '50s) previously used to suppress women. Many second-wave feminists (for example, Betty Friedan, author of *The Feminine Mystique*, 1963) rejected the demands on women of the '50s and '60s to be beautiful and ladylike. Today, the situation is different, Stoller says. Women have a choice, and a woman in stiletto heels should be considered just as good a feminist as one in Birkenstock sandals. Interestingly, in this column, users are invited to write what they think (an example of the commentary type of interactivity mentioned earlier). Readers' comments can change the context of the original article, but the device also gives readers opportunity to become authors. Most commentators agreed with Stoller; however, some criticized her, too.

> Stoller, you seem to be implying that it's ok to wear make-up because such "girlie shit" is a symbol of your solidarity with other women. However, while you can rant all day about how it's ok to wear make-up and still be a feminist since it's YOU who's making the choice, I dare say you aren't fooling anyone besides yourself. It's pretty obvious you're ignoring the question of WHY it is you want to wear make-up. You may THINK you're making a free choice based on what you want, but you're just a

victim "choosing" what patriarchial society has determined you ought to desire: to look like a "beautiful feminist." Just what every guy always wanted: a lady AND a whore. That's the truth, deal with it or toss the lipstick.

The person who wrote this sees a certain appearance as an expression of gender oppression. Stoller is talking about one's own choice; her discussion is about a single person, the self—not the collective. As an individual, she feels that she should be able to look the way she wants and still be respected. This commentator, however, thinks that Stoller is a victim of patriarchal society who is suffering from "false consciousness." She accuses Stoller of agreeing to "rules" that say that feminism is okay as long as the messenger is an attractive, dressed and made-up, female. Maybe Stoller is not a threat as long as she hides her "radicalism" behind a mask of glamour. By using the consumer goods of patriarchal capitalism and thereby also allowing herself to become an appealing object to be consumed, she is working for patriarchy, not for feminism. This is analogous to the way feminism itself has become a saleable item. One could compare Stoller's strategy (in the eyes of the commentator) to that of the protagonist of Joan Rivière's text (1992): "Womanliness as a Masquerade"; an intellectual and successful woman who feels the need to hide her competence behind a mask of femininity. She does this by flirting with men, thus playing a feminine role. To accentuate one's femininity with dress, looks, and behavior and thereby allow oneself to become an object of the male gaze is, according to the citation, to subject oneself to patriarchal society.

In the long history of feminism, there have been different strategies. In the 18th century, Mary Wollstonecraft criticized the demands on women to look beautiful with unhealthy means such as corsets and high heels. The suffragettes and other liberated women in the nineteenth century fought for women's right to wear trousers. And in the 1970s, bra-burning became a feminist symbol in the mainstream media.[20] In politically correct circles, true feminists rejected facial makeup and dresses, and the masculine dressing style continued in the 1980s when women executives learned how to powerdress. At the same time, however, it was important not to lose one's femininity if one wanted to succeed in the corporate world. This pinpoints that there is an important line between looking too feminine (too much facial makeup, too sexually provocative) and too masculine. This is also confirmed by my own interviews about makeup with middle-class women (Ladendorf 1996). To be taken seriously, women should not look too feminine, because efficiency and ability are usually associated with masculinity. But at the same time, a woman who is not trying to please men is seen as a threat. As a woman, it is thus extremely difficult to navigate and be exactly right.

In the 1990s, the Riot grrrls and other "girlie feminists" reused the mix of the supermasculine and pornographic femininity of punk. To look sexy can be seen as yet another feminist strategy. Second-wave feminists were often described as ugly and unfeminine in the mainstream media, and the new look could be a way to appeal to young women. But it could also be seen as a commercialization of feminism. This is evident in the new marketing strategy of *VeckoRevyn,* the largest

Swedish girls' magazine: which makes use of feminism. However, *"VeckoRevyn* should not be a feminist in a gray woolen cardigan that smells badly. There must be some glamour too," the new chief editor, Emma Hamberg, says (Johansson 2000).[21] Hence, the feminist femme fatale is challenging one stereotype (the gray and boring feminist hag) by using another: the sexy woman. But at the same time, the sexy object has a voice. Also, by not trying to look natural, she could be deliberately attempting to expose the constructed nature of femininity.

This could be read along the lines of Fraser's deconstructive feminism and the theories of Judith Butler (1990: 138), who advocates parodic acts that expose the constructed nature of gender and sexuality. Butler exemplifies with phenomenons like drag shows and butch/femme play of lesbians, but such acts are not limited to these. Even though these styles originate in patriarchal culture, they are recontextualized and hence they denaturalize and destabilize gender identity. Moreover, all parodic acts are not subversive, according to Butler, and of course the position of a man dressed in drag is quite different to that of Stoller, who is using the stereotypical attire of her own gender, not the opposite. However, Stoller does not think that glitter and glamour should belong exclusively to the female gender. She advocates the androgynous ideal that became popular during the glam rock era of the '70s: "In fact, I think the choice to dress sexy should be extended to both genders. As far as I'm concerned, the more men who try to look like David Bowie, the better." Thus, Stoller does not want to uphold the dichotomy between the sexes. She sees the painting and adorning of the body as something pleasurable that she does not want to deny men.

Stoller and her critical commentator can thus be seen as spokeswomen for two different types of feminist strategies or identity politics. The latter advocates the right feminist look. The wish for images of "real women," or so-called natural women (often expressed in the imagery of second-wave feminism) without makeup and feminine attributes, expresses an identity politic and implies that there indeed is a 'true' female identity, outside of gender representation and media images. Stoller, however, seeks to destabilize feminist group identity by acknowledging feminists in Birkenstock sandals and in stiletto shoes as equally feminist. Furthermore, the superfeminine look raises the question of whether there indeed exists such a thing as a true female gender identity.

As stated earlier, most commentators were very positive, but several of their comments also contained interesting analyses. Two of them were more radical than the ideas in the original article, in which Stoller merely said that feminists should be allowed to dress sexily and still be respected. The following commentator thought that there was something inherently subversive in feminists reclaiming and using the superfeminine appearance,

I've always thought there was something deliciously subversive about today's girlie-feminists. Sure, after years of strictly enforced gender roles, there was something subversive about going braless, or dressing like Annie Hall, but we've already seen that women can reject the feminine ideal and still be women. The REAL frontier is

for women to embrace the feminine ideal as artifice. There's something about taking the feminine ideal to the extreme, as in go-go boots and thigh-highs, or tweaking social expectations by wearing lipstick but leaving your armpits unshaved, that showcases how artificial "femininity" really is. For years, women have been wearing makeup trying to look "naturally" beautiful, or wearing padded bras to look "naturally" curvaceous—screw trying to look natural! Being the uber-girl [*sic!*] feminist with the glitter eyeshadow shows what a drag show gender roles really are—and THAT'S what I call subversive.

This commentator has first of all a constructivist perspective regarding sex or gender. Sex, or rather gender, is seen as constructed, something learned in socialization (see. Beauvoir 1957). Femininity is thus not seen as natural, it is merely a mask or a performance. And the mask of femininity is as constructed and superficial on a woman as it is on a man who "plays" woman. Efrat Tseëlon (1995) describes how woman has been seen as a bearer of masks. Her analysis provides a view on femininity as something without essence that has been inspired by psychoanalytic and poststructuralist theories (among others, the earlier-mentioned Rivière). Tseëlon thinks that the masquerade, and the unstable identity position of which it is an expression challenges patriarchy, but at the same time is dependent on it. The use of feminine attire such as makeup and an "unnatural" look, together with classical feminist attributes such as unshaved armpits, destabilizes gender identity, thus creating the "gender trouble" that Judith Butler (1990) is talking about.

The next commentator seems to be directly inspired by queer politics:[22]

Maybe we need to be sensitive to the fact that "beauty" has been used to oppress women, while recognizing that reclaiming and reframing [*sic!*] can empower, much in the way that the gay rights movement's identification as "queer" has dispelled the dishonor in the word.

In queer theory, sex and gender are not seen as separate, as in earlier constructivist feminisms; instead, biological sex is seen as uncomprehensive outside of the constructing discourses. Subordinate groups, such as homosexual and bisexual, transexual, etc., should not try to be "normal" to blend into society. Instead, "queerness" is seen as a platform for revolt against repressive society, something that in queer theory goes under the name *compulsory heterosexuality*. One can, as in the citation above, draw a parallel between compulsory heterosexuality and compulsory masculinity. It says that women should not have to adapt to masculine (read: patriarchal) culture; they should instead revalue their own feminine culture and its symbols and create a radical alternative to masculine culture. Such a strategy could be seen in the Riot grrrl movement, in which rock singers such as Courtney Love and Kathleen Hannah dressed in girly dresses but at the same time behaved aggressively, were topless on stage (a behavior formerly reserved for male rock stars), and reclaimed words such as "bitch" and "slut." Connected to these ideas is the celebration of everything pink and girly, together with the reuse of old female

icons and representation. But mixing blood-red lipstick with unshaved armpits and girly dresses with aggressive behavior was clearly deconstructive in a way that is analogous to the identity politics in many grrlzines.

The webzine *Riotgrrl* takes its name from the feminist punk movement and is thus related to an aura of radical feminism. The Riot grrrl movement was loosely knit, without formal leadership. Every girl or young woman was free to call herself a Riot grrrl and to define what Riot grrrl meant: There existed no single manifesto. (The *Riotgrrl* webzine on the Net, however, violates this code of free use and definition by putting a copyright (©) symbol beside its name.) In the webzine, there is a recurrent criticism of body ideals, especially those concerned with body weight. An innovative feature is the game "Feed the Supermodel," in which the user can choose what the supermodel has to eat to gain weight and then see her get a more rounded body silhouette. Here, interactive technology is used to create a type of media content than would be impossible to do in a printed magazine. In this virtual media, the user can control the body weight of the supermodel by feeding her hamburgers or "good food," thus making her gain and lose weight. But feminist issues other than body size are absent, and the representations of women (and also men) are generally highly stereotypical. *Riotgrrl* regularly judges women by "sexiness" (by the standards of the webzine's female writers) and has narratives in which women fight each other. The main themes in *Riotgrrl* are popular culture (mostly film and TV) and consumption, all with a women's angle. Like many commercial magazines fixed between commercialism and feminism, *Riotgrrl* exposes a double standard.[23] On the one hand, the webzine criticizes body ideals, but on the other, it judges people on a scale of sexiness. However, the feminism of *Riotgrrl* mainly circles around body image and weight, something it has in common with many of the other grrlzines.

To conclude, the feminism of grrlzines is about resisting beauty and body ideals, to help create strong and independent young women with the ability to choose whomever one wants to be. The goal is to lessen or do away with rules for how to look and act, either from patriarchal society or from other feminists. There are also some expressions of a deconstructive feminism, which acknowledges differences among women and aims to abolish gender dichotomies. Deconstruction and parody are, however, even more noticeable in the drawn and photographic images of the grrlzines.

Pinups and Grrrls

Two recurring attitudes in the grrlzines are parody and irony. This is even more obvious in the use of images in the grrlzines, which often reuse pictures from other and earlier media. It is possible to talk about a pictorial feminism or a feminist visual aesthetic. In Janice Winship's (1987) study of British feminist and women's magazines, she concludes with these hopes for the future of women's press:

I'd like a new magazine to strive to create non-oppressive visual forms of indulgent pleasures and fantasies. . . . Unless we try to do that it is difficult to see how the nexus of femininity-desire-consumption which commercial magazines and their adverts trade in can be broken or how a different visual vocabulary around femininity and masculinity can be developed. Such a visual project would have to give high priority to colour, glossy paper and to advertising. It would probably involve re-using, making fun of and commenting on the colour and stylistic conventions customarily used by women's magazines rather that wholly breaking away from that format. . . . The post-modern reliance on retro styles which raid the past for its images and re-present them in contemporary contexts makes such a design and visual project more feasible. (Winship 1987: 162)

In Winship's study, three British print magazines were analyzed: *Woman's Own*, *Cosmopolitan*, and *Spare Rib*. *Spare Rib* was a dominant feminist magazine with a leftist orientation that spoke against the popular culture of consumption that flourished in women's magazines. The other two flirted with feminism but in a half-hearted way, because of their fear of losing advertisers. Winship had a dream about a new type of women's magazine, which would combine feminist consciousness with a pleasurable reading experience and in which the visuals would play an important role. Could today's grrlzines and feminist webzines be the realization of her dream? The Internet cannot provide glossy paper and perfect color quality, but the playful popular culture of its grrlzines might provide as much pleasure as the traditional women's magazine, even if it is being presented in a different form.

In many cases, the commercial women's press has inspired the grrlzines, both in terms of choice of subjects and their visual aesthetics. The most vivid examples of this are *Disgruntled housewife*, *Smile and act nice*, and *Darling* (even if the latter has most in common with print magazines for young women and the entertainment supplements in the Swedish tabloids). The grrlzines use the aesthetics of the women's press, but develop it in sometimes more feminist directions and in some cases give it new meanings. A tradition that has much in common with the grrlzine is the fanzine. In the fanzine, or the "zine," editors have the freedom to write about what they please, without regard for the demands of the market. Zines are often created by a small group of enthusiasts, or by a single person. The grrlzine that has most in common with the fanzine, as described by Duncombe (1997), is *Disgruntled housewife*. Nikol Lohr, its creator, produces both text and layout. The subjects covered in the fanzine are whatever interests the editor and can present very diverse themes. Fanzines that are created by one person and revolve around his or her interests and fancies are called *perzines* (personal zines). *Disgruntled housewife* is a perzine in Web format.

According to its editors, one reason for starting *Darling* was to constitute an alternative to the traditional images of women in the popular women's press (Beck-Friis 1998).[24] It is therefore important to ask in what way its images can be seen as alternative. The Web version of *Darling* saw the light of day in December 1996,

and in September 1997 a paper version followed. The latter is distributed and sold in most Swedish cities and has an edition of about 30,000 copies (as of February 2000). At first, *Darling* was created by a nonprofit organization, but it was later adopted by the multinational Internet bureau, Spray. *Darling* is one of the grrlzines in my sample that has most in common with the form and content of the commercial girls' magazine.

The front page of one of the *Darling* issues (no. 23, February 1999, The Naked Issue, see Fig. 1) is built in squares, and this is similar to other issues. According to the editor Brita Zilg, the design is inspired by print magazines. Design that is created for a female audience or feminine users traditionally has projected round, soft images and with mellow colors instead of dark or loud ones (Smith 1990). *Darling*'s logotype appears to be a combination of round and angular forms. A star instead of a dot above the "i" indicates both playfulness and youthfulness. The angular shape can be seen as a sign of toughness and independence replacing the more traditional forms of femininity. Below the logotype appears a square photograph of a nude young man. He is huddled up in a fetus position, asleep, and this leaves him looking soft and vulnerable. This impression is, however, contradicted by his looks. He has plenty of blue tattoos, and he sports spiked black hair and silver jewelry that make him look a bit "dangerous" and possibly participant in some youth subculture. Above the boy is the headline: "Darling of the Month. But he hasn't any clothes on?"[25] The *Darling* front page described thus seems to be an androgynous mix of masculinity and femininity.

The women's magazine in general is a conservative genre, evident in various places in a magazine. One of the more obvious is the front cover, which is used to sell the magazine and give it an identity that will appeal to the reader. This identity is most successful when it is similar to the identity of the reader herself. Ellen McCracken (1992) asserts that this identity isn't the true identity of the reader; it is an ideal identity that the magazine promises will be attained when the reader has perfected herself with the help of the magazine. The reader is thus lured into buying the magazine and the various products it advertises. The model of the cover, therefore, must help in the process of identification but at the same time function as an ideal image. Janice Winship (1987) has shown that the model usually is a woman depicted as a single figure, and variants include a woman with a child or a woman with a man. The *Darling* front page breaks this rule. However, the front page of the paper magazine has always had a female model, even if one front page (no. 1 The Statistical Issue 1999) featured a female geek (complete with glasses with a bit of adhesive tape on them) instead of the conventional beautiful smiling model. This depiction of a non-ideal type of femininity regenerates the girls' magazine genre and cover conventions and also connects to the ideas of geek feminism. Another convention that is ignored here is nudity and males. Traditionally, the nude "object" was female, in art, pornography, and the mass media. In the weeklies and other popular press, it has mainly been the men's magazines that have featured nude or seminude women. In recent years, the women's press has followed and has been generous in showing pictures of scantily clad women. Nude

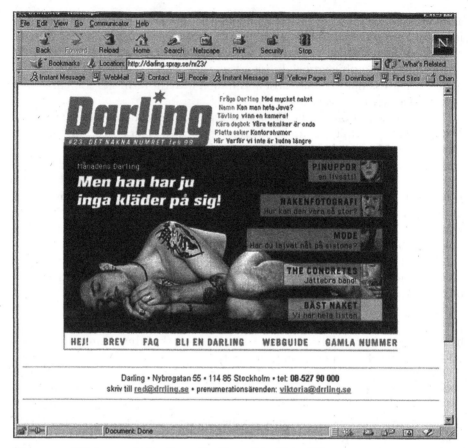

Figure 4.1. With permission from *Darling* editor Brita Zilg.

men have not been as numerous, especially on the front pages; when they are so depicted, they must usually assert their "maleness" by standing in an upright posture, firming their muscles and looking the spectator in the eye (Dyer 1994). The *Darling* man is quite the opposite; lying huddled up, he looks vulnerable and does not meet the eyes of the spectator. He is depicted as a child (a fetus), which is more common in pictures of women (Goffman 1979) all over the western world. One must ask if it is easier to ignore the conventions in the webzine, because a selling front page isn't as important on the Internet as it is on the magazine stand.

Another webzine that uses features from traditional women's magazines is *gURL,* which presents both personal stories and more playful features. Visually, *gURL* uses the technological possibilities of the Internet more extensively than do the other webzines. This webzine also plays with many of the conventions of the women's press. An example is the virtual makeover in which girls send in their photos, which are then manipulated in graphic processing programs by the *gURL* staff. The intent is not to make the girls better looking or trendier, but to play with

style under the motto: "the crazier, the better." Witty texts have been added to the images, for example: "Sonya wanted to bloom" (beneath a picture of Sonya before the makeover) and "Now she's letting her head's garden grow" (beneath a picture of Sonya with green hair and lots of flowers in it). Here, style and looks revolve around fantasy and playfulness instead of the necessity to be up-to-date with current trends and fashion. *Darling* and *gURL* are by no means typical for the grrlzine. The genre is much too diverse to constitute a typical case. But it is interesting that these images exist, that they generate new meanings and form a contrasting picture to the traditional women's press.

Some of the grrlzines use old pictures, both photographic and drawn, which in the new context generate new and changed meanings. Christa Scott (1998) points out that the Riot grrrls, contrary to earlier feminists, often use symbols and artifacts from the commercial culture that have been directed towards females. On such example is "Hello Kitty," a small cat character that is also a motif on numerous writing pads, bags, and calendars produced by the Japanese company, Sanrio. This cat and her cocharacters have been popular with young and older girls since the 1970s. In this way, the Riot grrrls celebrate what is cute, pink and "feminine" in a way that is analogous to the use of "girls" instead of "women" when they refer to themselves. The feminists of the '60s and '70s felt that the label "girl" was degrading, and they insisted on being called women. The tactic of the Riot grrrls is to reclaim the word "girl", and everything associated with it. In the same way, some of the grrlzines use older images of women that could be labeled sexist (for example, pinups, playboy bunnies, and '50s housewifes), but they put them into new contexts.

Uses of images from the '50s, or with '50s connotations, can be seen in *Bust, Disgruntled housewife,* and *Smile and act nice*. In the United States, the era of the 1950s seems to be seen as some kind of golden age when prosperity, morals, and other positive values flourished. One can see a lot of nostalgia for this age, especially in American design, as seen in food packaging in which the forms and images of the 1950s are used. However, feminists and others have placed in question this nostalgic dream image and called attention to, among other things, the restrictive role of women during that time.[26] The use of '50s imagery in the grrlzines could therefore indicate a certain amount of critique and irony and at the same time make the reading a pleasurable experience.

Disgruntled housewife uses the '50s theme to the extreme. Topmost in the right frame in this webzine (Fig. 2), is the message: "Disgruntled housewife: Your guide to modern living and intersex relationships." To the right of this headline is an image of a woman with red hair who is wearing a blue satin dress. She looks very glamorous, and her bodily curves and shapes invoke the '50s ideal. This image fits very well with the headline, for the 1950s are said to be the era of the housewife (and also the disgruntled housewife).[27] Both headline and image are reminiscent of the women's magazine. The headline alludes to the many "schools" and "guides" common to the genre, especially those that will help women deal with the opposite sex. To the left of the woman, there are icons,

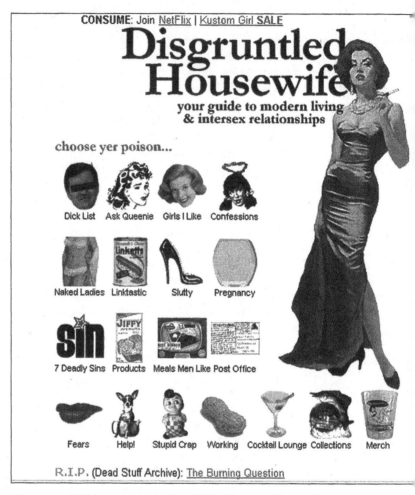

Figure 4.2. With permission from Nikol Lohr, editor of *Disgruntled housewife*

many with '50s connotations, that lead to other sections in the webzine.
are also so called rollovers, because the images change when the mouse p
moved over them. Rollovers are often created to make Web pages more li
also to entice users to click on the icons. But the changing nature of th
being "two pictures in one," also has implications about their meaning.
ond image brings something new to the first, and this can sometimes ha
funny and ironic effects. Two examples of this are when the icon "conf
changes from an angel to a devil, and when the icon "pregnancy" changes
unidentifiable pink blur to birth control pills. The latter expresses a view
the ideology that women should be mothers but also celebrates the fact th
women in the Western world now control and decide if and when to be n
The icon leads to a section about pregnant women in which Nikol Lohr,

editor of *Disgruntled housewife*, writes about her feelings of disgust for pregnancy and motherhood:

> They've all got creepy little monsters growing inside them like parasites. I don't want kids. Sometimes I like kids okay, sometimes they're funny or smart, but I don't want one growing inside me like a tape worm. (*Disgruntled housewife*, section "Pregnancy," access date 19 February 2001)

The sections "Slutty" and "Naked Ladies" are about women as sex objects. Here, the popular culture of the '50s and '60s is celebrated, in this case through pornographic playing cards, the American pinup girl, Playboy bunnies and other pornographic stereotypes (the nurse, the schoolgirl, the odalisque, etc.). In "Slutty," Lohr writes that she wants to look like a slut, which is her ideal. Here, a degrading stereotype is given a new and more positive meaning; pinup girls and sluts are seen as role models instead of inferior creatures. Here, Lohr inverts the hierarchy between the Madonna and the whore, becoming disgusted by the former and celebrating the latter. In this way, the meanings of some female stereotypes are changed by the use of these stereotypes instead of trying to avoid them.

In the showing of pictures, the grrlzines often make use of a montage technique. Frederic Jameson (1983/1998) talks about postmodern art forms such as pastiche, montage, and collage. It is important, however, to point out that these techniques have roots in modernism. Montage and bricolage appeared again in the punk fanzine, which is one of the forerunners of the grrlzine, and in other aesthetic expressions of punk rock. Craig Owens (1983/1998: 70) describes how postmodern feminist artists such as Dara Birnbaum, Cindy Sherman, and Barbara Kruger use the female object position. Instead of trying to avoid and resist the male gaze (Mulvey 1975/1999) and the objectification of women it leads to, they scrutinize and revert it through their pictures. Owen claims the feminine to be invisible in our culture, and that feminist artists' use of the female object is a strategy to make it visible. Both Birnbaum and Sherman use the mass-produced images of women. Birnbaum does it more directly by using the products of mass culture as material for her art, and Sherman does it through putting herself in the position of the object (for example in her "film stills"). This works to deconstruct the female role as an object in (popular) culture. The artists often use older images or conventions from popular culture. Sherman dresses herself up as the heroines of the movies of the '50s and '60s, and Birnbaum uses the old TV series, *Wonder Woman*. This use of older popular culture is analogous to the grrlzine editors'. Rosi Braidotti has written about the postmodern feminist artists and also about rock singers who expose the constructed nature of body and gender (for example, Dolly Parton and Michael Jackson). She asserts that the explorations of the female object can be subversive and liberating, calling this attitude "the philosophy as if." This is using gender stereotypes as if they were true, but in a parodic manner.

The feminist "philosophy of as if" is not a form of disavowal, but rather the affirmation

of a subject that is both nonessentialized, that is to say no longer grounded in the idea of human or feminine "nature," but she is nonetheless capable of ethic and moral agency. As Judith Butler lucidly warns us, the force of the parodic mode consists precisely in turning the practice of repetitions into a politically empowering position. What I find empowering in the theoretical and political practice of "as if" is its potential for opening up, through successive repetitions and mimetic strategies, spaces where forms of feminist agency can be engendered. In other words, parody can be politically empowering on the condition of being sustained by a critical consciousness that aims at the subversion of dominant codes. The ironical mode is an orchestrated form of provocation and, as such, it marks a sort of symbolic violence and the riot girls are unsurpassed masters of it. (Braidotti, Web document, found under the headline "The Politics of Parody")

Irony has often been used successfully by female writers. Jane Austen and many feminist critics have followed this tradition.[29] Three Swedish feminist researchers in organization theory (Wahl et al. 1998) have investigated how irony could be used as a strategy for women in organizations. They point out that irony can be used by people in power; then it becomes an instrument to suppress, but it can also be used by the less powerful as a strategy to gain power and influence. Women in organizations can use irony in three ways. First, it can be a means to get by in a subordinate position. Second, it can be a way for women to get strength as a group and a create feelings of solidarity. Third, irony can be used to protest against gender roles, because it simultaneously makes them visible and transgresses them. Thus, it has the potential to change status quo (Wahl et al. 1998: 109). A characteristic of irony is to put an issue in question without openly challenging. It thus allows people to think for themselves and possibly change society. Patriarchy is reproduced through sexuality and the objectification of women. Wahl et al. see the uses of pinups in the workplace as an ironic strategy of the powerful to objectify the women in the organization (Wahl et al 1998: 121). Some of the grrlzines, however, use the image of female pinups for their own purposes. This is in direct opposition to the one described by Wahl et al. Toril Moi writes about irony in theoretical texts, but the same ideas can also be applied to pictures.

> Irony is a matter of tone: either we hear it or we don't. The more subtle the irony, the more it tends to split the audience between those who get it and those who don't. To get the irony of a text, the reader has to be able to imagine the author's point of view [.] (Moi 1999: 174)

Irony and parody are thus important strategies for deconstructive feminism. Moreover, irony can be more or less subtle, and it can be difficult to assert wether the intentions behind the grrlzines and wether their use of certain images are ironic or not. The intention could just as well be aesthetic. But in my own reading of the texts, I can see ironic attitudes to a certain extent. Furthermore, the feminist context changes the range of possible interpretations, and in some cases, the irony

is explicit. An example of the parodic mode can be seen in *Geekgirl* (no. 1, April 1999, see Fig. 3), in which the editors have used an older pornographic or erotic symbol: the Playboy bunny. The symbol for the issue that is portrayed in numerous places within the webzine is a drawing of a female face with pink rabbit headgear, black framed '60s glasses, and a big, red mouth. The prototype for the *Geekgirl* bunny is the cultural icon of the Playboy bunny. This bunny was a very important part in Hugh Hefner's erotic business empire. The choice of its symbol might be explained by the rabbit's reputation for an extensive sex life and fertility. But the choice of dressing women in rabbit or "bunny" suits puts them in the position of soft and defenseless prey that should be "laid down" by the male hunter: the playboy. Young, beautiful women dressed in rabbit costumes waited on the male guests at the playboy clubs. The *Geekgirl* bunny, however, is of a different kind. She is not particularly beautiful; she wears glasses and has a big red mouth. In films and other popular culture, a woman who must wear glasses traditionally has been seen as less attractive and therefore less feminine; she is often portrayed as a spinster wrapped up in her books. She is usually an independent woman, and thereby poses a threat to the male hero. The glasses are also often used in a kind of Pygmalion theme, in which the man lifts off the spectacles and thereunder finds a beauty. The fact that the glasses are associated with the nonfeminine is probably because they seem to connote scholars and intellectuals. The big mouth symbolizes an ability to make use of language, to argue and protest, something that has been seen as less attractive in a woman. The *Geekgirl* bunny, consequently, is the definite opposite of the Playboy bunny; instead of being a willing (?) and passive victim of a man, she has great self-confidence, is witty, cocky, knowledgeable, and intelligent.

The home page of *Riotgrrl* has very few images, and these are all drawings, not photographs. The images are three female figures; one is a picture link to the Web ring *Chickclick,* and the two remaining are *Riotgrrls* own figures. They have Farah Diba hairdos and their upper bodies are dressed in bras and nothing else (see Fig. 4). One of them has a cigarette in the corner of her mouth. They look like tough chicks from some '60s film about bikers. Angela McRobbie and Jenny Garber have described the popular myth of the female biker:

> The motor-bike girl, leather-clad, a sort of subcultural pin-up heralding—as it appears in the press—a new and threatening sort of sexuality. This image was often used as a symbol of the new permissive sexuality of the 1960s and was encapsulated in the figure of Brigitte Bardot astride a motor-bike with her tousled hair flying behind her. More mundanely this image encoded female sexuality in a modern, bold and abrasive way. With matte pan-stick lips, an insolent expression on her eyelined eyes and an unzipped jacket, the model looked sexual, numbed and unfeeling, almost expressionless. This was an image therefore at odds with conventional femininity and suggestive of sexual deviance. (McRobbie and Garber 1991)

The semi-nudity of the women connotes sluttishness. But the women also give off impressions of hardness and toughness. Thus they are separated in two different

Figure 4.3. No permission given. Web page has vanished from the Web.

ways from the traditional femininity sanctioned by society, but without
their sexual allure. One can see a fascination with "bad girls" in certain parts
women's movement, above all the punk movement, of which Riot grrrl
part. Bad girls can be seen as rebels, and Riot grrrl is about rioting and putt
"common sense" of society in question.

To use images from the 1950s and 1960s in the year 2000 could have nc
motives. But all signs instead point to irony. The nostalgic reuse of the des
the '50s is very common in the United States. In Sweden, among young
born in the 1970s, there is greater nostalgia concerning the '70s and the '
Darling, this can be seen in the use of pictures from the Swedish romantic
book *Starlet* from the '70s and '80s, and in a general fascination for the popu
ture of that time, including the Muppets and *Star Wars.*

To conclude, the female body is extremely important in grrlzine aesthetic
is something grrlzines have in common with the genre of women's magazin
the use of comic line drawings and images of glamourous ladies from th
shows a greater distance from the ideals of beauty and bodies than do the cc
porary images of women seen in most commercial magazines today. The
grrlzines tend not to provide role models that will be hard or impossible tc
for female readers. On the contrary, they become ironic comments on the
tional dominant views on woman, her body, and her role in society. There
merous cases in which the grrlzines break certain rules or conventions
women's magazine, as seen on the cover of *Darling* and in the makeover of
In the other grrlzines, a certain amount of ironic distance from the genre
seen. In this sense, some of Janice Winship's (1987) hopes for the feminist
zine of tomorrow are fulfilled, including her call for the re-use of popular
and images as ironic comments to stereotypical representations of women.

In Nancy Fraser's terms, this can be seen as a struggle for recognition (

Figure 4.4 With permission from Nikki Douglas, *Riotgrrl* chief editor.

1997: 2000). Fraser is critical of how this struggle often ends up in identity politics. The grrlzines' twisting of print magazines' conventions and their playful uses of feminine images and ideals can be seen as such a politic. But not of the kind Fraser criticizes, those that: "impose[s] a single, drastically simplified group identity, which denies the complexity of people's lives." Instead, a destabilizing identity politic is at play, in which one wants to allow the individual to decide how she experiences her gender identity and how she will let it be seen. Instead of trying to create one, "true" picture of woman, the grrlzines use the now-clichéd images of women in patriarchal society to show how false those views of women really are.

This is very similar to the artwork of feminist postmodern artists. The tools used for attaining this in the grrlzines are irony and parody. Hence, the protest against patriarchal society and its defining power is not open, but disguised under a layer of pleasure and "fun."

This shows that the Net is a site that is not freed from old genres or conventions, but that these could be developed in new and more subversive ways. This could of course also happen in a paper grrlzine publication, but in comparison to print media the Net has many advantages. Duplication and distribution are easier and cheaper, and the advertising aspects as well as the demands of advertisers are less powerful than in print media. In addition, some of the mainstream women's press in Sweden has made efforts to be more politically correct. Feminists viewing these efforts as a commercialization of feminism often ridicule them. Feminist media and grrlzines could, however, be seen as subaltern counterpublics (Fraser 1997): "Still, insofar as these counterpublics emerge in response to exclusions within dominant publics, they help expand discursive space" (Fraser 1997: 82). In their own public sphere, they criticize the mainstream women's magazines and try to create an alternative. By doing this, they influence the mainstream media and, in Fraser's words, expand discursive space. In Sweden, this has already happened with *Darling* and *VeckoRevyn*, when the latter decided to undergo a feminist makeover with the feminist *Darling* as a role-model.[30] It seems, however, that the mainstream print media are more easily influenced by a print magazine. When *VeckoRevyn* declared itself feminist, discursive space about gender inequality was widened, and perhaps the meaning of the word "feminist" was altered, too. The feminism of *VeckoRevyn* is feminism for all, but the question is whether the word loses its powers by entering the mainstream or will result in a liberating change of "*everybody's sense of self*" (Fraser 1997: 15). In this case the counterpublic uses generic conventions from the mainstream public it opposes, and by twisting and subverting its meanings it creates new ones. The influence thus goes in both directions, from mainstream to alternative and then back to the mainstream media that is eager to use new ideas as long as they can be marketed.

Notes

1. Above all in the United States, one talks about a "third wave" of feminism, which consists of the daughters of the second wavers, the women's libbers who were active during the 1960s and 1970s. (The first wave was the suffragettes, who fought for women's vote in the late nineteenth and early twentieth centuries.) The third-wavers have grown up with feminism. They criticize the charge that feminism has been a club for white middle-class women. Important issues include right to abortion, incest, date rape, anorexia/bulimia, fixation on body ideals, and poverty among women (Tobias 1997). Examples of third-wave women's groups are the Riot grrrls and Guerilla girls (Braidotti).

2. According to *Webster's Third New International Dictionary* (1993), irony is "humor, ridicule or light sarcasm that adopts a mode of speech the intended implication of which is the opposite of the literal sense of the words." Parody is "a form or situation showing imitation that is faithful to a degree but that is weak, ridiculous, or distorted."

3. To read different meanings of the names, I have used *Webster's Third New International Dictionary* (1993).

4. The term "Riot grrrl" is spelled sometimes with two and sometimes with three r's. It refers to both a feminist movement and an online phenomenon. In this article I will use "grrl," *Riotgrrl*, "grrlzine" when talking about online phenomenon, and "Riot grrrl" when talking about the movement.

5. "Patriarchy" is a feminist term that can be defined as: "A system of male authority which oppresses women through its social, political and economic institutions. In any of the historical forms that patriarchal society takes, whether it is feudal, capitalist or socialist, a sex-gender system and a system of economic discrimination operate simultaneously. Patriarchy has power from men's greater access to, and mediation of, the resources and rewards of authority structures inside and outside the home. (Humm 1989: 156)

6. See Bucholtz (forthcoming) for an extensive discussion about female geeks and geek feminism. See also the Web site *Geekgirl Global* at < http://www.geekgirl.com >

7. When searching the term "girl" on the Net, one usually get a great number of hits to sites with explicit sexual content. The term girls, for example "Girls! Girls! Girls!" (often used on the signs of strip bars) is, to men especially, indicative of fun, sex, the illicit etc.

8. Internet came along earlier than the World Wide Web, and included media such as MUD (see chapter 3 in this volume), IRC, email. The World Wide Web consists of Web pages written in HTML, who include pictures, sounds, video, whereas only simple text and the downloading of pictures, sounds etc. was possible on the early Internet.

9. A Web ring is a site that links to a collection of sites in a certain area of interest. The sites linked by the main page also links back to it, and preferably also to other sites in the Web ring.

10. See, for example, Landow (1992) and Aarseth (1997).

11. For the history and politics of "open source," see Dibona, Ockman and Stone: *Open Sources: Voices from the Open Source Revolution* (1999). According to Dibona et al. (1999: 3), the idea of open source is related to the idea of free speech.

12. See, for example, Landow (1992/1997: 77-83), who speaks about the borderless text.

13. < http://www.drrling.se/nr4/grrls >

14. Women's magazines are dependent on advertisers, and to please these, even the editorial features have incorporated elements about goods, shopping, and consumption.

15. Women and young people have less power than other groups (e.g., middle-aged men) in most societies, and young women belong to both of these groups.

16. A common definition of a feminist is someone who thinks there is inequality between the sexes and is prepared to do something about it.

17. See, for example, Hirdman (1996; 2000); Bordo (1993).

18. A closer look at *Silikon* shows that there is nothing very feminist about it. Makeovers and shopping tips are mixed with intimate talk about sex and relationships in the "girl couch." Occasionally, there is a feature about girls' playing hockey or being raped; these are always dealt with in a very superficial manner.

19. See the boob files: < http://http://magzine.gurl.com/looks/boobs/index.html

20. It is, however, important not to build up false dichotomies between second- an wave feminisms. In the 1970s, known feminist Gloria Steinem wore miniskir button that read "Cunt Power" (Hex 2000), and in year 2001 there are both "f fatales" and aggressive looking young feminists in Dr Marten boots, dread loc numerous piercings.

21. See also the first issue with Hamberg as its chief editor, *VeckoRevyn* no 21, Aug. or an interview with her (Persson 2000). The biggest change is banning the c of the Miss Sweden contest from the magazine.

22. Butler 1990; Jagose 1996.

23. A common double standard in women's magazines is the publishing of fashion with thin models and diet advice next to not always low-cal recipes.

24. Ironic enough, *Darling* has received criticism from both readers and the m using "anorexic" models in its fashion spreads.

25. "Darling of the Month" is a recurrent feature in *Darling*, something that is sh the entertainment-oriented Friday supplement of the Swedish tabloids. These ments also feature "Babe of the Week," usually some famous artist or actor, not or seminude woman! The darlings of *Darling* usually have their clothes on, t the theme of this month's issue was nudity. The image text: "But he hasn't any on?" can also be seen as a reference to H.C. Andersen's famous story about i peror's new clothes.

26. See, for example, Finkelstein (1999) and Tobias (1997).

27. Sheila Tobias (1997) describes how Betty Friedan wrote about the dreary live housewives of the 1950s, or "the problem that has no name" in *The Feminine M* Even if they were seen to have everything they could want when it came to mat longings, many women felt dissatisfied. The book became one of the starting for the second wave of feminism in the United States.

28. The correct semiotic term for these is "symbols," but on the Internet, the c symbols are commonly referred to as icons.

29. See Moi (1985/1987: 31-41); Moi (1999: 173-177).

30. This is evident when one looks at both graphics and content in the new *Veck* Immediately after *VeckoRevyn's* new look, however, *Darling* also changed to dist self from the style now taken over by the mainstream print magazines.

References

Grrlzines
Bust accessed 17 July 1999 < http://www.bust.com >
Chickclick accessed 6 November 1999 < http://www.chickclick.com >
Corky accessed 2 December 1999 < http://www.corky.nu >
Darling accessed 23 June 1999 < http://www.drrling.se >
Disgruntled Housewife accessed 4 August 1999 < http://www.disgruntledhousewife
Geekgirl April–June 1999 Issue, accessed 10 May 1999 and "Crush the millennium"-
 accessed 8 December 1999 < http://www.geekgirl.com.au >. (By 2001, Geekgir
 to be nowhere in sight on the Web.)
gURL accessed 23 April 1999 < http://www.gurl.com >

Lumumma accessed 2 November 1999 <http://www.lumumma.com>
Razzberry accessed 28 March 1999 <http://www.razzberry.com>
Riotgrrl accessed 24 March 1999 <http://www.riotgrrl.com>
Smile and act nice accessed 5 August 1999 <http://www.smileandactnice.com>

Interviews
With *Darling* editor 4 February 2000
With *Corky* editors 14 February 2000

Literature
Aarseth, Espen. *Cybertext: Perspectives on Ergodic Literature*. Baltimore: John Hopkins University Press, 1997.
Altculture: Riotgrrrls, access date 16 December 1999, <http://www.altculture.com/.index/aentries/r/riotxgrrrl.html>
Baym, Nancy. "The Emergence of On-Line Community" In *Cybersociety 2.0: Revisiting Computer-Mediated-Communication and Community*, edited by Steve Jones. Thousand Oaks, Calif. Sage, 1998.
Beauvoir, Simone de. *The Second Sex*. New York: Knopf, 1957.
Beck-Friis, Ulrika. "Spegel, spegel på väggen där . . ." *Svenska Dagbladet* 31 December 1998.
Björk, Nina. "Alice Bah tog över. I Vecko-Revyn byttes bantningsråd ut mot hur man gör karriär" *Dagens Nyheter* 9 December 1999.
Bordo, Susan. *Unbearable Weight: Feminism, Western Culture, and the Body*. Berkeley: University of California Press, 1993.
Braidotti, Rosi. *Cyberfeminism with a Difference*. access date 11 November 1999 <http://www.let.ruu.nl/womens_studies/rosi/cyberfem.htm>
Bucholtz, Mary. "Geek Feminism. "In Proceedings of the First Conference of the International Gender and Language Association. Stanford: CSLI (forthcoming).
Butler, Judith. *Gender Trouble: Feminism and the Subversion of Identity*. New York: Routledge, 1990.
Cherny, Lynn and Elisabeth Reba Weise, *Wired Women: Gender and New Realities in Cyberspace*, Toronto: Seal Press, 1996.
Connery, Brian A. "IMHO: Authority and Egalitarian Rhetoric in the Virtual Coffeehouse" In *Internet Culture*, edited by David Porter. New York and London: Routledge, 1996.
Dibona, Chris, Sam Ockman and Mark Stone. *Open Sources: Voices from the Open Source Revolution*. Sebastopol: O'Reilly, 1999.
Duncombe, Stephen. *Notes from the Underground: Zines and the Politics of Alternative Culture*. London and New York: Verso, 1997.
Dyer, Richard. "Don't Look Now." In *Screen* 23 no. 3-4 1982.
Finkelstein, Norman H. *The Way Things Never Were: The Truth about the "Good Old Days."* New York: Antheneum Books, 1999.
Fornäs, Johan. *Cultural Theory and Late Modernity*, London: Sage, 1995.
Fraser, Nancy. *Justice Interruptus: Critical Reflections on the "Postsocialist" Condition*. New York: Routledge, 1997.
Fraser, Nancy: "Rethinking Recognition," *New Left Review* 3, May/June issue (2000): 107-120.
Friedan, Betty. *The Feminine Mystique*. New York: W. W. Norton, 1963.
Geekgirl Global, access date 6 October 2000, <http://www.geekgirl.com>
Goffman, Erving. *Gender Advertisements: Studies in the Anthropology of Visual Communication*. London: Macmillan, 1979.

Habermas, Jürgen. *Structural Transformation of the Public Sphere.* Cambridge, UK: Polity Press, 1962/1989.

Hawthorne, Susan and Renate Klein, ed. *Cyberfeminism: Connectivity, Critique and Creativity.* Melbourne: Spinifex, 1999.

Hex, Celina. "Fierce, Funny, Feminists: Gloria Steinem and Kathleen Hannah Talk Shop, and Prove that Grrrls—and Womyn—Rule." in *Bust,* no. 16, 2000.

Hirdman, Anja. "Veckotidningen och damrummet." In *Medierummet,* edited by Jan Ekekrantz and Tom Olsson. Stockholm: Carlssons, 1996.

Hirdman, Anja. "Male Norms and Female Forms" In *Picturing Politics: Visual and Textual Formations of Modernity in the Swedish Press,* edited by Karin Becker, Jan Ekekrantz and Tom Olsson. Stockholm: JMK Skriftserien, Stockholm University, 2000.

Humm, Maggie. *The Dictionary of Feminist Theory.* Hemel Hempstead: Harvester Wheatsheaf, 1989.

Jagose, Annamarie. *Queer Theory: An Introduction.* New York: New York University Press, 1996.

Jameson, Frederic. "Postmodernism and Consumer Society." In *The Anti-Aesthetic: Essays on Postmodern Culture,* edited by Hal Foster. New York: The New Press, 1983/1998.

Jensen, Jens F. "'Interactivity': Tracking a New Concept in Media and Communication Studies." in *Nordicom Review* 19, no. 1 (1998): 185–204.

Johansson, Linna. "Du får Damernas Värld istället." In *Bleck* no. 2 (2000): 11.

Klein, Kajsa. "www.oneworld.net. Internet och den kosmopolitiska demokratin." In *IT i demokratins tjänst,* edited by Erik, Amnå: SOU 1999: 117. Demokratiutredningens forskarvolym VII, Stockholm: Fakta Info Direkt (1999): 129–156.

Kollock, Peter. "The Economies of Online Cooperation: Gifts and Public Goods in Cyberspace." In *Communities in Cyberspace,* edited by Marc A. Smith and Peter Kollock. London: Routledge, 1999.

Ladendorf, Martina. *Skönhetens roll. Åtta medelklasskvinnor om attityder, praktiker och förebilder,* Master's dissertation in Media and Communication Studies, Department of Journalism, Media and Communication (JMK), Stockholm University, 1996.

Landow, Georg. *Hypertext: The Convergence of Contemporary Theory and Technology.* Baltimore: Johns Hopkins University Press, 1992.

Larsson, Lisbeth. En annan historia. Om kvinnors läsning och svensk veckopress, Stockholm and Stehag: Symposion, 1989.

Levy, Madelaine. "Kathleen Hannah" in *Bibel* no. 8 (1999).

Marres, Noortje and Richard Rogers. "Depluralising the Web, Repluralising Public Debate: The Case of the GM Food Debate on the Web." In *Preferred Placement,* edited by Richard Rogers. Maastricht: Jan van Eyck Akademie Editors, 2000.

McCracken, Ellen. Decoding Women's Magazines: From "Mademoiselle" to "Ms." London: Macmillan, 1992.

McHugh, Michael P. "From E-zines to Mega-zines" in *Networker,* November/December 1996, access date 21 April 1999. < http://www.zinebook.com/resource.html >

McRobbie, Angela and Jenny Garber. "Girls and Subcultures." In *Feminism and Youth Culture: From Jackie to Just Seventeen,* edited by Angela McRobbie. London: Macmillan, 1991.

Moi, Toril. *Sexual Textual Politics: Feminist Literary Theory.* London and New York: Routledge, 1985/1987.

Moi, Toril. *What Is a Woman? And Other Essays.* Oxford: Oxford University Press, 1999.

Mulvey, Laura. "Visual Pleasure and Narrative Cinema." In *Visual Culture: The Reader,* edited by Jessica Evans and Stuart Hall. London: Sage, 1975/1999.

Owens, Craig. "The Discourse of Others: Feminists and Postmodernism." In *The Anti-Aesthetic: Essays on Postmodern Culture,* edited by Hal Foster. New York: The New Press, 1983/1988.

Persson, Kjell B. "J och L möter Emma Hamberg." *Nöjesguiden, Malmö och Lund,* September 2000.

Rivière, Joan. "Kvinnligheten som maskerad" in *Diwan* no 5, 1992.

Scott, Krista. *"Girls Need Modems!" Cyberculture and Women's Ezines.* Master's research paper, Graduate Women's Studies, York University, access date 21 April 1999, <http://www.zinebook.com/resource.html>

Smith, Dorothy. "Femininity as a Discourse." In *Texts, Facts and Femininity,* London and New York: Routledge, 1990.

Steiner, Linda. "The History and Structure of Women's Alternative Media." In *Women Making Meaning: New Feminist Directions in Communication,* edited by Lana F. Rakow. New York and London: Routledge, 1992.

Tobias, Sheila. *Faces of Feminism. An Activist's Reflections on the Women's Movement.* Boulder: Westview Press, 1997.

Tseëlon, Efrat. *The Masque of Femininity: The Presentation of Woman in Everyday Life.* London: Sage, 1995.

Wakeford, Nina. "Networking Women and Grrrls with Information/Communication Technology: Surfing Tales of the World Wide Web." In *Processed Lives: Gender and Technology in Everyday Life,* edited by Jennifer Terry and Melodie Calvert. London and New York: Routledge, 1997.

Wahl, Anna, Charlotte Holgersson, and Pia Höök. *Ironi och sexualitet: Om ledarskap och kön.* Stockholm: Carlssons, 1998.

VeckoRevyn no. 21. 2000.

White, Cynthia L. *Women's Magazines 1693–1968.* London: Michael Joseph, 1970.

Winship, Janice. *Inside Women's Magazines.* London & New York: Pandora, 1987.

5 *Kajsa Klein*

CYBERGLOBALITY: PRESENTING WORLD WIDE RELATIONS

> We remain handicapped by a change-resistant
> culture, inadequate information technology
> infrastructure, lack of training and, above
> all, failure to understand the great benefits
> that information technology can provide when
> used creatively . . . There is enormous scope
> for the entire United Nations system to
> become better integrated, on-line, providing
> the world's people with information and data
> of concern to them.[1]

This assessment is taken from the Millennium Report *We the Peoples* by the UN Secretary-General, Kofi Annan. "Information technology infrastructure, UN system Web sites: how boring," you might think. I argue that the consequences of what Annan envisions—a better integrated UN system online—could be far-reaching, innovative, and, cosmopolitical.

Globalization, as I see it, presupposes cooperation and standardization and is experienced through shared symbols and simultaneous media events. Historically it has been tightly linked both to general modernization processes and to the development of specific new communication technologies. Right now it is the Internet that is considered the most important medium of globalization. The World Wide Web is for instance by nomination worldwide; a global, globalizing medium—does this make it all-inclusive in practice? Of course not; to paraphrase James Rosenau (1997: 81) the processes of globalization are only *capable* of being worldwide in scale. The world has not yet seen such a thing as complete planetary penetration. In practice, globalization is embedded rather than overarching. This is naturally also true of what I refer to in this chapter as "cyberglobality," the global pretensions and expectations, and, to a lesser extent, the global realities of the Internet. Cyberglobality is, like globalization more generally, about local manifes-

tations—sites. It can be captured through an analysis of any Web site, including seemingly peripheral personal home pages.[2]

My choice of study object has to do with the offline world. The starting point is that the UN is *the* world organization. Despite the long list of shortcomings and unfulfilled hopes associated with it, few would dispute its central role in world affairs. To quote the Millennium report (2000: §319) again, the UN is "the only global institution with the legitimacy and scope that derive from universal membership, and a mandate that encompasses development, security and human rights as well as the environment." Another reason why the UN is interesting to analyze is its contradictory nature: United *Nations* as a *global* institution with *universal* membership.[3] Rosenau (1997: 387) describes it as a "bridge across the frontier that separates states in the state-centric world and NGOs (Non Governmental Organizations) and other actors in the multi-centric world." This perspective has much merit to it, especially if the entire UN *system* of organizations (the UN itself, its programmes and funds as well as specialized agencies, WTO, and the Bretton Woods institutions) is taken into consideration.[4] The system can be said to mediate between private and public, between people and peoples, and between human rights and national interests. A bridge, however, also invokes something rather static and passive: are these really suitable characteristics of the UN system? Is mediation all it actually does?

Globalization is, according to Zygmunt Bauman (1998: 58–60), about unintended global *effects* rather than global *initiatives* and order-*making*. It is something that *happens to* us, regardless of whether we like it or not. This story is partly about how the UN is adapting itself to globalization. Saying that, it is also important to point out that globalization entails cooperation. Indeed, twentieth-century-style internationalization, of which the UN system is a direct result, can be seen as crucial to the globalization process. Even now, in the twenty-first century, states still count, and if all governments suddenly were to choose isolationism and protectionism, globalization would be seriously undermined. It takes work to sustain connectedness. What if people suddenly stopped traveling and shopping across borders, stopped emailing? What if presidents lost patience with interpreters, jet lag, over-negotiated paragraphs, pressing police violence and pissed-off anti-globalization protesters? These are questions with alarming actuality, not least after the 11 September events in fall 2001 and the so-called "war on terrorism."

At the heart of this chapter, is the interplay organization—the Web site. The discussion draws primarily on arguments developed from cybercultural studies, from democracy theory, and from organization studies. In some ways it is a critical discourse analysis.[5] Power relations are foregrounded; I look at identities, representations, and relations. The media text is seen as a product of a number of more or less motivated and conscious choices. It is assumed that the texts do a lot more work than simply mirror reality, which is why the choices are so important. Throughout the text I will quote extensively from the Web sites. One document is given particular weight: "We the Peoples," the Millennium report of Kofi Annan.[6]

But I also move beyond the Web text and look at the production side. A substantial part of the analysis is based on interviews with webmasters. In addition, I make use of Web-specific tools such as link analysis and search-engine results.

I start by looking at how the UN is presented to the public, at the UN New York Headquarters (NYHQ), and on the Web. What is included, what is excluded? The question is, ultimately, to what extent facilities for being a world citizen are provided on the sites. Second, I turn to production. How have the Web sites developed over time? How autonomous are the webmasters? Third, is there a coherent UN system Internet policy? What are some of the major issues? The fourth section is about placement and partnerships. Where is the UN system placed on the Web and what are its relations as visualized in linking? I point to public-private partnerships as a major trend, arguing that the UN, as it adapts itself to globalization, is slowly moving towards heterarchy (an organizational form characterized by diversity and minimal hierarchy). The concluding section, "People vs. peoples," binds together thoughts on the limitations of politics at the global level with a critique of cyberglobality in the UN system shape.

The UN NYHQ and the UN on the Web

```
Welcome to the UN. It's your world.
<title> UN routing page <http://www.un.org>
```

In this section I will juxtapose a "real," physical visit to the UN New York Headquarters with material from the UN Web site. How is the organization presented to the world? What are the linkages and overlaps between real and virtual? All quotes in the courier type font indicate quotes from the Web, here from the alphabetically organized "information guide for the public about the UN" section.[7] After the introduction with the physical visit as starting point, a look at organizational self-presentations and an overview of the different Web sites and their top pages.

United Nations, First Ave. & 42nd St., New York, NY 10017. First there is a security check. The next thing you see is the lobby. To the left a reception desk, to the right elevators and a stairway leading to the basement (or "public concourse level" as it is officially called). Straight ahead, a small exhibition area. In the basement there is the Gift Centre, a bookshop, a post office and a coffee shop. This constitutes the public part of the UN New York Headquarters—public because it is open to world citizens (presumably people wealthy enough to be in New York and people interested enough to check it out). Let us walk down the stairs.

```
Welcome to the United Nations Bookshop, the
premier source for books on global issues,
some of which are available in English,
French and Spanish and other languages. But
the Bookshop carries more than just books. It
```

has a vast collection of international gift
items from desk flags and postcards of 185
Member-States, to language books for the
students or the international traveller,
international cookbooks of exotic dishes from
all over the world, posters of historical
conferences and United Nations souvenirs for
the avid collector.

This sounds very "global" and "international." In the shop and online you can for
example get:

The DO's and TABOOs of Body Language Around
the World.
Over 200 gestures used in 82 countries
141 whimsical and informative illustrations
Rules of decorum such as how close to stand,
eye contact, and when, what and how to touch
Price: $15.95

No? Try the Gift Centre instead:

The Gift Centre, located in the Public
Concourse at UN Headquarters, carries a
variety of United Nations and New York City
souvenirs, unique handicrafts and a wide
selection of international gifts and
accessories from around the world.

In the shop there is a noticeable division between the larger space for international
gifts, organized by Member State (at the left) and the smaller UN and New York
souvenirs area (at the right). "Don't mix Estonia with New York, keep China away
from the UN," seems to be the logic. All Member States are not represented and
the simple explanation is that the purchaser is only able to buy items from diplo-
mats who have their papers in order (including their U.S. social security num-
bers). Let us now move on to the "Post Office."

The United Nations is the only organization
in the world which is neither a country nor a
government that is permitted to issue postage
stamps. In arrangements with postal
authorities in the US, Switzerland and
Austria, United Nations Postal Administration
issues stamps in three different

```
denominations, namely US dollars, Swiss
francs and Austrian schillings.
```

Better take the opportunity! The books you can always get later on the Web, but the stamps . . . Speaking of stamps, what about passports?

```
The United Nations is an organization of
sovereign States and not a world government.
It therefore does not confer international
citizenship status, nor does it have
information on this question. The issuance of
passports, other travel documents and visas
to private individuals is exclusively a
function of national authorities.
```

Too bad. Perhaps check out the exhibit on the first floor before we leave? Among the themes during the year 2000: "Visions of a new millennium" (artwork by "global children" [*sic!*] What are *global* children?); "Orbit" (view of the earth from outer space, by *National Geographic*); "One heart, One world" (inspired by poems written by the physically challenged); "Our World in the Year 2000" (for UNICEF); "UNRWA—50 Years of assisting Palestinian refugees."

Confused? As I have tried to show in this short introduction, there are several strong links between the UN Headquarters and UN on the Web. It is sometimes quite difficult to distinguish between real and virtual, original and copy.[8] Most of the above-mentioned exhibits are accessible on the Web site. Which is the main exhibition, the one on the Web or the one in New York City? The invisible is also interesting. Just as the public lobby and basement is all you get to see as a visitor, there is a lot of digital stuff that you don't have access to. The UN has a public Web site, but it also has a private Intranet (albeit mostly with "housekeeping stuff," from what I'm told). As a world citizen, one needs special permission to access the private areas. The highly restricted guided tour in the meeting room facilities has a virtual, even more restricted counterpart. Is this all there is to the UN on the Web, or does the site in some ways manage to go beyond the NYHQ version of global publicity? Let us start anew, this time at the top pages of the Web sites, but first, a brief theoretical explanation of what presenting an organization on the Web entails.

Organizational Self-Presentations

The issue of self-presentation concerns the power of words and images but also the relation and dynamics between presentation and what is being presented. Manuel Castells (1997: 70) has argued that social movements must be understood through how they present themselves, "they are what they say they are." What about international organizations with social movement elements: is Castells' statement

applicable to the UN system? Is it reducible to what it says it is? Not quite—there are important material aspects of the work of the organizations that should not be overlooked, and at times there are important gaps between image and reality.

Andrew Barry (2001:23) is somewhat less drastic than Castells; he describes institutions as experts in self-presentation. Reports, press releases, mission statements and policy documents divide the inside from the outside: "They establish a space within which professional and scientific work and business is possible. But they also serve to protect the expert, and the institution, from public scrutiny of the (inevitably) imperfect exercise of technical skill and expertise." Barry, influenced by Bruno Latour and Michel Foucault, emphasizes the professional and control aspects of self-presentation. Other analysts have, following Goffman's (1959) distinction between expression given and given off, pointed to the involuntary components, see for example Sveningsson's chapter on "Cyberlove" in this book, or Chandler (1998) on identity construction and personal home pages. Completely left out in Barry's list of "elaborate literary technologies" for dealing with the problem of self-presentation is the Internet. This is a little strange, since I think it is fair to say that the invention of the Web site revolutionized organizational self-presentation. The home page was more than just a new document type; it offered radically new possibilities, to the extent that there are now organizations best described as Web-based.[9] What does the presentation "present?" If personal home pages deal with the "Who am I?" question, then organizational home pages generally attempt to answer "Who are we?," alternatively, "What is the organization?" Does this mean that everything on a given home page is self-presentation? The totality of the home page could be, in my view, interpreted as such; however, more explicit and coherent versions are usually found under headers such as "About x'" or "Organization." Usually these are very carefully and consciously constructed. They are collective resources, or to use Charles Tilly's (1998) term, they are *standard* stories constraining social interchange. Tilly describes how people's construction and deployment of standard stories in the context of contentious politics do a wide variety of work (e.g., self-justification, mobilization, moral condemnation, and cementing of agreements). In the case of Web sites one might add globalizing and standardizing work. There is much more to the sites than just mere self-presentation. This is something I will expand on at the end of the chapter.

What does the medium do to the presentations? Four aspects are particularly important. The first can be captured in the popular expression *"under construction."* To keep identities flexible on the Web is relatively easy and many home pages are indeed continually updated. This gives the presentations an ephemeral, dynamic, at times almost performative quality; which can be problematic for Web site analysts. There are no online wastelands or exhaustive archives. In some cases, however, the development of sites can be traced in "recent additions" sections and the like. The second aspect is *"hyperlink diplomacy."* What makes the Web so special is that it is based on hypertext. A home page never exists in isolation. Placement, power relations, and popularity are made visible in links. Geographical and architectural metaphors are common, there is talk about real estate prices, Web centers,

and digital peripheries. The third aspect, *"coproduction,"* is a form of interactivity (see also Ladendorf, this book). Who is the producer of a Web site? Is it the official responsible for keeping together the standard story? Is it the programmer who wrote the code? Is it the user who provides irreverent feedback in the chat forum? Coproduction acknowledges the complexity that digitalization tends to introduce. The fourth aspect is *"multimedia."* Home page presentations often incorporate images, sound and video clips. Creative or disturbing? One thing is certain: the Web is the most inclusive medium ever; its visual style privileges fragmentation, heterogeneity and endless remediations.[10]

"Inclusive" is also true of the UN, and its organizational complexity is as we shall see well reflected online. The next section provides an overview of UN system Web sites.

Different Sites—an Overview

The first thing that struck me when I started to analyze the UN on the Web was its multiplicity and diversity. There are a lot of different Web sites. Nearly all UN programmes and funds have their own URLs. There is, besides the New York Headquarters site, the Geneva site, the Vienna site, and the Nairobi site. Thirty-one UN information centers have developed their own sites in 17 languages, "to deliver the United Nations message and materials in local languages and adapted to the local context," as explained in a report on the multilingual development of the sites.[11] Then there is a UN Intranet, a United Nations Development Programme (UNDP) Intranet, and so on, not to mention all the rest of the UN system organizations' sites.[12] In addition to all the organizational home pages, finally, crosscutting sites like < http://www.developmentgateway.org > and < http://www. onefish.org > are being developed.

Where did it all start? I haven't managed to get this confirmed—which is in itself rather telling—but rumor has it that the very first UN system Web site was that of the United Nations International Drug Control Programme (UNDCP). In an email, Anders Norsker at the Information Support Unit says that the programme "went live" in 1994: "I do not know whether we are the oldest but [we are] definitely one of the first." Norsker adds that the UNDCP assisted a few other UN organizations in establishing their Web sites and that the *New York Times* nominated UNDCP, also back in 1994, as the lead agency within the UN system working with the Web.

However, just as is the case with the World Wide Web itself, the UN system on the Web is not an entirely decentralized and chaotic affair. There is some order to it, and one of the ways this is imposed is through linking. In the comparison above (and in the rest of the chapter) I have chosen to include the four sites that I see as particularly central. The sites are quite different from each other in age, popularity, size, and scope.

The largest and oldest is < http://www.un.org >, the UN New York Headquarters site. The Member State site < http://www.un.int > offers access to permanent

mission Web pages (the missions use UN server space but have full responsibility for content). The two UN system sites: < http://www.unsystem.org > and < http://acc.unsystem.org >, finally, are closely related to each other. The first is the official UN System Web Site Locator, the second is the home page of the Administrative Committee on Coordination (ACC). As table 1 shows, both sites are rather small, especially compared to < http://www.un.org >. What about users? The most simple measure of a Web site's popularity is number of hits. In 2000 the UN site got approximately 1,000,000 hits per day (4,000,000 in 2001). For < http://www.unsystem.org > the figure was 50,000.[15]

TABLE 5.1: Central UN Web Sites

Web site	Age (year of foundation)	Size (number of pages)[13]	Language (top page)[14]
< http://www.un.org >	1995	36,667	English, French, Spanish, Arabic, Russian, Chinese
< http://www.unsystem.org >	1997	404	English, French, Spanish
< http://acc.unsystem.org >	1999	50	English
< http://www.un.int >	1999	2,183	English, French

Of special importance, as in all kinds of Web sites, are top pages.[16] They are simply most central, hierarchically speaking. Often they function as both index and title page, and they add some truth to the cliché that first impressions last. A poorly designed top page can scare away potential return visitors. In the next section, I take as the starting point the top pages of < http://www.un.org >, < http://acc.unsystem.org >, and < http://www.unsystem.org >.

The UN Home Page

First there is a routing page on which all six official languages are given equal weight. The < title > is: "Welcome to the United Nations. It's your world." Next comes the top page. The Web site dates back to 1995 but the current version was released on 5 September 2000. Before, the top page used to be dominated by the division in the UN Charter between peace and security, international law, human rights and so on.[17] With the facelift, more categories were added and people were put into the picture—eight representatives of the world citizens, four women and four men of different age and color. The text "We the peoples" gives associations to the Charter (and that's where you go if you click on it) but also to the Secretary-General's Millennium Report. Pop-up boxes tell you what's hidden beneath the navigation buttons.

The Web site has over 36,000 pages, so in this overview I will be able to touch on only a few of the major categories of information. I will start with "Main Bodies" (General Assembly, Security Council, Economic and Social Council, Trusteeship Council, International Court of Justice, and Secretariat). Noteworthy in the presentations is the tension in terminology between international and universal, and between organization and Member States. Here are just a few examples: The UN Security Council has responsibility for the maintenance of

"international peace and security." The Economic and Social Council (ECOSOC) was established to promote higher standards of living and to work out solutions to ". . . international economic, social, health, and related problems; and international cultural and educational cooperation; and (c) universal respect for, and observance of, human rights."[18]

The Secretariat (where the site is produced) has 8,600 employees. In the presentation it is made clear that they answer to "the United Nations alone for their activities . . ." They are even obliged to "take an oath not to seek or receive instructions from any Government or outside authority . . ."[19]

The head of staff is the Secretary-General, "both spokesperson for the international community and servant of the Member States—roles that would seem to guarantee some amount of friction."[20] Information about the Secretary-General can also be reached through a link from the "Secretary-General" button of the top page. Note that it is placed on the right column. The General Assembly's president goes on the left (a better placement). Hierarchically, the president is the most important of all UN personnel, and in this formal, political context it does not matter that Nobel laureate Kofi Annan is who people are looking for.

"Main bodies" is an example of a general interest item. Others include the Charter, the Declaration of Human Rights, the Information Guide for the Public about the UN. These are available in all six official languages. The part of the site with lowest proportion material in Arabic, Chinese, French, Russian and Spanish is the News Centre. This section does not consist only of press releases, it includes continually updated Web-specific content, created as part of the organization's attempts to "meet the challenges of the 24-hour global news cycle." Structurally related to the News Centre are the other multimedia sections, including radio, photo, video and web casts of everything from press conferences to General Assembly sessions to special events for NGOs and students.

An important part of the site is the section on international law <http:// www.un.org/law>. It is very extensive, almost a Web site in its own right. This only reflects the state of affairs: the rule of law, between states as well as within states, is a UN priority area.[21] Some documents are available free of charge, others (e.g. the UN Treaty Collection) have restricted access. Private islands of public international legislation—strange! The great number of documents is a real challenge, and some mistakes are inevitable. At times, however, the result is very confusing. Consider this example: 70% of the earth's surface falls under the UN convention from 1982 on the Law of the Sea. If you click on "Law on the Sea" you end up at a page where at the bottom you find an invitation to participate in a WHO survey on preferences for health systems performance assessment.

The UN traditionally dealt with *inter*national peace and security—with states and regimes, not people; with borders, not cities. This is as we have seen still reflected

in the presentations of the main bodies above but if you look at the international law section you get a different impression. What is the real scope of the UN today? One way to answer that question is to consult "Global Issues on the UN agenda."[22] I don't have the space here to cover all 43 items, only enough for a few observations. Most striking is actually that the list is so long that very general policy areas are labeled global (education, health, energy). Positive wordings dominate: development rather than decline, peace and security rather than war and insecurity. What is absent? You can find food on the list but not water, international finance, but not communication, culture, or religion. Men don't get a category of their own, unlike children, persons with disabilities, family, indigenous people, refugees, women, and youth. Those seven groups can be seen as the "patients," the "others" that need recognition and special attention. What about regions? There is the "Africa Initiative," the "Least Developed Countries," "outer space," and, finally, the "question of Palestine." How should these inclusions and exclusions be interpreted? Do they represent arbitrary "othering" on a massive global scale, or are they simply expressions of pragmatic politics to combat injustices and discrimination? Noteworthy is also that no individual Member States are mentioned in the list; this could be because information about individual states is considered a private matter in the UN context. In paragraph 22 of the "Information guide for the public about the UN" is the uncompromising sentence: "The United Nations provides no information on individual Member States." The Web solution for this dilemma is the site < http://www.un.int >, where the UN provides server space for the permanent missions to create their own home pages. Not all Member States are represented, however. At the time of my survey (July 2000), the number was 85 (of 189). I cross-checked with the Human Development Index (UNDP 2000) and found that 77% of the 45 high "human development" countries, 50% of the 94 medium human development countries, and 26% of the low human development countries had Web sites.[23] Quite striking![24]

From the right hierarchically inferior column of the top page is a link to "UN Works." These pages are interesting in that they focus on particular individuals. The explicit aim of this promotional campaign is to link the issues on the UN agenda to "the issues of people."[25] Another example of a similar approach is the "United Nations Year of Dialogue among Civilizations 2001" pages. The purpose is to encourage and facilitate worldwide dialogue through "interactive, intellectually stimulating pages." According to a Secretary-General report on the subject, it was designed to "appeal to all cultures and age groups."[26] The pages were, however, "under construction" and less extensive than the report suggests. Most developed, at the time of my visit, were "Eminent Persons" and "The Unsung Heroes of Dialogue." The first category lists celebrity UN supporters, such as Nadine Gordimer and Amartya Sen. The second category, "Unsung Heroes" consists of brief presentations of twelve individuals "from a spectrum of societies who have reached across the 'divide' to the 'other'." On the Web site it

is stated that "Examples are the best means to convey a message in a convincing manner."[27]

The UN constantly battles with advocacy vs. objectivity and impartiality demands, whether in "news," "international law" or campaign material like "UN Works." Realism is by far the dominating aesthetic choice, especially when it comes to reports and policy documents. This is not least visible in the many disclaimers, copyright notices and caveats (even on the top page!). The major exception to the rule, a place where play is allowed, is "Cyberschoolbus," the section for kids. It is funded by a Trust Fund for Education and has been one of the most popular parts of the site since it was created in 1999 (the most visited part is employment opportunities). Here, well-written overviews of policy areas, "UN-briefing papers for students" are mixed with "quizzes" and simplified versions of the UN Charter and UN Core Treaties. Interestingly, the picture of the organization conveyed to youth is sometimes more realistic than in the adult version. Cyberschoolbus uses explicit language. Consider this paragraph:

> What the structure does not show is that decision-making within the UN system is not as easy as in many other organizations. The UN is not an independent, homogeneous organization; it is made up of states, so actions by the UN depend on the will of Member States, to accept, fund or carry them out. Especially in matters of peace-keeping and international politics, it requires a complex, often slow, process of consensus-building that must take into account national sovereignty as well as global needs.

We have thus seen a few snapshots of the UN site. Before moving on I want to point to the section of the site that I personally visit most often. It is "recent additions." Here, all the major updates of the site since 1997 are listed: very useful! Table 5.2 is mainly based on this information; it shows the expansion of the Web site 1995–2000.

TABLE 5.2: UN home page time line

1995	1996	1997	1998	1999	2000
English	French and Spanish	Web versions of Image & reality, UN chronicle, UN Bookshop	Russian, Arabic, Chinese. Daily radio service, live Web casts	Cyber schoolbus, UN & Civil Society, and UN & Business	Top page facelift Reports, resolutions and treaties

The ACC Home Page

The top page of the Administrative Committee on Coordination (ACC) site is dominated by a globe and hyperlinked logos of 17 of its members. Compared with <http://www.un.org> the site is still in its infancy. It has not undergone any major changes since it was first created. The current version, as of this writing, is 1.0. From the top page there are links to ACC submachinery including secretariat contact information, there are also links to important documents such as annual reports and draft conclusions from meetings. Here I focus on the sections of the site that provides the "standard story."

What is the ACC? It could be called the cabinet of the UN system, because all chief executives (including the chair, Kofi Annan) are represented in it. Or perhaps the ACC is a poor cousin to the EU Commission. A third alternative would be to see it as an elite network, a discussion club with the purpose to make the UN system work better. However, it is always much safer to stick to the explanations taken from the Web site; self-presentations on home pages are official. At <http://acc.unsystem.org>, you learn that the ACC was established in 1946 by ECOSOC Resolution 13. It meets twice a year and its members are the UN programmes, funds, but also the UN specialized agencies with responsibilities ranging from health to agriculture and employment, the WTO, Bretton Woods institutions. It is the ACC that deals with the global conferences convened by the UN (in the 1990s, notably those on sustainable development, population, human rights, and women). The ACC issues recommendations; its decisions are in other words not legally binding.

Why is the committee called "administrative" when much of the work consists of coordination of the development work? The explanation given in the Web site's FAQ section is that it has to do with its composition "the executive heads of the organizations of the UN system as distinct from their Member States—in the same way as, in the Charter, the Secretary-General is referred to as the Chief Administrative Officer of the Organization."

There is a major difference between the UN Secretary-General and the ACC, however. Whereas Kofi Annan is a global symbol, the ACC is virtually unknown. In the UN system Organigram the committee is invisible. There is something very contradictory about the fact that the ACC produces the organizational chart but is not in the chart itself. In *Political Machines* Andrew Barry (2001) examines how the conduct of politics today is a technical matter and how technical innovation has become an important part of political life. To Barry the "political" is that which has been made contestable. The deployment of technology is often a way of avoiding the noise and irrationality of political conflict. It offers a set of practices and objects with which it is possible to evade and circumscribe politics. In my view, the ACC can be seen as an example of what Barry refers to as the "technical style of government." The term "committee" arouses much less suspicion than "cabinet" or "elite network."

Important to add to this picture is that most aspects of the ACC currently are in flux. In recent reports there is even talk of renaming it to clarify its function.[28] The proposed new name is Board for Chief Executives (BCE) of the United Nations system. A new Web site is under construction.

The UN System Locator

The site was created in 1997 and is the official listing of UN system Web sites. All UN system organizations have agreed to have a link to this site on or near their home pages. The UN System Locator could be described as a portal, with a meta dimension. Mann and Stewart (2000: 221), define portal as "a marketing term used to describe a Web site that serves as a starting point to other destinations or activities on the World Wide Web. Portals commonly provide services such as email, online chat fora and original content."

For a portal, < http://www.unsystem.org > is thin. The top page is dominated by a long, hyperlinked alphabetical listing of the organizations. There are no email or chat services, and very little original content. Minimalist does not necessarily have to be bad but the language at the site is sometimes a little technical. In the "about" section it is for instance pointed out that the design work was performed "in compliance with W3C and CAST guidelines."

Interesting in terms of inclusion/exclusion, are the 20 sites selected for "UN System Highlights." Most noteworthy, if you consider the list of sites is that peace and security—what many see as the core areas of the UN—are absent. Many of the Web sites are instead related to development, human rights, and ICT in one way or another. There are the charity sites (NetAid, TeleFood, the Hunger site), the conference sites (Infoethics 2000, the World Summit on the Information Society 2003) and the publications sites (the Millennium Report, the Human Development Report, translations of the Universal Declaration of Human Rights).[29]

In the December 2000 update of < http://www.unsystem.org >, the < title > was changed from "United Nations System" to "Welcome to the Official Web Site Locator for the UN System of Organizations." This is an interesting development. The previous title suggested that it was the official UN system home page. Now that the ACC Web site also exists, that would not have been possible. Gradually I have come to realize that the UN System Locator should be described as part of the ACC site. Why? If you look at the ACC top page, you get the impression that the UN System Locator is part of the site. In late 1999 the ACC (through its newly founded Secretariat, the Office of Interagency Affairs, OIAA) took control of the production of < http://www.unsystem.org >. It is also possible, however, to argue that the opposite is true, that the ACC site is part of the < http://www.unsystem.org > site, the oldest and most visited of the two. Technically "acc" is a "unsystem" subdomain. This is obviously a complicated and delicate issue. The Web site structure is under perpetual construction and ultimately its development concerns the status and autonomy of the UN system vis-à-vis its members. This discussion will continue throughout the

text and I will in most cases treat the unsystem as a semi-separate part of < http://acc.unsystem.org >.

Producing Global Web Sites

Here I address production. What are the design routines? How have the sites developed over time? The section is based on interviews with webmasters; I start with the UN HQ site and then turn to the two UN system sites. At the end of the section I look briefly at production policies and guidelines.

To get in touch with UN people online is difficult, at least if you use the general addresses. Who is the UN webmaster? The Web site gave me no clue, and my email to the address available on the site < webmaster@un.org > bounced back. How about at United Nations, First Ave. & 42nd St? The receptionists tried to direct me back to the Web site and then advised me to phone a person whose name I was told was confidential. To my surprise, it worked out: a few voice and email messages later I had an appointment. The webmaster is a former Bangladeshi reporter[30] who has now been working for the UN in almost 20 years. In 1994 he was appointed chief of the central news operation and that was where he saw the need for a Web site . . .

The interview took place 11 November 1999 in the webmaster's office.[31] First we talked a little about the situation back in 1995 when the Web site was created, ad-hoc fashion. Six people, two of whom were from the technology department, got together and set up the site. At the time there were already other sites around, like that of the UNDP and the UNDPC. The reason the UN Web sites developed in such a decentralized manner, the webmaster explained, had to do with how the UN as an organization functions. The UNDP went on the Web before the UN itself simply because they were more flexible budgetwise than the UN Secretariat.

Speaking of the "budgetary situation," in November 1999 there was still no official budget for < http://www.un.org >. The 17-person team headed by the webmaster was, with a few exceptions, temporary. In fact, when the webmaster and I met, the budget for 2000 and 2001 was being discussed and Member States made it clear that they were not interested in "multimedia fancy graphics."

What about the top page? The webmaster described it as a "classic example of design by committee."[32] They had requests for over 150 items to be included on the top page and everybody naturally wanted their item to be on top. "We finally had to fall back to the Charter, to figure out the main containers under which all the other things will be contained."

What were the general production routines? The webmaster had policy guidance from a number of groups including the Secretary-General's communications group. The team created very little Web-specific content up until the middle of 1999. Recycling and remediation, in other words, of print material they got from the "content creating offices." The library—apart from being a major document source—provided indexes and meta data to be incorporated with the documents.

Some Secretariat offices were allowed to post directly to the Web site in the interest of speed. The existence of the Web site has brought changes to the organization. The webmaster explained that even though they work in the same building they used to be very "compartmentalized," but that because of the Web site there has been a lot more interaction between parts of the Secretariat. The example he gave concerned the peacekeeping missions: "We need to have input from the department of peacekeeping operations, department of political affairs, the media division, and sometimes a special representative for the Secretary-General and a number of other offices."

Most of the content is politically sensitive, even when it comes to Cyberschoolbus. "Info Nation" is an educational feature with basic facts about the Member States. According to the webmaster, all the figures come from the governments. "We ourselves cannot go to Member States and collect the information. Because the UN itself is an intergovernmental organization, it will have to rely on the information that is given to the UN." Another Cyberschoolbus section is the "Flag Tag Game" (three flags come up randomly at a time and the challenge is then to match them to their countries). When the game was first added to the site, a Member State official complained, "Well, I don't want my flag to be beside this flag."

The webmaster emphasized that they wanted to reach everybody but realized that users had access to the Web as well as some degree of education and some level of interest in and understanding of the international system. "But there is no size fits all, that's why we have Cyberschoolbus." The UN site has a feedback section. At the time of the interview, they got about 3,500 emails a month. [33] The messages were routinely redirected to other departments and offices, especially to the Public Inquiries Unit. According to the webmaster, the feedback messages were used to make changes to the site. He exemplified this with the "What's New" section that was changed to "Recent Additions": "A lot of people told us that they thought that would be the area to find the latest news."[34] We have already seen that the average number of hits in 2000 was 1 million a day.

Where do their users come from? U.S. academia and private sector (dot.edu and dot.com) dominate, with Canada and Australia as other important domains. What else did they know about users? The webmaster mentioned a couple of highly targeted surveys (larger surveys were unfeasible because of the budgetary situation). The first was targeted to the permanent missions, the second to teachers about a specific publication dealing with basic facts about the UN. Late in 2000, a preprogrammed form was added to the feedback section (whose title was then changed to "comments"). It states that all comments and suggestions are read and appreciated and that the information is kept confidential. Users are also asked to rate the site according to usefulness as a scale of 1 to 5. Technical questions are referred to the webmaster's address and all other questions to the "Q and A" (questions and answers) page.[35] In the first three months, 800 people filled out the form (200 comments were discarded because they were judged totally irrelevant). As the Cyberschoolbus coordinator has remarked, "When people find a forum for the UN, they tend to send everything."

At the end of the interview we talked about < http://www.unsystem.org > and how it is also somehow a UN main site. The webmaster had some problems with this: "By far < http://www.un.org > is the largest site in terms of size, in terms of material and in terms of scope. Our Web site deals with almost every single issue that the system deals with: health, children, population and development. The specialized agencies are specialized. We are sort of the umbrella entity and we do everything. The UN Secretariat has a division that collects statistics on everything that happens everywhere. We have our department of public information, which puts out information on everything that happens across the system."

The < http://www.unsystem.org > was launched in 1997. Initiator and web-master at the time was the Information Systems Coordination Committee (ISCC) secretary. The ISCC is an advisory committee to the ACC. It is for the en-tire UN system, including the UN Secretariat. The ISCC secretariat (the secre-tary and a Web assistant) is based in Geneva but most of the work is actually done on a voluntary basis by staff in the participating organizations. The interview with the webmaster took place in November 1999 in New York. We discussed the gap between ambitions and budgetary (and other) constraints. "It would be great if it could be the place where citizens of the world went but the reality is that's just not going to happen. We do this in our spare time. What we can do is provide a highest level index; a portal is still something passive. We're going to stay pas-sive and as such we might be known as an easy way to find information. We our-selves are never going to be as current or as up-to-date as < http://www.un.org > or < http://www.unesco.org > or < http://www.fao.org > ." The production situ-ation was in other words even worse than for < http://www.un.org > . The web-master worked on the site in his spare time.

Now let us look at < http://acc.unsystem.org >, the site closely related to < http://www.unsystem.org >. It was launched in August 1999 in connection with the creation of an ACC secretariat (the Office for Interagency Affairs). Just as was the case with the UN site, there were at that time already a few Web sites of subsid-iary ACC bodies with versions of ACC key documents and the like. Those had arisen independently. At the time of the interview (November 1999), developing the sites accounted for one-sixteenth of the New York-based webmaster's time. [36] Soon thereafter she also took over the responsibility for < http://www.un-ystem.org > from the ISCC secretary. The "technical" aspects of production were handled by the ISCC Web assistant in Geneva. This situation is of course remark-able. The UN system sites were produced by a small group of people working to-gether on two continents.

The ACC site was originally intended for both internal personnel and the gen-eral public and the result was a compromise. It was recognized that the site had to be "world-friendly," but to meet the needs of the personnel group a solution with password-protected private areas in the midst of the public material was chosen. The webmaster talked about how the Web site made things easier but how it was still difficult for her to get people to understand that when a document is pro-duced it should go on the Net as part of the work: "Up until now we've had a

public information department; more and more all of the departments have a webmaster or someone who is in charge of the Web." She concluded that the ACC needed to learn how to use information not only to do its work but to promote its work as well. "In the whole diplomatic world it was just something that you never thought, that you have to sell your institution. You hope it's substance over style, but many times it's not."

Another issue she faced in being responsible for the Web site was freedom of information limitations. She exemplified this with the directory of senior officials. The document, which has the fax number to the Secretary-General's office, is not confidential, but on the other hand neither is it accessible: "They don't want every crazy in the world to be faxing the Secretary-General's office." Still, she felt that the directory should be made available somehow, preferably on the Web.[37]

The people involved in the production of the two UN system sites seemed to agree on the need to have a better coordinated Web site structure, perhaps even one URL where you could find everything under it. At the same time, they warned against underestimating the strength of territoriality. A parallel was drawn with governments where it is sometimes different to get different ministries to cooperate. In the case of the UN system, all member organizations have their specific mandates, constitutions and constituencies.

Production Policies and Guidelines

> Lots of times you have a policy and then events follow the policy, but in this case we needed to develop a policy because events were moving so fast, technology was moving so fast. (UN webmaster)

Who are the central actors for the UN Web sites? Who maintains power over inclusion and exclusion? The General Assembly decides on budget matters through its Committee on Information (COI). Then there is the Secretariat with the Secretary-General, the Under Secretary-General for Communications, and a publications board, each with a say about content. Finally, there is the Web production team in the Department for Public Information (DPI). As for the UN system, there is the ACC and its Secretariat, the Office of Interagency Affairs (OIAA). There is also the Information Systems Coordination Committee (ISCC) and the Joint United Nations Information Committee (JUNIC). Finally, all of the ACC members, the UN organizations and their respective bodies, who each maintain their respective sites.

In November 1999, the Webmasters I interviewed all mentioned an increase in interest about the Internet within their respective organizations. During the year 2000, several reports on different aspects of the Web sites were published from all of the above-mentioned actors. In addition, the Internet suddenly emerged as an important issue in more general reports, such as the Millennium Report. In 2001, almost seven years after the first UN Web site was established, the UN issued

guidelines for Web site production as well as an updated communications strategy that now included the Internet in substantial ways. Let us have a look at some of the debate. Here is, to begin with, an assessment from an ACC ad hoc working group (with the UN system webmasters as members).

> 42. It was recognized that the UN System as a whole does not take enough advantage of technology to relate to the outside world. Each organization has its own public web site, and sometimes, as in the case of the UN Secretariat, many public web sites. Substantive information provided to the public and civil society by UN System organizations is not provided in a consistent manner, and it is not easy to find all the information on a specific topic. The general public has difficulty understanding the UN System structure.
> (Report of the Ad-Hoc Inter-Agency Working Group on the Co-ordination of ICTs in the UN System.)[38]

It is a dark picture. Later on in the report it is noted that the percentage of budget allotted to ICTs is considerably lower in the UN system organizations than in governments and corporations. According to another report, of the UN Committee on Information, 90% of the resources goes to the "traditional" media.[39] A Reuters article "Experts Tell UN It Doesn't Understand Internet Age," is quoted, in which existing initiatives were described as competitive and disjointed and marked by a serious lack in organization and leadership, even in researching basic user statistics. A third report, reviewing the ISCC, notes that coordination in the field has remained narrowly focused, with attention primarily on administrative uses of ICT as well as technical standards and guidelines.[40]

So, how can this situation be improved? The report of the high-level panel of experts on ICT appointed by Kofi Annan[41] calls for "a coherent set of training and organizational measures aimed at bringing the Organization's collective mindset into the digital age." The ACC ad hoc working group report [42] talks about "controlled diversity and maximum connectivity" through "(a) standardization of document formats and indexing for retrieval, and (b) simplifying access to the information." It is noted that very few organizations have implemented the ISCC standards and that the simplification aspect could be addressed by a UN System Information Portal. The UN System Web Site Locator and the replacement of "the obsolete web site search engine" are described as intermediate steps on the way to the portal. The Secretary-General's Report on the Multilingual Development, Maintenance and

Enrichment of the Sites,[43] states that Web-site matters are encompassing the entire organization and that: `"management and coordination of Web site issues can no longer continue to be an ad hoc activity."` The operation, maintenance, and enhancement of the UN Web sites were scheduled to be included in the regular budget beginning in 2002. I mentioned before that this newly awakened interest in Web sites is mirrored in general policy documents as well. There are plans to isolate the ICT issue and give it the same status (in terms of conference, campaign, and budget) as gender, AIDS, and sustainable development. A World Summit on the Information Society is scheduled for 2003. To summarize, there is ample evidence that the ad hoc establishment phase is coming to an end. Much, however, remains to be done.

Placement and Partnerships

In this section I focus on relations. The World Wide Web was designed as a single global space in which anything could be linked to anything. Links can be read as "and," "to," "from," "with." The number of links to a Web page is also an important measure of popularity. Rogers and Morris (2000: 150) compare granting a link with references in science and receiving a link with citations. The fact that people don't tend to include links by mistake makes links in some ways more valid as a measure of popularity than hits. It takes a lot more effort to link to another site than to click on one. Important to bear in mind, however, is the fact that Web pages are *public*. Far from all relations of significance are openly acknowledged.

Again, every single Web site can include links to all other Web sites on the Internet. It is important to emphasize this, because it means that the UN could hypothetically choose to link to *any* of the other Web sites, including all personal home pages, all dot.coms and all dot.edus. Imagine that, one all-encompassing, global, Web site with links to everything and everybody . . . First a few examples of linking, then a discussion of UN system link policies.

How do the four UN sites compared above link (and don't link) to each other? Figure 5.1 shows outgoing prominent links on top pages as of August 12, 2000.[44]

Figure 5.1. Top page linking.

The linkages shown below seem to suggest that the less established link to the more well-known. Next question, how many links are there *to* these Web sites from the entire Web?

TABLE 5.3: Links in

Web site	Number of links in
<http://www.un.org>	86,501
<http://www.unsystem.org>	7,387
<http://acc.unsystem.org>	128
<http://www.un.int>	2,505

Source: AltaVista search 26 February 2001

Here I use AltaVista figures, the difference between these figures and those found by the search engine Google, is huge.[45] The numbers most certainly lie. What seems correct however, is the relative weight <http://www.un.org> — <http://www.unsystem.org>. The former is approximately 10 times more popular than the latter, regardless of which search engine is used. That <http://www.un.org> gets more links is hardly surprising. What is noteworthy, if anything, is the fact that the gap is not bigger. The table also shows how marginal the ACC site is, 128 links in all.

The importance of links is something that the webmasters all seemed well aware of. The UN webmaster discussed strategies for increasing the linking to the site. One of the things they had been doing was to talk directly to the search engines, something that had made a big difference. "About two years ago if you entered UN in any of the main search engines our main UN Web site would be the last on the list. Alphabetically it came under U." Now let's look at <http://www.unsystem.org>. In July 2000, I searched all 26 UN system organization sites and found that 16 out of 26 had a prominent link back to the UN system. In fact, more linked to that site than to <http://www.un.org>. This is probably at least partly explained by the fact that the organizations have been actively encouraged to link back.

Another aspect of linking is the problem with what should be considered external links.

TABLE 5.4: Links to acc.unsystem.org

Internal(accnet/unsystem)	30
UN	36
UN System Organizations	30
edu	10
other	21

Source: AltaVista, 23 February 2001.

It is far from obvious, as this ACC example (table 5.4) shows. Few links come from sites without connection to the UN system. This raises the issue of borders

between Web sites, between Web sites and organizations and, finally between organizations and organizations. Here I took URL as starting point when I categorized the linking sites; this is a common but far from unproblematic way of delimiting sites.

The last empirical example before turning to UN system link policies is taken from the permanent mission pages at < http.//www.un.int > .[46] Four main categories of prominent outgoing links were identified. The first and most common was linking to international governmental organizations (e.g. the EU). The second category, almost as recurrent as the first category, was links to particular issues (e.g. Libya linking to Lockerbie, Israel to pages about the Middle Eastern Peace process, Bulgaria to Unita sanctions). The third (tourism) and the fourth (dot.coms) category were exceptions to confirm the rule: states normally don't link to individuals or companies, the linking is public, not private.

Just as the Member States have different link policies, so have the UN system sites. This is something that came up in the interviews and it's also something that is visible on the Web. The strictest link policy is that of the < http://www.un.org > site. They are not supposed to link outside the UN system. The webmaster explained to me in the interview that this was an opinion expressed by the legal counsel (the chief UN legal officer): "It would imply endorsement of the contents by the UN of the other Web sites . . . we have provided some links to some non-commercial entities [the example he gives is the International Chamber of Commerce] with a disclaimer that these links are provided for convenience only, and that the UN has no control over that Web site and that you are now leaving the official UN site."

What about < http://www.unsystem.org >? The policy used to be "fairly liberal." There was a category called "other organizations" where the webmaster linked to sites "aiding world peace and supporting the mission of the UN." After the ACC Secretariat took over responsibility of the production, this category was simply deleted. Some links to non-UN system sites remain however, such as a link to the Hunger Site < http://www.thehungersite.com > among the 20 "Highlights."

Here are a few more examples of link policies as they are explicitly formulated on the Web sites. The International Labour Organization (ILO), by definition a tri-partite organization, encourages reciprocating links to other Web sites in order to "increase visibility to both sites." The Food and Agriculture Organization (FAO) link policy stresses that "the sole purpose of links to non-FAO sites is to indicate further information available on related topics." The World Health Organization (WHO), to take a third example, states that hyperlinks should not be to individual constituents of a page (such as a picture)—that could result in "the unauthorized inclusion of the WHO logo."[47]

Some links cross geographical borders, others the border between public and private. The problem with different link policies is that the sites also link to each other. The Web user will hardly notice moving from one UN system link policy

to another. Although there are different sites, to most people it is all the same UN. There seems to be a need for coordination here. The ISCC Secretary/UN system webmaster wrote a general policy guideline in 1997 stating that it was important to be careful and make it obvious through copyright notices that the link does not endorse the contents of the linked site. Many sites have indeed followed the guidelines, especially the last part about caveats and copyright notices. The question is how effective the caveats really are. Do people even take the time to read them?

My final point is that the link policy problem doesn't exist in isolation as something Web-specific. In the interview, the ACC webmaster recalled the sponsorship debates of the early nineties and emphasized that people and organizations wanting to benefit from the UN name is something they have had to deal with for a long time, way before the onset of the Web. Most likely, this problem is only going to grow bigger in the future. Why? For the same reason that "Global Compact" and "UN and Business" pages were recently added to the UN site. The UN is more and more starting to work with the private sector in partnerships.

> The United Nations once dealt only with Governments. By now we know that peace and prosperity cannot be achieved without partnerships involving Governments, international organizations, the business community and civil society. In today's world, we depend on each other.
> Kofi Annan, UN Secretary-General.[48]

The turn of the millennium was in the UN context marked by two major trends — information technology for development, and partnerships with civil society and business. In the Millennium Report there is a good deal of attention given to how the UN should best help governments, civil society, and the private sector to work together in "global policy networks."

> §340. They are non-hierarchical and give voice to civil society. They help set global policy agendas, frame debates and raise public consciousness. They develop and disseminate knowledge, making extensive use of the Internet. They make it easier to reach consensus and negotiate agreements on new global standards, as well as to create new kinds of mechanisms for implementing and monitoring those agreements.

A concrete example of a UN initiative in this spirit is the Global Compact, <http://www.unglobalcompact.org> featured as one of 20 "UN System Highlights." The Compact was first launched in 1999 by Kofi Annan at the World Economic Forum in Davos. It is presented on the Web as a platform for promoting good corporate practices in the areas of human rights, labor, and the environment, with the goal to have 1,000 major companies participating by 2002. Two years after the launch, on 28 January 2001, Kofi Annan addressed Davos again. In the speech he acknowledged corporations as powerful actors and "the first truly global citizens," telling them that they should not wait for governments to impose laws. Companies should engage in "global corporate citizenship."

There is a qualitative leap from sponsorship debates to partnership debates. Do the global compact and other global policy network initiatives, as some have argued, represent a corporate hijacking of political power? Two different positions can be heard in the debate: One takes at its focus the privatization of public space, the other the innovative potential of partnership. The probably most well-known representative of the critics is Naomi Klein. In *No Logo* (2000: 441–42), she writes about the drain of political energy as voluntary codes of conduct replace legislation. Another critical voice is Ellen Paine (2000), at the Global Policy Forum <http://www.globalpolicy.org>. The fundamental problem with the Global Compact, she argues, is that it is so vague and that there are no monitoring mechanisms. The participating corporations are offered UN bluewash but only cosmetic changes in company behavior is to be expected in return. Paine concludes:

> "The UN could lose its public support if it
> is seen as scarcely distinguishable from
> business-dominated institutions like the WTO
> or the IMF . . . We must advocate a financially
> and politically-strengthened UN that is
> responsible to the needs of ordinary
> citizens."

In the introductory chapter of this book we talked about the ambivalent implications of convergence. The partnership trend can in my view be understood as a form of organizational convergence. Is this the same as a movement toward centralization and homogenization? Does convergence in the organizational field always have to add up to hierarchical megamonopolies run by corporate moguls? No, say the researchers associated with the heterarchy seminar initiated by Columbia University sociologist David Stark. Convergence can involve decentralized network structures. The description of the heterarchy concept given below, builds heavily on an introduction published on the Web by Stark.[49]

Heterarchies are characterized by the organization of diversity and involve rela-

tions of interdependence. Frequently they take the form of a blurring of the boundaries of public and private. Intelligence is distributed, even across the boundaries of the organization, and institutional friction is seen as positive. One example is the Internet itself [which is]

```
"a rich array of heterarchical features: from
its origins in the military ARPAnet to its
tendential features as an ubiquitous public
utility, from its distinctive (non zero-sum)
network properties of asset interdependence
and its tendencies for an asset to increase
in value precisely to the extent to which it
is given away, and from its proclaimed self-
governance through network-like institutions
that are neither market nor hierarchy to its
incresing prominence in debates about public
accountability."
```

One of the major challenges with heterarchy, coproduction à la Internet, and flexible public-private partnerships of the UN system kind, is how to achieve accountability. In a global policy network, who is in charge? What are the implications for democracy?

People vs. Peoples: The UN System on the Web

I summarize below the study by looking at in turn: production, text, and users. A concluding discussion follows on the Web sites in the light of democracy theory and recent research on standardization and globalization.

Production

This has, until recently, been a very low priority. For the UN it is estimated that 90% of the budget goes to traditional media. The organization has for a long time been busy remediating and recycling all that has come before. More and more Web-specific content is now developed. The existence of the Web sites has brought changes to the organization. More people get involved in the production, and because of the Web site there has been a lot more interaction between parts of the UN Secretariat and the system. There is currently a tendency toward both professionalization and politicization. Formal rules constitute important restraints and affects everything from linking to the structure of the UN top page. Member States have the final say, "they are the bosses." A big part of the Web team's work consists of translation, since language parity (the UN has six official languages) is

one of the few Web-related issues that the Member States through the General Assembly have decided to prioritize. When it comes to the two UN system Web sites the production situation is even worse than for the UN.

Text

Significant improvements have been made recently, especially in the content and design of < http://www.un.org >. The site is more up-to-date, not least thanks to the daily briefing and the live webcasts. The content is predominantly realist but can sometimes be unintentionally fictional (because of the mistakes, but also when the advocacy concerns have a romanticizing impact). Important things are not always made explicit: the section for kids, Cyberschoolbus, is in some ways more informative than the main part of the site. Some, but far from all of the pages are consciously designed to be "world-friendly." The language is at times highly technical. Finding one's way among the thousands of standards documents, formal reports and resolutions requires a high level of understanding of the UN structure. Some signs of more public-private partnerships are visible in linking. Cosmopolitization, manifest in all the talk about people and in the particularizations (for example the "Unsung Heroes" narratives), is also a growing phenomenon. There is currently an effort to put people, not peoples, in the center. Many of the contradictions pervading global politics today have become institutionalized in the Web sites. Organizational home pages deal with the question "Who are we?" In the case of the UN however, the "we" is at least three-sided: We the UN staff, we the Member States, and we the people of the world. Important differences in this regard exist between the different sites. To simplify matters, one could say that if < http://www.un-system.org > is the highest-level, most universal site, and < http://www.un.int > is the site of international politics, then < http://www.un.org > is the most "borderlandish" and cosmopolitan of the sites.

Users

The sites are more about showing (demonstrating) than about conversation or participation. The sites are edited, not so much coproduced with the help of users. Feedback and user statistics have until recently been a rather low priority. The UN is a 24-hour Web site in that it gets accessed from all time zones, but U.S., Canadian, and Australian users dominate. This matches the profile of Internet users globally (see Norris 2001). In the intro I mentioned that the visitors to the UN NY HQ are people wealthy enough to be in NY and people interested enough to check it out. The same seems to be true of the Web. One reason for this could be the language issue, which is closely related to access. Most of the material, despite the production team's efforts, is available in English only. The 2001 average was 4 million hits a day. Employment opportunities was the most visited part of the site.

Concluding Discussion

I chose to study the UN because of its off-line status as *the* world organization. Yet, on the Web and elsewhere it is repeatedly pointed out that "The UN is an organization of sovereign States and not a world government." In the absence of a world government, how is the world governed? One important but often overlooked aspect is the global standardization work.

In §324 of the Millennium report, it is pointed out that the UN system's influence on the world is greater than many believe. The examples include the World Health Organization's quality criteria for the pharmaceutical industry worldwide and the World Meteorological Organization's (WMO) redistribution of weather data from individual states. Later on in the text (§360), Annan concludes that the UN must continue to be "the place where new standards of international conduct are hammered out, and broad consensus on them is established."

Without standardized weather data there would be no reliable climate analyses. In fact, without standards there would be no globalization, no Internet, no UN. Bowker and Star (1999: 13) define standardization as "any set of agreed-upon rules for the production of (textual or material) objects." Brunsson and Jacobsson's (2000) definition of standardization is also extremely broad. In their list of standards documents, they include books on the best way to run our lives. An important point they make is that many people are engaged in standardization activities without knowing it, and certainly without calling themselves "standardizers." A strong element of innovation may be involved in the creation of standards, but successful standards paradoxically often have an inhibiting effect on innovation. Each standard inevitably valorizes some point of view and silences another. Standards that are presented as standards have certain characteristics that facilitate diffusion. They are voluntary, explicit, and usually based on scientific expertise. When it comes to *global* standards, a by-product is *globalizing* work; standards help the globalization process.

Most standardizers lack the resources to enforce the standards; they are left to lobby for other parties to do that work for them. One efficient way is to form an organization around the standard. Brunsson and Jacobsson (2000) mention the UN as an example of a standard-based organization. The purpose of the UN was to make states follow rules of non-aggression and respect human rights. The organization was created with these rules in its statuses and tried to enroll every state as a member. The UN system is today also an important center of explicit standardization activities. One of the best places to look for standardization documents with document numbers is the UN system organizations' Web sites.

Standardization can be seen as undemocratic in comparison to nation-state politics. In many ways it is a substitute for a nonexistent world government. Often standardizers offer technical solutions in a technical language; standardization can, to use Andrew Barry's term, be quite antipolitical.[50] What would the alternative to

standardization be? Is a world government conceivable, "a one world, one law, one government"? A distinction between universal and cosmopolitan can be useful. Universal politics in the all-inclusive, centralized, standardized sense, with a world government, can be understood as totalitarian. Cosmopolitanism, on the other hand, is parasitic and messy; it stands for openness to the world.[51] Cosmopolitan politics, or perhaps cosmopolitics, is different from the universal in that it is based on pluralism and an idea that only a few but very important issues concern all of humanity. The cosmopolitan encapsulates instances of the national and the international as well as the global (e.g., human rights). It is based on overlapping, flexible, heterarchical structures.

If cosmopolitans celebrate diversity, then universalists can be said to do the opposite—they believe in the abstract and general. The distinction between universal and cosmopolitan may seem a bit "black and white"; with a normative bias to cosmopolitanism, I want to emphasize that inclusion, centers, and standards can be something very good. Besides, standards make existing diversity more visible.[52] Globalization, itself a result of standardization, increases the demand for worldwide standards, partly because of cultural diversity and lack of common norms. Better than to think in terms in either/or, is probably to look at universal, cosmopolitan, standards and diversity as interrelated in complex ways.

At the beginning of the chapter I emphasized that cyberglobality never exists independent from its local manifestations and that globalization is embedded. This is a real challenge for the producers of UN system Web sites. It is impossible to find a truly global language and it is impossible to include the whole world in one Web site. Consider the choice of pictures to illustrate the UN Web sites. It will always be a reduction of complexity. The expression given off is cosmopolitan and particular rather than universal. Of course, this doesn't stop the organization from trying to invent suitable global symbols. One year Cyberschoolbus published a "girl child puzzle" to commemorate International Women's Day, which consisted of a young, dark-skinned girl in an exotic outfit, dismembered into six pieces, the challenge being to put her together again. Slightly morbid, but the choice of female symbol was hardly surprising. In this particular context, an affluent-looking career woman (or for that matter, an obese teenager in T-shirt with Nike or Coca Cola logo) would have been inconceivable.

Another example of a UN symbol is the scarf advertised below:

```
$ 55.00 UNIFEM scarf
In silk, with stylized irises, lilies and
hummingbirds symbolizing the work of UNIFEM
in developing countries which enables women
to grow economically and politically
```

The global is intangible and impersonal. Images tend to have a particularizing effect. This however is not to say that the UN is powerless in the context of globalization and collective symbol production. It is because of its central position that

the discussion is interesting. Do we want the UN to be personal or impersonal in its address to the world citizens? Should the organization in the interest of equality and representation avoid examples? Carol Gluck, on world history writing: "One sometimes feels that the exclusion is total: that there are no people in the world, only peoples; no human beings, only humankind" (1997: 207). Is this the kind of UN we want?

> Exhibits on the first floor which are open to the general public normally require scheduling and review by the Exhibits Committee six months in advance. These exhibits should relate to a UN theme and must be sponsored or co-sponsored by a UN agency or department. Exhibits by one artist, one photographer or one country will normally not be accepted for the Public Lobby, although exceptions can be made under special circumstances.

UN exhibits for the public should, as can be concluded from the excerpt from the Web site above, be global/public/universal as opposed to national/private/ biased. The same goes for UN system participation in international exhibitions. In 1999, the ACC issued guidelines stating that priority is given to participation in exhibitions of a "universal nature." The purpose must be "to present a positive image of the United Nations system" and "no member may have a separate presence at the event except in special circumstances." This last point, that members should avoid a separate presence was, as we know, not applied on the Web.

In the UN New York Headquarters bookshop, I buy a blue notebook. On the front, the UN logo, and on the back, the preamble to the UN Charter and a statement about how visiting the UN Headquarters is in effect sharing the common endeavor to build a better, brighter world, and that "you are always welcome at the United Nations." Curiously, however, it also includes the following sentence: "Since that time [the founding of the UN in 1945] in a little over a quarter of a century, more than one hundred countries have joined the United Nations. Today, 'we the peoples' means 157 nations . . ." What? Is that right, 157? In the "Information guide for the public about the UN," it says that the UN has 185 Member States. The correct figure, as of this writing, is 189. Obviously, it is not a conscious choice to deceive the public; it is just that this particular text on this particular notebook is regarded as relatively peripheral and therefore has not been recently updated. When it comes to the 185 figure of the Web site it is, in my view, a different matter. What you find on official home pages is the standard story. Mistakes on the Web sites are, no matter how harmless they may seem, problematic. In fact, all UN mistakes are highly problematic, simply because of its role as vanguard of mankind as spelled out in the Charter. It presents itself as

the world organization. UN behavior is supposed to be normative; when the organization lacks resources to live up to its own standards, whether on the ground in Afghanistan, or in the office of the legal counsel, it very soon gets dangerous.

In ($9) of the Millennium report, the UN is said to exist to: "to serve its Member States," but also that:

> "even though the United Nations is an
> organization of states, the Charter is
> written in the name of 'we the peoples.' It
> reaffirms the dignity and worth of the human
> person, respect for human rights and the
> equal rights of men and women, and a
> commitment to social progress as measured by
> better standards of life, in freedom from
> want and fear alike. Ultimately, then, the
> United Nations exists for, and must serve,
> the needs and hopes of people everywhere."[53]

To serve the needs and hopes of people everywhere is both extremely worthy and extremely difficult. What difference could Web sites make? What's really at stake? How central are the Web sites to the core of what is the UN system?

One way to conclude would be to focus on the external users and despair: "although the sites address the whole world, most users still fall into either the U.S. academia or private sector." Another way would be to pick the interactivity issue and discuss how it is related to political action. There are certainly lots of things that the Web sites could potentially be used for, as the UN system has a unique position and should take advantage of it. However, the first step is to provide useful information about the UN system, but also to make clear, perhaps in a direct "welcome to the UN, it's your world" spirit, that "these are your rights, this is the state of the world, this is what is going on." The sheer amount of information is a big problem. In my view, it is very much a question of coordination and standardization. The UN system on the Web is still a complicated, distributed, and uncoordinated phenomenon. There is a plethora of different sites. How would the consequences of coordination be cosmopolitan and inventive?

One of the difficulties, in the absence of a world government, is how to deal with crosscutting issues. If the eradication of poverty is the overall goal, who takes the lead? The UN conferences of the nineties made this dilemma obvious to the people working with the issues, and there are reasons to believe that the mere existence of the Web sites has the same effect. The need for coordination is just so evident. Self-presentations encourage self-reflexivity, which can lead to change. When different subcommittees dealing with the same issue all have Web sites linked to each other, it is much easier to compare them. Two types of sites are particularly important in this process. The first is the crosscutting sites: the day there

is one single UN system site devoted solely to the eradication of poverty with input from all the organizations, much of the coordination job is probably already done. The other site type is the portal. What would be the state of world government (not only of *inter*national relations in the traditional sense) if the UN system sites developed into a full-blown, well-structured UN system page covering all the issues in a transparent, "world-friendly" and interactive way? And also, since this is where things slowly seem to be moving at present, is coordination always good? What are the potential risks? Immediately, we are back at the universal standard vs. cosmopolitan diversity dilemma.

Organizational self-presentations as they appear on official home pages tend to be reductionist and exclusive. Contested versions of the "About us" story can sometimes (due to lack of resources or for other reasons) be found on the periphery of a site. The lack of centralized control is problematic in so far as it prevents communication. On the other hand, less standardization means more diversity. In the periphery there is more freedom to say whatever you want, and in the UN case, sometimes also escape the domination from the Member States.[54] Just how dominated by the Member States is the UN at the present? Some states undoubtedly have a lot of influence but organizations are usually more than the sum of its parts.

At present the ACC is transforming into a Board for Chief Executives of the UN System. Could one way to evade the domination of national interests be coordination at a higher level than the UN? A better coordinated UN system (with the IMF, the World Bank and the WTO drawn closer to the UN) would, in terms of scope, be something of a world government. Cosmopolitan or universal? This is, ultimately, why the UN system Web sites are interesting. "Respond to the challenge of globalization by identifying areas for coordinated action," would be one way to describe the BCE's mission. To achieve this the plan is to make the system (in the best of heterarchical spirits) more flexible, issue-oriented and network-based. It is too early to say what this particular development will bring about. The UN system is neither passive, nor static; it is under construction as much as the Web sites. Most likely, the Web sites will play important roles.

Notes

1. A/54/2000 §350 *"We the Peoples": The Role of the United Nations in the 21st Century. Report of the Secretary General.*
2. Carol Gluck (1997: 207-213) writes about the imprint of the world on the local, and argues that everything can be "worldized." At the same time, she warns against a world history consisting entirely of edges—it would be empty at its center.
3. Universal membership shouldn't be taken too literally though. All the world's states are not UN members, and there are a number of undemocratic regimes among the members.
4. WTO (World Trade Organization), the Bretton Woods Institutions (i.e. the International Monetary Fund (IMF) and the World Bank).

5. See for example Norman Fairclough (1995) and Stuart Hall (1997).

6. This is for a number of reasons: the report is highlighted on the sites; the topic of the report is the UN in an age of globalization and information (it can be read as a popularized summary of globalization theorists such as Manuel Castells, David Held, and Saskia Sassen); and, last but not least, the report carries real political weight

7. < http://www.un.org/MoreInfo/pubsvs.html > consulted 5 September 2000. I visited the UN New York Headquarters in November 1999 and in May 2001.

8. This problem actually complicates quotation as well. All the UN reports I cite exist in both paper and digital form. Since I retrieved all documents online I have chosen to apply the same courier format to them as to the rest of the material taken from the Web.

9. See for example < http://www.oneworld.net >, analyzed in Klein (1999).

10. For definitions and discussions on the historic roots of multimedia, see Packer and Jordan (2001).

11. A/AC.198/2000/7, A/AC.172/2000/4 *Multilingual Development, Maintenance and Enrichment of United Nations Web Sites. Report of the Secretary-General.*

12. The currently most exhaustive listing of sites is available at < http://www.unsystem.org >.

13. The figures, from an AltaVista search (26 February 2001) show the number of pages on the sites.

14. Note that language here refers to version. It does not mean that all information on the site is available in the above languages. I've looked at the English versions, and I find these to be generally the most complete and the most visited. English is also the language of the six official UN languages that I know best.

15. Source: Cyberschoolbus Coordinator interview and UN System Web assistant email communication. I don't have any figures for < http://www.un.int > or < http://acc.un system.org >. In the case of the ACC site I was told that there had been "a configuration error in the statistics generator."

16. What is the difference between a top page and a home page? As I see it, every Web site (not only organizational home pages) is bound to have a top page. An organization's home page may in fact contain several pages, including the top page. Home pages are special in that they are official.

17. Curiously, one year after the facelift, the old version of the top page is still preserved on one of the UN Information Center (UNIC) sites.

18. < http://www.un.org/overview/organs/ecosoc.html > Consulted 5 September 2000.

19. < http://www.un.org/overview/organs/secretariat.html > Consulted 5 September 2000.

20. < http://www.un.org/overview/sg/sgfunc.html Consulted 5 September 2000.

21. Rule of law within states? As this is written, the organization is engaged in writing national constitutions; it actually governs in Kosovo and East Timor. Almost all aspects of terrorism-related legislation and the field of International Criminal law more generally are highly politically sensitive.

22. Consulted 30 October 2000.

23. The index is part of the annual Human Development Report (HDR), which assesses the state of human development around the globe. Indicators include (a) life expectancy at birth, (b) adult literacy, (c) gross primary, secondary and tertiary enrollment, and (d) GDP per capita.

24. Something else that seemed to matter a good deal was size of population. Eighty-five percent of the 27 big countries (here defined as having a population of over 40 million)

had Web sites, as opposed to only 29% of the 62 small countries (with a population of less than 4 million). All but two of the 20 most developed countries had Web pages; the two exceptions both fell into the "small country" category. Interestingly there also seems to be a correspondence between Web site ownership and increased HDI ranking and between lack of Web site and decreased HDI.

25. A/AC.198/2001/9 §3 *Report on the activities of the joint UN Information Committee (JUNIC).*

26. A/AC.198/2001/3 §3 *Public information activities for United Nations Year of Dialogue among Civilizations (2001) Report of the Secretary-General.*

27. < http://www.un.org/Dialogue/heroes.htm > Consulted 29 March 2001.

28. ACC:\ACC SumOct2000 §22.

29. Consulted 17 December 2000.

30. He does not work undercover. When we met he had recently been voted one of the 100 most influential UN people. To protect his email address, I omit his name here.

31. In May 2001 the Cyberschoolbus coordinator updated me on some aspects.

32. Note that the interview was conducted before the redesign in September 2000. The answer refers to the previous version of the site.

33. With the exception of a few "spamming" incidents such as during the crisis in East Timor in the fall of 1999 when they received 140,000 emails in the span of three days. A Portuguese Web site put out a petition that went automatically to the U.S., French, Russian, and Indonesian presidents and to the UN Secretary-General (using ecu@un.org, the "Electronic Communications Unit," the name of the IT section when it was first set up since long abandoned).

34. As more and more items are added, this is not all together wrong, it is for instance under recent additions that you find links to live webcasts. The interview was conducted in November 1999.

35. Noteworthy in that the form asks for country of residence rather than citizenship, and also that Non-Governmental Organizations (NGOs) tops the list of proposed fields of work.

36. What about the other fifteen-sixteenths? She was in charge of the management and operation of the ACC Office for Interagency Affairs and the secretary of the ACC Committee for Sustainable Development, among other things.

37. As of 2000, the document is published on the ACC Web site. Whether this makes it easily accessible or not is disputable. The ACC site is not exactly the most popular or widely advertised Web site on the Internet.

38. ACC/2000/CCAQ-HL/3 *Report of the Ad-Hoc Inter-Agency Working Group on the Coordination of Information and Communication Technologies in the United Nations System.*

39. A/55/21 §21 *Committee on Information. Report on the Twenty-second Session (1-12 May 2000).*

40. (A/55/619 §13) *Review of the Information Systems Coordination Committee.*

41. A/55/75-E/2000/55 §24 e) *Report of the High-level Panel of Experts on Information and Communication Technology.*

42. ACC/2000/CCAQ-HL/3

43. A/AC.198/2000/7 A/AC.172/2000/4, §20-27.

44. The UN System could be said to link to all, but here I still chose to omit those links because they are embedded in a long alphabetic listing. Also note the date of the survey, since August 2000 the new version of www.un.org has been released.

45. <http://www.un.org>: 27,900 links; <http://www.unog.ch>: 583 links; <http://www.unsystem.org>; 2,830 links; <http://acc.unsystem.org>: 116 links; <http://www.un.int>: 68 links. (Google search 26 February 2001.)

46. All 85 missions with Web pages were included except the Turkish, for the simple reason that it repeatedly gave me system error. Cyberterrorism?

47. <http://www.ilo.org> (under Disclaimer, Copyright and Permissions), <http://www.fao.org/COPYRIGH.HTM>, <http://www.who.int/home/related_links/index.html>

48. <http://www.un.org/partners/civil_society/home.htm> Consulted 2000-1205.

49. <http://www.sociology.columbia.edu/workshops/seminars/heterarchies/index.html> Consulted 17 December 2000.

50. Barry makes a distinction between politics and the political. An action is anti-political "to the extent that it closes down space of contestation." (2001:194-195). Another way to describe it would be to say that the UN system organizations engage in what Keohane and Nye (1998: 86) call "soft power." It rests on "the appeal of one's ideas or culture or the ability to set the agenda through standards and institutions that shape the preferences of others."

51. Ulrich Beck (2000: 43) distinguishes between globalism and cosmopolitanism, with the global being equated with "McDonald's," a single-commodity world, and the cosmopolitan characterized by plurality, civility, and globality (the self-reflective awareness of world society). On cosmopolitan democracy, see Archibugi, Held and Köhler (1998) and Held et al. (1999).

52. Comparability is central to standardization. See also Benedict Anderson (1998) on the ever-present specter of comparison and relations between internationalization and globalization.

53. Note how he very elegantly moves from peoples (nations) to people.

54. In a situation when one or several national governments block global policy initiatives there are basically two options: either to escape the direct influence of governments or to mobilize enough public opinion pressure. The latter presupposes that the state(s) in question is democratic (this is quite often the case, e.g. USA).

References

Web sites
<http://www.un.org>
<http://www.unsystem.org>
<http://acc.unsystem.org>
<http://www.un.int>

Literature
Anderson, Benedict. *The Spectre of Comparisons: Nationalism, Southeast Asia and the World*. London: Verso, 1998.
Archibugi, Daniele, David Held, and Martin Köhler (eds.). *Re-imagining Political Community Studies in Cosmopolitan Democracy*. London: Polity Press, 1998
Barry, Andrew. *Political Machines: Governing a Technological Society*. London: Athlone Press, 2001.

Bauman, Zygmunt. *Globalization: The Human Consequences*. Cambridge, UK: Polity Press, 1998.

Beck, Ulrich. *What is globalization?* Oxford: Blackwell Publishers, 2000.

Bowker, Geoffrey C. and Susan Leigh Star. *Sorting Things Out: Classification and its Consequences*. Cambridge, Mass.: MIT Press, 1999.

Brunsson, Nils, and Bengt Jacobsson. "The Contemporary Expansion of Standardization" in *A World of Standards*, edited by Nils Brunsson and Bengt Jacobsson. Oxford: Oxford University Press, 2000.

Castells, Manuel. *The Power of Identity. Volume II, The Information Age*. Oxford and Malden, MA.: Blackwell Publishers. 1997

Chandler, Daniel. *Personal Home Pages and the Construction of Identities on the Web*. <http://www.aber.ac.uk/media/Documents/short/webident.html>, 1998.

Fairclough, Norman. *Media Discourse*. London: Arnold, 1995.

Gluck, Carol. "Asia in World History." In *Asia in Western and World History: A Guide for Teaching*, edited by Ainslie T. Embree, and Carol Gluck. Armonk, N.Y: M. E. Sharpe, 1997.

Goffman, Erving. *The Presentation of Self in Everyday Life*. New York: Doubleday Anchor, 1959.

Hall, Stuart. 'The Work of Representation." In *Representation: Cultural Representations and Signifying Practices*, edited by Stuart Hall, London: Sage, 1997.

Hastings, Donnan, and Thomas M. Wilson. *Borders: Frontiers of Identity, Nation and State*, Oxford and New York: Berg, 1999.

Held, David, Anthony McGrew, David Goldblatt and Jonathan Perraton. *Global Transformations*. Stanford: Stanford University Press, 1999.

Keohane, Robert O. and Joseph S. Nye. "Power and Interdependence in the Information Age." In *Foreign Affairs* Vol. 77, no. 5 (September/October 1998): 81–95.

Klein, Kajsa. "www.oneworld.net. Internet och den kosmopolitiska demokratin." In *IT i demokratins tjänst*, edited by Erik Amnå (SOU 1999: 117. Demokratiutredningens forskarvolym VII), Stockholm: Fakta Info Direkt (1999): 129–156.

Klein, Naomi. *No Logo*. London: Flamingo, 2000.

Mann, Chris, and Fiona Stewart. *Internet Communication and Qualitative Research: A Handbook for Researching Online*. London: Sage, 2000.

Norris, Pippa. *Digital Divide: Civic Engagement, Information Poverty and the Internet in Democratic Societies*. New York: Cambridge University Press, 2001 <http://www.pippanorris.com>.

Packer, Randall, and Ken Jordan (eds.). *Multimedia: from Wagner to Virtual Reality*. New York: W.W. Norton, 2001.

Paine, Ellen. *The Road to the Global Compact: Corporate Power and The Battle over Global Public Policy at the United Nations*, <http://www.igc.org/globalpolicy/reform/papers/2000/road.htm> 2000.

Rogers, Richard and Ian Morris. "Operating the Internet with Socio-Epistemological Logics." In *Preferred Placement*, edited by Richard Rogers. Maastricht: Jan van Eyck Akademie, 2000.

Rosenau, James, N. *Along the Domestic—Foreign Frontier Exploring Governance in a Turbulent World*. Cambridge: Cambridge University Press, 1997.

Sassen, Saskia. *Globalization and Its Discontents: Essays on the New Mobility of People and Money*. New York: The New Press, 1998.

Stark, David. *Heterarchies: Distributed Intelligence and the Organization of Diversity* < http:// www.sociology.columbia.edu/workshops/seminars/heterarchies/index.html >, 1999.

Tilly, Charles. *Stories of Social Construction*. (Lecture published and distributed at the Workshop on Contentious Politics, Columbia University, New York,) 1998.

UN Reports
(available in *pdf* format on the Web)

A/54/2000. "We the Peoples": The Role of the United Nations in the 21st Century. Report of the Secretary General.

A/55/21. Committee on Information. Report on the Twenty-second Session (1–12 May 2000).

A/55/75-E/2000/55. Report of the High-level Panel of Experts on Information and Communication Technology.

A/55/619. Review of the Information Systems Coordination Committee.

ACC/2000/CCAQ-Hl/3. Report of the Ad-Hoc Inter-Agency Working Group on the Coordination of Information and Communication Technologies in the United Nations System.

A/AC.198/2000/7/ A/AC.172/2000/4. Multilingual Development, Maintenance and Enrichment of United Nations Web Sites. Report of the Secretary-General.

A/AC.198/2001/3. Public information activities for United Nations Year of Dialogue among Civilizations (2001). Report of the Secretary-General.

A/AC.198/2001/9. Activities of the Joint United Nations Information Committee in 2000. Report of the Secretary-General.

1999 ACC Guidelines for Participation of the United Nations System in International Exhibitions. (word document emailed to the author)

UNDP Human Development Report 2000, Oxford University Press, 2000.

Interviews
UN Webmaster and Chief of IT Section, 10 November 1999.

Principal officer and secretary, ISCC, 10 November 1999, 23 November 2000 (email).

UN System Webmaster /Information Network Coordinator, ISCC, 4 September 2000 (email).

ACC official at the UN Office for Inter-Agency Affairs, 10 November 1999, 1 May 2001.

UN Cyberschoolbus coordinator, 4 May 2001.

Steve Jones

POSTSCRIPT:
ACADEMIA AND INTERNET RESEARCH

It is remarkable how quickly the Internet, originally an object of science more than anything else, has quickly become an object of popular culture. Only Sputnik and the atomic bomb made the transition as or more quickly (and, interestingly, these are technologies with similar military and collaborative origins). The Internet has a firm grip on the public imagination. It is thus not unfair to ask: Who needs TCP/IP (Transmission Control Protocol/Internet Protocol) when the Internet is everywhere in our minds and our media?

Almost as quickly as it entered the public imagination, the Internet has become an object of scholarly inquiry and discourse. It had long been a medium of academic discourse, and a scientific project within an academic research setting, of course. But has the Internet sufficiently captured the scholarly imagination? And, if it has, with what consequences for the ways scholars go about their work, both in terms of research and collaboration, but also in regard to the ramifications of Internet scholarship for longer-term considerations involving careers, disciplines, and, ultimately, epistemology and academia's values?

In his essay "Thinking the Internet: Cultural Studies vs. The Millennium" Jonathan Sterne (1999) noted that a central issue for cultural studies approaches to "thinking the Internet" is quite literally how to think about it beyond traditional dichotomous perspectives. Instead of asking whether the Internet will lead us to a utopia, or whether it will destroy the fabric of society, Sterne asks how we might examine the Internet as another media technology situated in everyday practice and everyday life? Scholars must pay attention to the routines undergoing transformation because of networking, for it is in the realm of the mundane that we most clearly see the consequences of the Internet. Sterne asks us to imagine a day

in the life of one of his students, and to note the ways in which the Internet, or more appropriately perhaps *Internetworking,* is embedded in mundane routines and practices. Stopping in a computer lab between classes to check email, for instance, or sending a note to a professor while doing homework are examples he cites of common practices made possible by Internetworking.

Faculty practices and routines have undergone similar interesting changes, and not just in terms of the amount of time most faculty now spend in front of a computer sending and receiving email. Collaborations have been facilitated, data shared, and, in some cases, entire research agendas created as a consequence of Internet use. For instance, a scholarly conference examining the WorldWideWeb was held in 1998 at Drake University.[1] Many of those assembled had known one another for years from other scholarly conferences, from graduate school, or from publications. But before that conference only one or two were known to be interested in studying the Web. How then did it come to be that we all were in one place at one time discussing the Web, its metaphors and meanings?

What became clear at the Drake conference was the participants' common interest in a technology that somehow managed to encompass previous intellectual interests (if not in some ways to swallow them whole) but also to put a "twist" on previously held theories and concepts. For instance, those who had been studying popular music and its audience quite literally had an entirely new medium with which to contend—a medium that challenged popular music's industrial processes and fan practices and discourse and therefore challenged theories concerning the relationships between performers, fans, and the music business.

An overarching issue that became clear at that conference is the manner in which network technologies implicate the objects and subjects of scholarship, along with scholars themselves, in new webs of significance and meaning that impart new frameworks to our experiences and encounters. In addition to encapsulating us in any variety of panopticons, as in some global Hawthorne effect, network technologies affect our thinking and behavior as much because of the attention we pay the technology (and ourselves embedded in it) as because of anything else. Discussions of published materials on disciplinary email lists, flame wars, the quality of Web sites, online publication, and numerous other Internet activities not only make up part of scholarly activity but also create a new environment within which academic discourse takes place. We do not yet know what the consequences are of that environment for academic work, for the way we get to know one another and one another's work, and for the way we form opinions and make decisions about our work and that of others.

At the Drake conference there was a sense of unease among the participants. Given the degree to which the Internet has become a popular cultural icon, some wondered, will those who are undertaking Internet research find themselves vilified by sectors of the academy, as some popular culture scholars are? Will we see the creation of a new field—"Internet Studies?" We are, I believe, beginning to see it, though its shape and name are as yet indescribable. Will we see the creation of

new scholarly associations for those studying the Internet? The Association of Internet Researchers was born, essentially, at the Drake conference. It now consists of nearly 300 paid members with close to 700 subscribers from countries and disciplines too numerous to list on its email list,

But if there is a field, will it be short-lived or long-term, a passing fad or a lasting area of inquiry? To borrow—if not outright steal from my colleague Jan Fernback's 1999 essay on virtual community—though "there is a there there," when it comes to online social space, is there a *discipline* there?

Research on Internet-specific technologies and experiences must be informed by a longer tradition of research on network technologies *and* it must not overlook the centrality of the term "network" to the role that communication technology has played throughout history. The Internet is not one technology (e.g., the World Wide Web, email, etc.), but neither is it in most users' experience a totality. Perhaps the most satisfying way to define it at present is that the Internet is not only a "network of networks," it is also a "process of processes," ones that beguilingly insert themselves into everyday practices. Unlike media technologies that came before it, the Internet has yet to organize around one process the way that television in the United States, for example, rushed quite early in its adoption headlong into commercial uses and serial, episodic narrative that lent itself to specific modes of viewing.

While on the topic of history, it is also important to consider institutional and disciplinary histories and boundaries. To put it another way: What are the institutional dimensions of academic Internet research, and how are those related to the histories of particular disciplines and even departments? In communications, the field in which I have found a home, the tremendous variety of the origins of programs, in journalism, speech, theater, broadcasting, and so on, and subsequent incorporation of these programs in other departments and units, means great potential for a broad array of perspectives to be brought to bear on the Internet. But it also meant that communications programs have been less than cohesive among one another nationally (note that this is a U.S.-based situation, but I do know from the Digital Borderlands group that the situation is similar in the Nordic and most of the European countries as well). Communications departments have had to struggle to create a discipline-specific identity for themselves within their institutions, to the extent that the addition of new areas of research and interdisciplinarity may be perceived as a cost rather than a benefit.

There are also interesting parallels between geography and academia that have consequences for Internet research. One can see obvious connections between programs that engage in Internet research and the high-tech industries (Silicon Valley and Stanford, M.I.T. and Boston, Austin and the University of Texas, etc., in the United States). More interestingly, co-location is not just bricks-and-mortar but can be fluid, as is the case when scholars gather at conferences, or even gather within institutions, and so we should consider the dispersion of scholars and their work if we are to map the growth of new fields. We might also pay attention to the

confluence of scholars and those they study, as is the case, for instance, with community networking initiatives and studies.

There is also the matter of who Internet research is being *done for*. How might we identify audiences for the research? It may be an audience of academics, it may be the public, it may be industry, it may be students, or it may be some combination of all of these. How we answer the "who is this for?" question has important consequences at the institutional level. If we consider the study of the Internet not just as a scholarly endeavor but also a pedagogical one, that is, one related to the creation of courses, curricula, programs, centers, institutes. Relatedly, *how* we teach students about the Internet has important consequences both for the development of the next generation of Internet scholars but also for the development of general understanding of the Internet. A particularly vexing matter is that many of our students are more knowledgeable about online phenomena than we are. On the other hand, students most often ask me to tell them how the Internet works. Just as often I engage them in a conversation of what we mean by "the Internet." The ensuing discussions are mutually beneficial, to say the least.

What students seem to clamor for is, simply, education about the Internet and its social impact. Though they are savvy about the ways of academic institutions, they have little hint of where to get that particular education. There aren't professors of Internet studies, nor are there such departments. It would tell us much about what we think we are up to in relation to academic endeavors focused on the Internet if we were to come up with a job description for a "professor of Internet." I have seen numerous job ads seeking people to teach and do research on multimedia production, new communication technologies, new media, and so on. I have seen ads seeking people to teach and study online journalism, technology, and organizational communication, but I really cannot recall a job ad specifically seeking an Internet scholar and teacher. Though I try to imagine what it might say, it is not clear to me what we would look for in candidates. The reason it is useful to think about a job ad and the questions a job search inevitably brings up is that it helps us to focus on issues of identity that underpin all the questions I have asked thus far. The process of identity creation is itself a process of boundary-making—of marking off particular territories we inhabit, ones that differentiate and ones we might transgress or find transgressed by others. What might happen if we were forced to pin ourselves down as to an identity in relation to an interest in teaching and studying the Internet, much as we are in most disciplines? Will we become for instance, email, Web, chat, or webcam specialists? Or will we find other ways of forging distinct identities and categories of Internet scholarship? Many of us will likely declare ourselves not so much scholars of the Internet as scholars who find the Internet a worthwhile site from which to engage issues in our disciplines. That is either the mark of interdisciplinarity or an argument against an "Internet Studies." It is too soon to know.

It is of great importance that we engage issues of disciplinarity, interdisciplinarity, and postdisciplinarity. Allow me instead to approach those from a less-

than-usual angle and make some remarks based on the *materiality* of the situation in relation to jobs for Internet scholars. Interdisciplinarity is particularly difficult when it comes to real resources. It may work in principle, or in the realm of ideas, but when it comes to faculty lines and budgets, it is difficult to make forceful arguments based on "need" to administrators. If Internet studies is to gain a foothold in our academic institutions, we will need to make substantive, *intellectual* arguments for Internet research and teaching.

We will need to be aware of both the potential difficulties raised by what is defined as interdisciplinary and the costs and benefits of potentially competing against industry for researchers, students, and colleagues. Interdisciplinarity has not been, and continues to not be, materially easy for those in such positions. At each university at which I have been a faculty member, I have found that those faculty with interdisciplinary and/or joint appointments usually have the greatest demands made on their time and intellectual abilities. First, expectations are higher: they must work between disciplines and justify their existence in that space in-between, feats that other faculty do not have to accomplish. Second, in those cases in which they have appointments in two or more departments, they are often expected to participate in departmental life as if they had 100% appointments in each department. This is, of course, a potentially dreadful situation particularly for junior faculty, who during periodic reviews may have to meet the criteria of two (or more) units and be subject to additional review beyond that which a faculty member with an appointment in a single department encounters.

I realize I have made the interdisciplinary situation sound abysmal, but I do want to point out that the challenges hereby inherent in interdisciplinary and joint appointments are not insurmountable, and that in fact some faculty members are able to thrive in these circumstances. Moreover, interdisciplinarity is an intellectual necessity, as is illustrated by the quality of this very book. Were it not for the breadth of understanding its authors bring to bear on their analyses of life online and offline, I daresay it would scarcely make the important contribution it does.

But it is difficult to know what "Internet studies" can be unless we can pinpoint it in terms of its disciplinarity. It is important to know where one does "live," whether in the texts we create; the gatherings (conferences, symposia, etc.) we attend; the departments, centers, and institutes we create; or in the associations to which we belong. In material terms it is in all these places, but the least ephemeral of them, at least in modern academic life, is the department. And as of this writing there are neither departments of Internet studies nor professors of Internet (at least not in the United States).

There are, on the other hand, institutes and centers devoted to the study of the Internet scattered throughout the world (online as well as offline). There are some college and university departments considered as having an "emphasis" on the Internet because of the presence of one or more faculty within a department or an institution rather than from any institutional structure. And just as often, students are well served by that form of emphasis.

Inevitably, however, Internet research will be further institutionalized, in part because of student demand, in part because of the potential for external funding. When? Very soon, most likely. It is thus important that we ask ourselves more questions, so that we may pinpoint what we hope Internet studies will become. Studying the Internet and network technologies gives us opportunities to better understand modern life and culture, but it can also be great fun. I have found a similar situation in regard to another of my interests, popular music studies. In an insightful essay about popular music pedagogy, Larry Grossberg noted:

> Susan Sontag commented that one of the reasons she left academia was that her col-
> leagues could not accept the intersection of serious scholarship (and politics) with
> the pleasure of the popular . . . academic criticism has typically dealt with popular
> culture by way of value systems and classifications that simultaneously protect pro-
> fessorial authority and deny the popular its specificity. (1986: 177)

One of the most interesting aspects of Grossberg's essay is his discussion of his re-
lationship to his students in terms of their mutual claims to understanding, and ul-
timately to power. Studying and teaching the Internet is not "for free," and it is
not an activity we can take for granted. It is, I believe, an activity that must be artic-
ulated within the context of broader issues of modernity and post-modernity. We
must acknowledge the consequential and political dimension of Internet studies,
whether it be in relation to policy, censorship, access, privacy, or any number of
other important issues, lest we lose contact with the Internet as a *practice* (social,
economic, political). It is not merely a technology, value-free and apolitical.

Hence the value of *Digital Borderlands*. What its authors show is that the Inter-
net is embedded within culture in important ways. The Internet, it may be said,
creates a "virtual culture" (Jones 1997). But a virtual culture cannot be (at least not
yet) *entirely* disassociated from "real" life (Jones 1998). Wellman and Gulia (1999)
noted that most Internet research "treats the Internet as an isolated social phenom-
enon without taking into account how interactions on the Net fit with other as-
pects of people's lives. The Net is only one of many ways in which the same people
may interact. It is not a separate reality" (334). Our conditions of existence are not
all consumed by cyberspace, no matter how often or how much we may log on.
How we, as scholars and Internet users, determine the boundaries between the
online and offline will largely determine the phenomenological and ontological di-
mensions of our analyses.

If we are to begin to understand culture in cyberspace, we therefore need to
adapt our analyses, as Grossberg suggests cultural studies should, by "rethink(ing)
. . . articulations of culture and power" (1997: 354). Adopting a strategy set forth
by Deleuze and Guattari, Grossberg exhorts cultural studies to "explore the con-
crete ways in which different machines—or, in Foucault's terms, apparatuses—
produce the specific spaces, configurations and circulations of power" (355–356).
An articulation that must be interrogated is between the real and the virtual. As
Robins (1995) points out:

It is time to relocate virtual culture in the real world (the real world that virtual culturalists, seduced by their own metaphors, pronounce dead or dying). Through the development of new technologies, we are, indeed, more and more open to experiences of de-realization and de-localization. But we continue to have physical and localized existences. We must consider our state of suspension between these conditions. We must de-mythologize virtual culture if we are to assess the serious implications it has for our personal and collective lives. (1995: 153)

To do so will require that our thinking move beyond the hyperbole of "connection" between people, beyond analyses of social networks, groups, and communities that demonstrate that the Internet "connects." If it connects anything, it connects the real and the virtual. Another way to put it, to again borrow from Grossberg, is that the Internet is an apparatus that links processes of the real to those of the virtual. If the Internet can be understood as a "network of networks," it should also be understood as a "process of processes," one that inserts itself into everyday life, culture and community in a particularly beguiling way. To study the ways the Internet allows connection and then do little else is not only an acritical approach to the study of life online; but it ultimately reifies technology and subsumes human, interpretive activity to the tyranny of the Internet itself.

Thus we would do well instead to learn from *Digital Borderlands'* examples and examine the Internet's own connections to other realms of human endeavor. If cultural studies can "denaturalize and radically contextualize the Internet itself," as Sterne has said (1999: 277), scholars must think less about the connections users make online and more about what it is that connects the expression of particular interpretations and what compels repression of others. We must delve into the *how* and *why* of the connections made and into the formation and re-formation of both the structure of the Net *as both apparatus* and spatializing force, not in the sense of "creating space" (such as cyberspace) but rather in the sense that the Net creates affective spaces. Only by problematizing the relationship between the triumvirate of space, connection, and culture is it possible to do so. To borrow from Geertz, how might we "reduce the puzzlement . . . to which unfamiliar acts emerging out of unknown backgrounds naturally give rise" (1973: 16)? The goal should not be to merely "connect" the real and the virtual; it should be to embed one within the other. The choice one must make when doing Internet research, therefore, is deciding which one, the real or the virtual, is to be embedded in the other.

Notes

1. The presentations from this conference have been published in book form: Swiss, T. and A. Herman, (eds.): *The World Wide Web and Contemporary Cultural Theory*. New York: Routledge, 2000.

References

Fernback, Jan. "There is a There There: Notes Toward a Definition of Cybercommunity. In *Doing Internet Research,* pp. 203–220, edited by Steve Jones. Newbury Park, Calif.: Sage, 1999.

Geertz, Clifford. *The Interpretation of Cultures*. New York: Basic Books, 1973.

Grossberg, Lawrence. "Teaching the Popular." In *Theory in the Classroom,* pp. 177–200, edited by Cary Nelson. Urbana, Ill.: University of Illinois Press, 1986.

———. *Bringing it All Back Home: Essays on Cultural Studies*. Durham, N.C.: Duke University Press, 1997.

Jones, Steve. *Virtual Culture*. London: Sage, 1997.

———. *Cybersociety 2.0.* Newbury Park, Calif.: Sage, 1998.

Robins, Kevin. "Cyberspace and the World We Live In." In *Cyberspace/Cyberbodies/Cyberpunk* (pp. 135–155), edited by Mike Featherstone. London: Sage, 1995.

Sterne, Jonathan. "Thinking the Internet: Cultural Studies vs. the Millennium." In *Doing Internet Research,* pp. 257–288, edited by Steve Jones. Newbury Park, Calif.: Sage, 1999.

Swiss, Thomas, and Andrew Herman. *The World Wide Web and Contemporary Cultural Theory*. New York: Routledge, 2000.

Wellman, Barry, and Milena Gulia. "Net-Surfers Don't Ride Alone." In *Networks in the Global Village,* pp. 331–366, edited by B. Wellman. Boulder, Colo.: Westview Press, 1999.

INDEX

THE AUTHORS

JOHAN FORNÄS is Professor and head of research on cultural production and cultural work at the National Institute for Working Life Program for Work and Culture in Norrköping, Sweden. He also heads the Advanced Cultural Studies Institute of Sweden (ACSIS). His background was in musicology and in media and communication studies. He initiated the Digital Borderlands project, inspired by an interest in karaoke and other forms of musical interactivity in digital media. His English publications include *Cultural Theory and Late Modernity* (1995), *Youth Culture in Late Modernity* (1995) and *In Garageland: Rock, Youth and Modernity* (1995).

STEVE JONES is Professor and head of the Department of Communication at the University of Illinois in Chicago. He is also Senior Research Fellow for the Pew Internet and American Life Project and a leading scholar in the field of Internet research. His many publications prominently include *Cybersociety* (1995), *Virtual Culture* (1997), *CyberSociety 2.0* (1998) and *Doing Internet Research* (1999).

KAJSA KLEIN is a doctoral student of media and communication studies in the Department of Journalism, Media and Communication at Stockholm University, Sweden. In the fall of 1998, she was a visiting scholar at Columbia University in the United States. Her dissertation, which studies the world citizen as an Internet construct, has received funding from the Swedish Transport and Communications Research Board.

MARTINA LADENDORF is a doctoral student in the Department of Communication, Journalism and Computer Science at Roskilde University Centre in Denmark, having transferred in 2000 from Media and Communication Studies at Stockholm University. Her dissertation deals with female and feminist webzines in the United States, Australia, and Sweden.

JENNY SUNDÉN has a Ph.D. from the Department of Communication Studies at Linköping University in Sweden. She was a visiting scholar in the English Department at the University of California at Berkeley in 1998–1999, and is now teaching in the field of media and cultural studies. Her publications include *Material Virtualities: Approaching Online Textual Embodiment* (2002).

MALIN SVENINGSSON has a Ph.D. from the Department of Communication Studies at Linköping University in Sweden. As participant in a collective project that deals with Internet research methods, she is also publishing a methodological textbook in that area. Her publications include *Creating a Sense of Community: Experiences from a Swedish Web Chat* (2001).

Digital Formations

General Editor: Steve Jones

Digital Formations is the new source for critical, well-written books about digital technologies and modern life. Books in this series will break new ground by emphasizing multiple methodological and theoretical approaches to deeply probe the formation and reformation of lived experience as it is refracted through digital interaction. Each volume in *Digital Formations* will push forward our understanding of the intersections—and corresponding implications—between the digital technologies and everyday life. This series will examine broad issues in realms such as digital culture, electronic commerce, law, politics and governance, gender, the Internet, race, art, health and medicine, and education. The series will emphasize critical studies in the context of emergent and existing digital technologies.

For additional information about this series or for the submission of manuscripts, please contact:

Acquisitions Department
Peter Lang Publishing
275 Seventh Avenue 28th Floor
New York, NY 10001

To order other books in this series, please contact our Customer Service Department:

(800) 770-LANG (within the U.S.)
(212) 647-7706 (outside the U.S.)
(212) 647-7707 FAX

or browse online by series:

WWW.PETERLANGUSA.COM